Tattoo Art

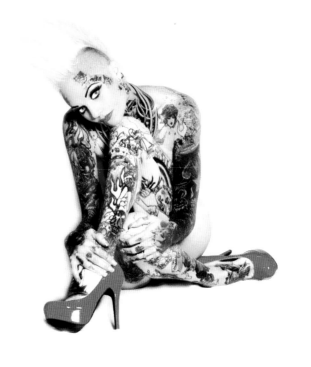

Publisher and Creative Director: Nick Wells
Project Editor: Catherine Taylor and Victoria Marshallsay
Picture Research: Catherine Taylor and Victoria Marshallsay
Art Director: Mike Spender
Digital Design and Production: Chris Herbert
Layout Design: Jane Ashley
Proofreader: Dawn Laker
Indexer: Helen Snaith

12 14 16 15 13

1 3 5 7 9 10 8 6 4 2

First published 2012 by
FLAME TREE PUBLISHING
Crabtree Hall, Crabtree Lane
Fulham, London SW6 6TY
United Kingdom

www.flametreepublishing.com

Flame Tree Publishing is part of Flame Tree Publishing Ltd

© 2012 Flame Tree Publishing Ltd

ISBN 978 0 85775 603 9

A CIP record for this book is available from the British Library upon request.

Acknowledgements:

RUSS THORNE (Author) Russ Thorne's experience of body art began with a tiny design from an even tinier high street shop, inked to the sounds of David Bowie. He was so nervous he didn't even do the countdown bit in 'Space Oddity'. Since then he's gone on to collect bigger and better pieces and has written extensively about tattoos and tattooing in books such as *Blood and Ink* and *Spiritual Tattoos*, as well as contributing regularly to *Skin Deep* magazine and meeting some generous, talented (and delightfully mad) artists along the way. He lives in York with his wife, who patiently listens to his tattoo ramblings, and an attention-seeking Jack Russell (who doesn't).

GUY AITCHISON (Foreword) Guy Aitchison began tattooing in 1988 after falling in love with the art form as a teenager. This was a time when the new wave of innovative young tattooers was just starting to emerge from the subcultural woodwork of the punk rock scene. He apprenticed with Chicago's Bob Oslon, and within his first year on the job he had already scored his first article in *Tattoo Magazine*, and he continues to publish regularly. He is best known for his abstract biomechanical tattoo work, a style that is loosely inspired by the work of Swiss surrealist H.R. Giger, but which Guy has taken in his own personalized direction. Aiming for a maximum visual impact, his style incorporates every trick in the book to imbue his work with depth, luminosity, texture, flow, and realism. Guy has taught seminars to other tattooists, and has also published a number of educational books, the most significant being *Reinventing The Tattoo*. He now works steadily on his regular clientele in a studio he shares with his wife, tattooist Michele Wortman.

Printed in China

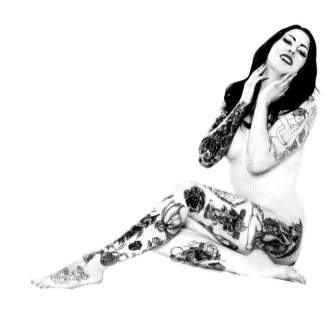

Inspiration, Style & Technique
from Great Contemporary Tattoo Artists

Russ Thorne

Foreword by Guy Aitchison

FLAME TREE
PUBLISHING

Contents

Foreword

attooing is an ancient art, as old as human culture. Over the course of history, it's sprung up in many forms in many different parts of the world, so apparently it's something that people just naturally do; it somehow has an inherent gut appeal. People who get tattooed and have a positive experience with it come out feeling empowered, improved and even healed or transformed. This isn't something our culture has taught us; it is something in our chemistry — something primal. But today's world citizens have been modernized to the point where a disconnect has happened: a state where we almost can't function without being reminded of the basics: Relax. Exercise. Eat good food. Spend quality time with your family ... and get tattooed!

There's been a lot of talk lately about the tattoo reality TV craze and the impact that it has had on the profession. One major effect is that it has created a bridge for the average person to visualize themselves actually getting inked. They can imagine it being gratifying, and they can see it in their mind's eye. These clients represent a whole new demographic of tattoo collectors, and they tend to have at least some sense of what makes a good tattoo. They also seem to be proof of tattooing's innate appeal; showing the larger public what is possible to achieve on the skin has resulted in a very positive new public awareness of the tattoo art form and has certainly encouraged countless new serious tattoo collectors to appear on the scene.

However, there is another aspect to this, which is bigger than the TV and the pop culture phenomena. To anyone who has been paying attention for any period of time, the answer is simple: It's about the art. The tattoo art form has evolved so rapidly, so dramatically, in such a short time that it's no wonder people are taking notice. This is the one factor driving everything else that is happening with the tattoo industry and which made tattoo reality shows possible: without the high-quality work, there would be nothing to build a TV programme around. It has also driven the growth of tattoo conventions, publishing, social networking and art collecting.

With every passing year, tattoos get more and more amazing. The language gets broader, the technique gets stronger and the range of available effects is expanded. The understanding of what works continues to evolve, from what makes for an effective composition that reads from across the street to how visually subtle or specific you can make a tattoo without compromising its longevity. Every year, the best work gets more remarkable and the most average work looks better than the very best from 20 years ago. We have truly come a long way.

So why all the artistic growth? After thousands of years of tattooing, why the explosion now? The answer isn't simple, of course, because it's part and parcel of the explosive growth in so many other human pursuits. It's safe to say that the availability of quality information has been one of the main reasons, though, and the fact that the industry came together and worked out a format for sharing information, in the form of conventions and other tattoo events, has made this possible. Tattooists have always been very guarded about sharing, especially technical information, and it marked a new point in the evolution of the industry when they were able to collectively overcome this reticence and begin benefiting from everyone knowing more.

The story of this new tattoo renaissance is far from over. The world of tattooing is now one of the most creatively and stylistically diverse artistic fields in modern times. It is without limit, and it is a field where uniqueness and invention are quickly recognized and rewarded. In my opinion, the real explosion is still happening and it is perhaps really just getting started. Right now is the best time possible to be involved in the tattoo world.

Guy Aitchison Biomech Tattooist

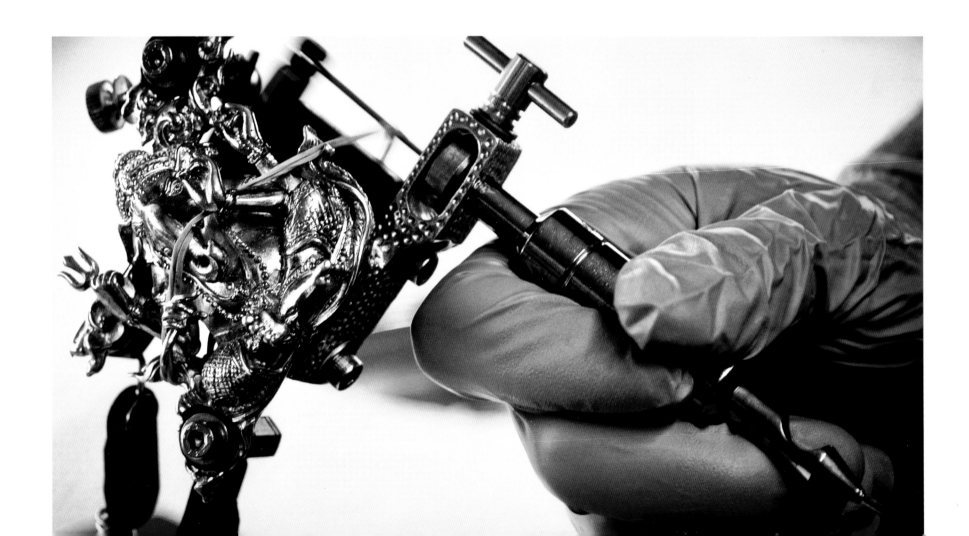

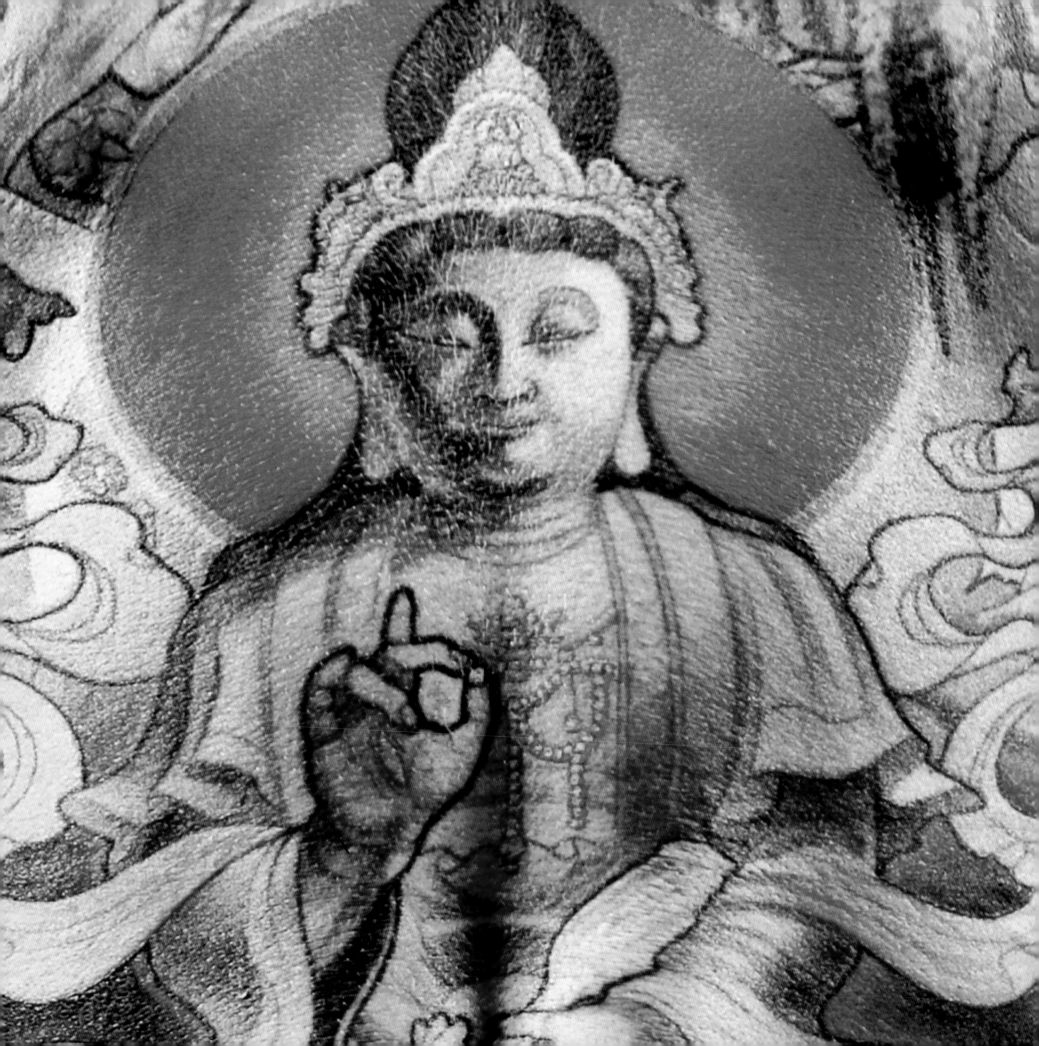

Introduction

Who do tattoos belong to? The answer has varied throughout the ages, as tribal warriors, rock stars, Egyptian princesses and celebrity tattoo artists have all worn, and still wear, tattoos. Then there is the commonly reported cliché that tattoos are no longer the sole preserve of bikers and criminals. And it's true: they're not. But it's also true that tattoos have *never* been exclusively the preserve of bikers and criminals – or princesses. They might wear tattoos, but they don't own them.

International Ink

Tattoos are a big part of our cultural history and heritage, and at the moment they are an even bigger part of popular culture than they have ever been. That's a good thing for artists and it means that more people can come into contact with great body art.

However, it can also mean that people rush out and get tattoos without thinking about it or without finding out exactly how great their art could be – and how meaningful. This book is here to help by collecting some of the very best art from the very best artists working today and putting it together in one beautiful place. Established 'collectors' (a popular term for those who wear tattoos), people contemplating their first tattoo or even those who have no desire to get inked but simply appreciate the art will find plenty of inspiration here to interest them. Indeed, there are some jaw-dropping pieces to just stare at and admire.

Those who want to dig a little deeper will find some explanation of the tattooing process from a few of the heavyweights in the business. It's a peek behind the curtain to see how tattoos come together, with a chance to see works in progress and get a real feel for exactly how much skill and magic goes into the art.

The Agony and the Ecstasy

As interesting as those technical explanations may be, the strange magic of tattoos is probably one of the reasons we remain fascinated by them (in some parts of the world, tattoos are still created as part of magic rituals believed to protect those who receive the ink). Everything that surrounds their creation – the artists, the buzz of the machine, the antiseptic and blood-metallic tang of a studio, and the pleasure/pain cocktail of the tattooing process – contributes to the mystique, as do the infinite reasons why people choose to wear them.

The concept of 'why?' is another compelling aspect of the tattoo world. Why get one? Getting a tattoo purely for its own sake, just as a piece of art, is as fascinating a decision as any other. It still involves planning and pain, and at the root of any piece of art's appeal is what it says to us, quietly, on a level we may not even understand ourselves. Choosing a tattoo simply because we like it still speaks volumes about us.

A tattoo is a true poetic creation, and is always more than meets the eye. As a tattoo is grounded on living skin, so its essence emotes a poignancy unique to the mortal human conditioin.

Modern Primitives

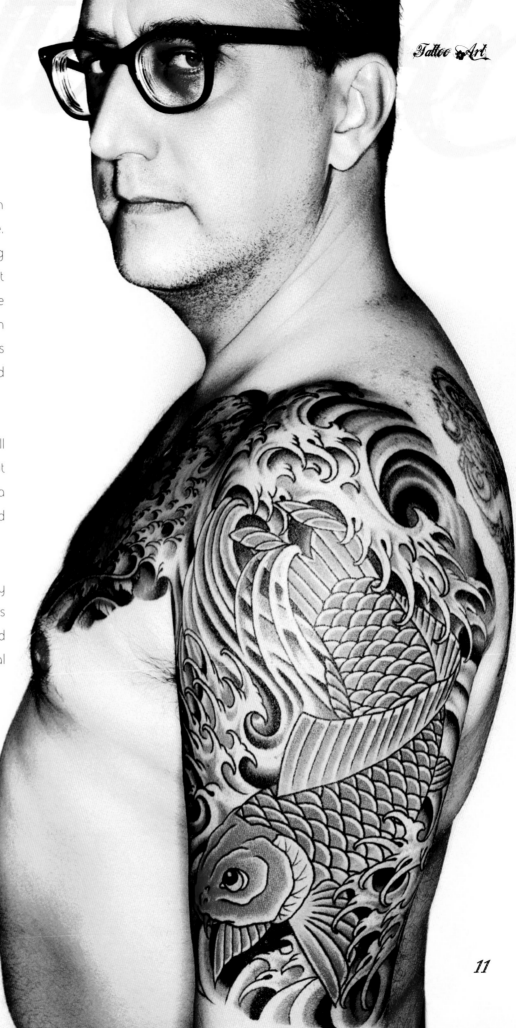

Practical Magic

Tattoos don't have to be matters of life and death, but wrapped up in their magic is the inescapable fact that a lot of the time they are. From tribal initiation tattoos to modern memorial pieces, creating tattoos that illuminate and commemorate the life experiences that have shaped us has been a human practice for as long as they have been around. So much so that some styles of tattooing have even evolved their own language of symbols and signs to help us express ourselves; getting a tattoo can be a way of showing who you are and where you have been.

So both for those seeking pure adornment and those wanting to tell a story through their tattoos, this book offers some suggestions about where to start. You'll find a tour through major tattoo styles and a look at the meanings behind some popular recurring images and subjects. And of course there is plenty of visual inspiration.

From there, it's up to you. Everyone creates their own unique story through their art – even similar-looking tattoos have different origins and contain infinite variations, because we are all infinitely varied ourselves. Tattooing doesn't belong to anyone, and that's the real magic: it belongs to everyone.

Boff Konkerz

Tattoo Artist

Boff Konkerz is a London-based tattoo artist who works without a typical tattoo machine. All of his work is applied using a simple tool he makes himself. This technique goes by several names, including 'handwork' and 'stick and poke', although Boff himself prefers 'machine-free tattooing'. Boff favours working in black ink and most often shades with dots. The machine-free technique takes a little longer to apply, but the healing time is much shorter as the hand tool causes less trauma to the skin than a conventional machine. Boff prefers to draw the tattoo design directly on to the client's skin, as he is then able to work with the contours of the body, although for some designs he will use a stencil. Boff is influenced by Indian mehndi designs, folk art and various tribal tattoo cultures from around the world. He travels extensively so he can introduce this method to as many people as possible, and has recently worked in the UK, Ireland, Norway, Sweden, Belgium, Austria, Iceland, California, France and the Faroe Islands. Boff is attracted to this way of working as he finds the slower pace and quietness of the work makes for a more personal experience for both himself and his client. He has described the work as a moving meditation, like T'ai chi for the skin.

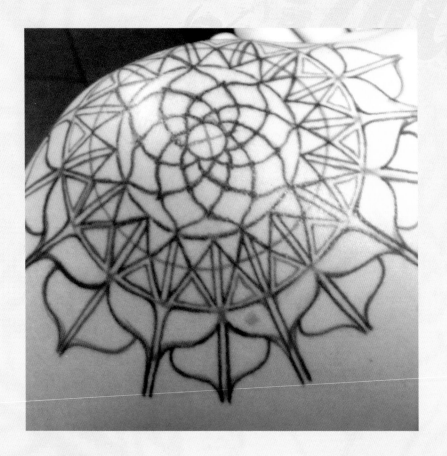

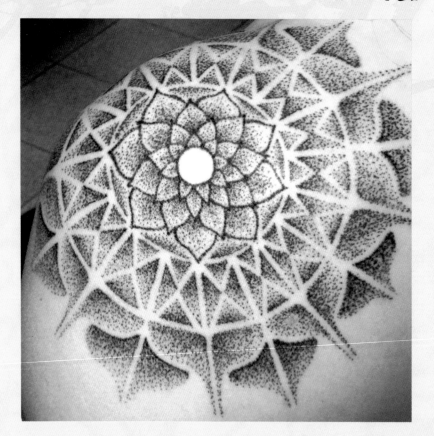

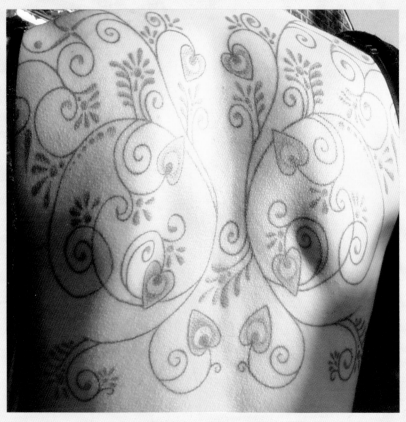

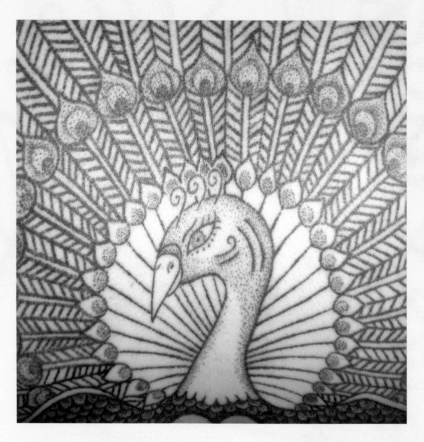

A Tale of Tattoos

attoos and tattooing are currently enjoying such immense popularity that it could be easy to perceive them as a colourful modern invention: a flashy twenty-first century adornment that we have conjured up from thin air like reality TV or the internet. But that's a long way from the truth.

We don't actually know how long we have been tattooing one another. (And that's another interesting thing about tattooing: it's rarely a solitary occupation, and it evolved hand in hand with our development as social creatures. Ever tried drawing on your own back? Exactly. It helps to have a friend around.) The earliest surviving examples of tattoo art suggest that it's been with us since we were wearing furs and fretting about how close those glaciers seemed to be getting.

The Iceman Cometh

The beginning of tattoo history as we know it starts – like all good stories – around the fire. It's the soot from the cooking process that we're interested in, though. Scrape it off and powder it up, then rub it into wounds in the skin made with a thorn (or something else sharp) and you end up with crosses, parallel lines and other assorted dots.

Add to this a fatal head injury and a whole lot of ice and you've got the life story of Ötzi. This Bronze Age man lived around 3300 BC and came to a sticky end in combat high in the Italian Alps, before being preserved in ice until the early 1990s, when his well-preserved body was found by hikers.

photocredits Photographer: Justice Howard/www.justicehoward.com

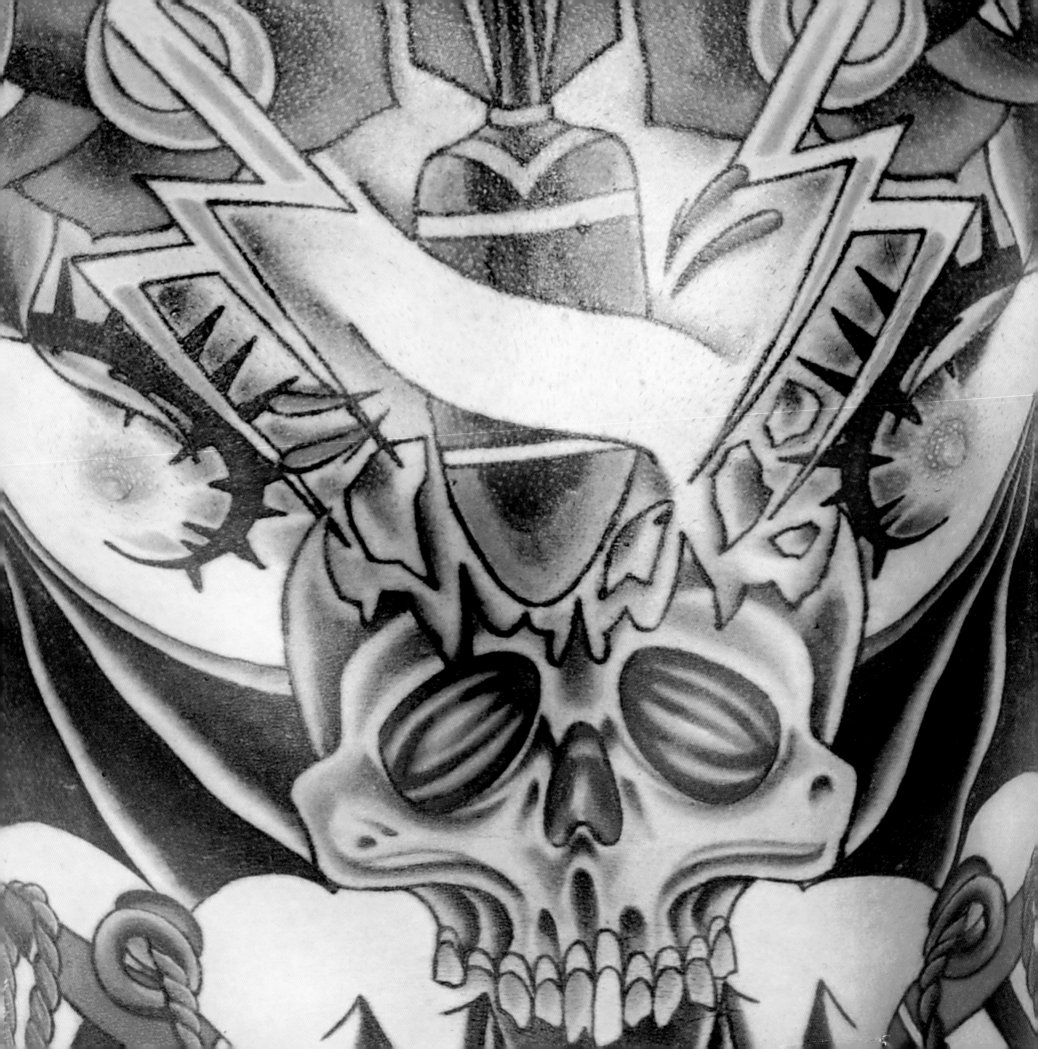

It was a remarkable find in itself, but for those interested in body art, the iceman had particular significance. His body was marked with more than 50 crude tattoos (created with the cutting edge Bronze Age 'soot and stick' technique) placed over what we now know to be important acupuncture points. Was it medicinal? Decorative? Religious? We'll never be sure, but Ötzi's art showed the world that tattoos have been around for longer than was previously believed.

More Mummies

While Ötzi is certainly the oldest mummified human to bear tattoos, he is not the only one we have discovered. Several Egyptian mummies (all female) dated to around 2000 BC have numerous dots tattooed on their bodies, which some scholars believe to be protective charms to help them during pregnancy and childbirth.

It's not all about the dots, though. A 2,400 year old member of the Scythian Pazyryk culture from the Altai Mountain region was found preserved in the Siberian ice and bearing ornate tattoos of mythical beasts, while a relatively modern mummy (from AD 450) was recently discovered in Peru with complex symbols covering her forearm.

Tribal Tattooing

Clearly, like religion, art and music, tattooing sprung up in unconnected parts of the world and developed over time, picking up different degrees of cultural significance along the way. For many tribal societies, such as those in Samoa, Aotearoa (the Maori name for New Zealand) and the Pacific Northwest, tattooing was an important ritual that lay at the heart of their culture.

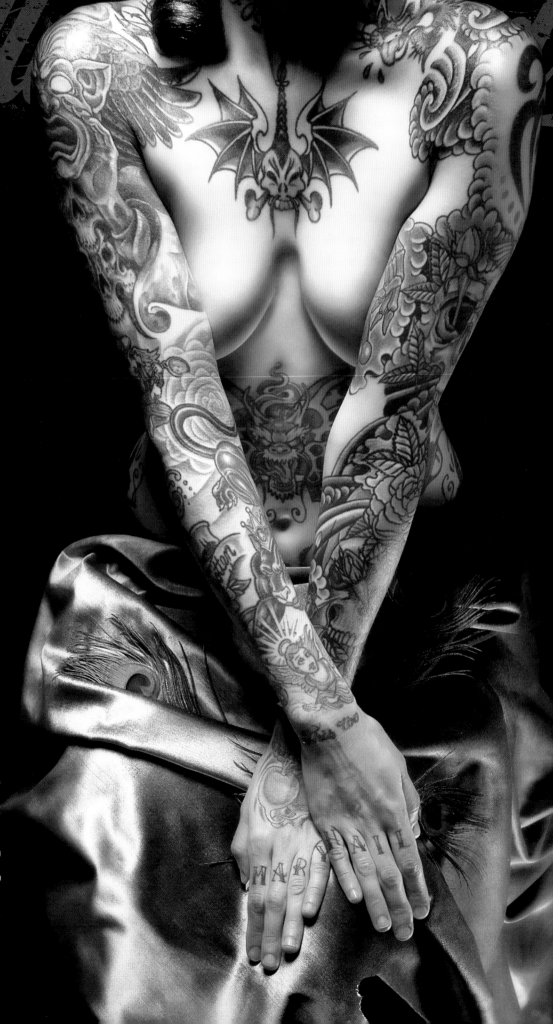

Tattoos could identify the wearer's tribe, role or rank within society and anyone skilled in reading the complex symbols could even trace a person's tribal lineage through their markings – the Maori *ta moko* facial tattoos are a good example of this. And once life came to an end, your tattoos were still useful, especially if you belonged to the Dayak people of Borneo, according to whom they would illuminate and guide you through the shades of the underworld to rejoin your ancestors.

Less poetic, but still useful, was the military function of tattoos, which could denote the number of kills a warrior had attained or act as a potent distraction in battle. Tattooed Tongan warriors would deploy their ink as a body-borne shock-and-awe tactic, intimidating their enemies and putting them off balance long enough for their spears to do their work.

Ritual Inking

The swirling geometry of early tribal tattoos was important, but just as significant was the process of getting one. Depending on your tribe, you could have faced sharpened bamboo needles being pushed into your skin, having the designs almost carved into your features by a Maori *uhi* (a chisel made from albatross bone) or the especially eye-watering Samoan *au*: a miniature rake with sharp bone teeth that was dipped in ink and hammered into the skin.

These Samoan *pe'a* tattoos were created as part of a ritual that could last several days and were part of the journey towards adulthood. No numbing cream here: you had to receive your tattoo with no complaints. It was painful, bloody and lengthy, as tattoos could often cover a large part of the body, starting at the hips and sweeping right down to the knees. On the flip side, once the tattoo was done you were considered mature and were allowed to speak to adults (who hopefully would turn out to be interesting).

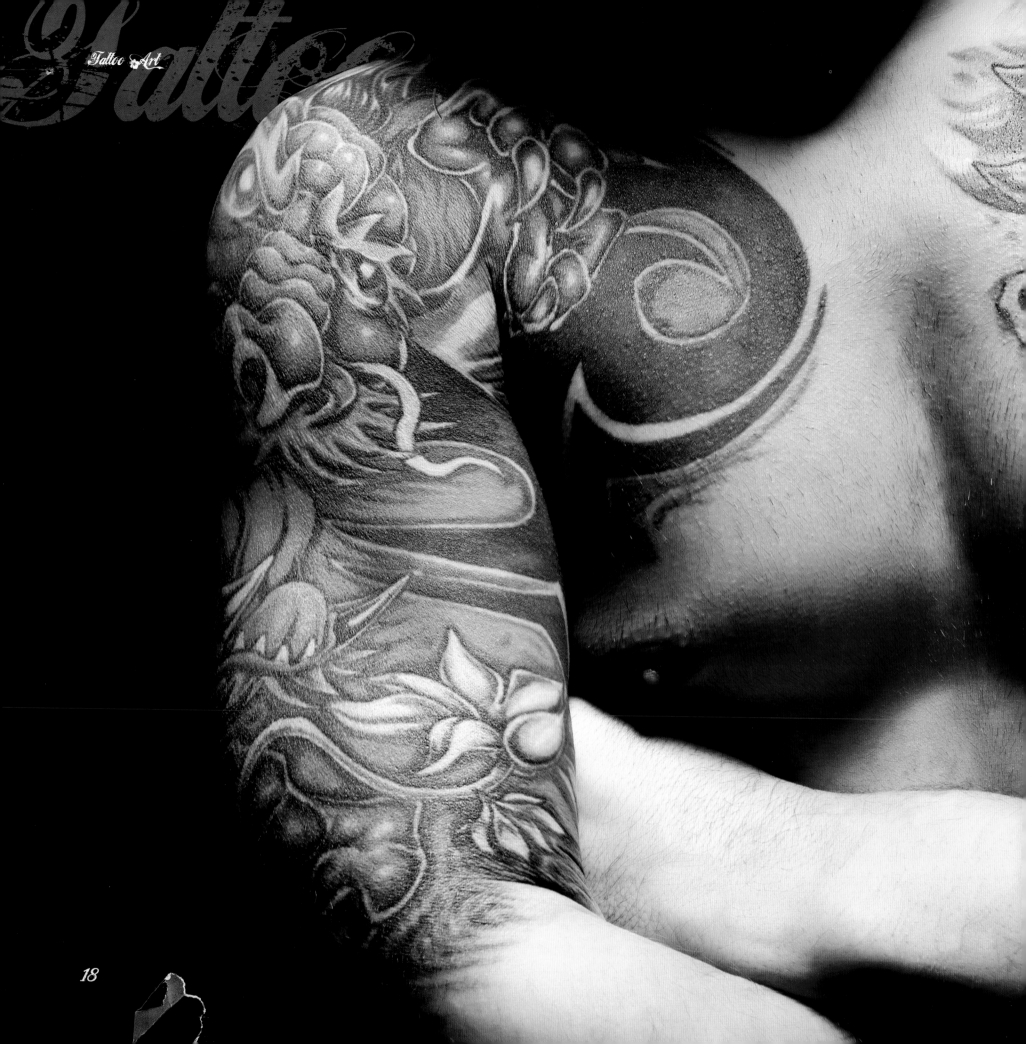

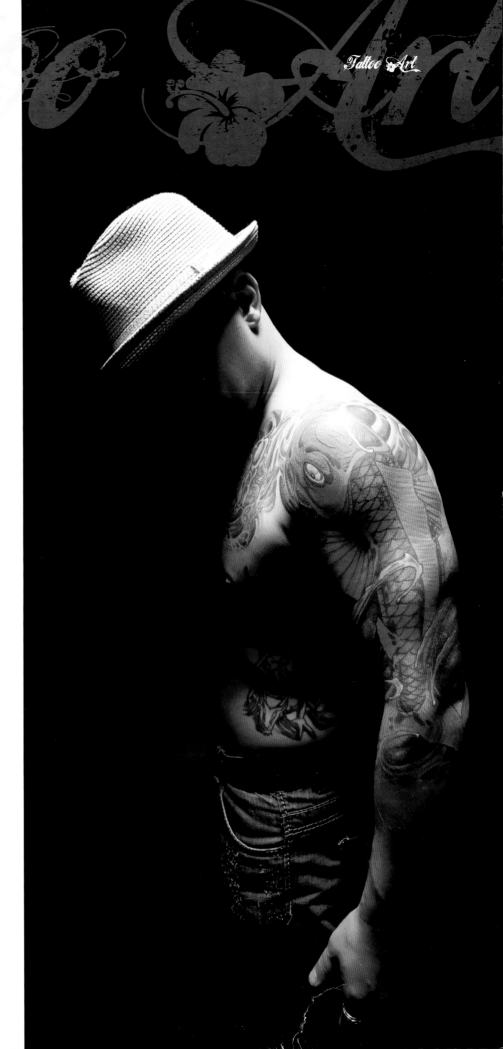

Unsurprisingly, it was common for the tattoo artists themselves to have an elevated position within tribal societies. They were the ones conferring adulthood, warrior status or even magical protection upon the wearers, after all.

O Captain, My Captain

Tattoos took a big step towards the West when Captain James Cook made his voyages into the Pacific Ocean in the eighteenth century. 'The universality of tattooing is a curious subject for speculation,' he wrote after arriving in Tahiti in 1769 to see the unique markings of the indigenous people he encountered there.

But if the tattoos he saw had an impact on the captain, it was the effect they had on the sailors in his crew that really changed the course of body art history. Collecting memorabilia from far-flung places was (and is) a hugely important part of naval life, and what could be a more striking keepsake than a tattoo? Some sailors duly submitted to the tattoo artist's talents and bore their tattoos home, exposing European culture to something they had never come across before.

Cook is also credited with giving the word 'tattoo' its current meaning in the English language. This term had previously been used to describe a rhythmic tapping sound but when Cook and company encountered what the Tahitians called *tautau*, they substituted the word with a similar-sounding one, dubbing the process 'tattoo'. Happily, its original meaning also fits with the rhythmic hammering sound that accompanies traditional tribal tattooing from the region, as needles are tapped into the skin.

Meanwhile, Further East

Tattooing has been part of the culture in Southeast Asia for more than 2000 years (according to Chinese writings), where it has been practised in Cambodia, Thailand, Laos and beyond. The traditional form is known as *sak yant* or *yantra* tattooing; often applied by Buddhist monks, it uses long poles and specially formulated inks that are blended with medicinal (read: trippy) herbs. The resulting tattoos were (or are) believed to have magical properties, protecting the wearer from harm.

The Ainu people of Hokkaido – Japan's most northerly island – took a different approach: only women were tattooed. They sported marks on their lips created by rubbing soot into small incisions – a practice that only really died out in the twentieth century.

Big in Japan

Japanese tattooing is a huge topic and the relationship between the Japanese and tattoo art has been a complex one. It may have begun as early as 5000 BC in the form of lines marking the face, but it was definitely outlawed by the eight-century BC, when tattoos were only used as a form of punishment. Criminals were conspicuously branded with marks detailing their crimes – they could even denote where a ne'er-do-well had committed their nefarious deeds.

Punitive tattooing stopped around the eighteenth century but a ban on tattoos remained in place until the end of the Second World War. However, tattoo art flourished all the same, especially during the Edo period of 1600–1800, during which it followed the fortunes of contemporary art. Woodblock artists such as Hokusai defined that era

and their influence can still be seen in Japanese tattooing, where the same style and balanced composition remain important.

Another major source of inspiration for Japanese tattooing was the illustrator Kuniyoshi, whose artwork accompanied a version of the Chinese novel *Suikoden*. The visuals of Kuniyoshi's version, complete with tattooed warriors, mythical creatures and a preoccupation with the relationship between foreground and background, and flora and fauna, were hugely influential on Japanese tattoo art.

Rise of the Machines

Whatever their cultural significance, all tattoos up until the nineteenth century had one thing in common: they were needled in by hand, either by tapping or repeated poking (probably not as fun as it sounds). That all changed thanks to two men: Samuel O'Reilly and Charlie Wagner, who both created electric tattoo machines.

They were both built on electromagnetic ideas put forward by Edison, but O'Reilly developed and patented his iron in 1891, whereas Wagner introduced his improved design in 1904. Along with the work of a third innovator, Percy Waters, the machines designed by these artists enabled faster, cheaper and ultimately more accessible tattoos.

The Professor

During the early twentieth century, the world of tattooing gained a few characters who would further shape its future. Amongst them was the Englishman 'Professor' George Burchett (1872–1953): a former seaman who gained tattoo experience all over the world and picked up influences from the Holy Land, Asia and Africa, bringing all of them together in his tattooing.

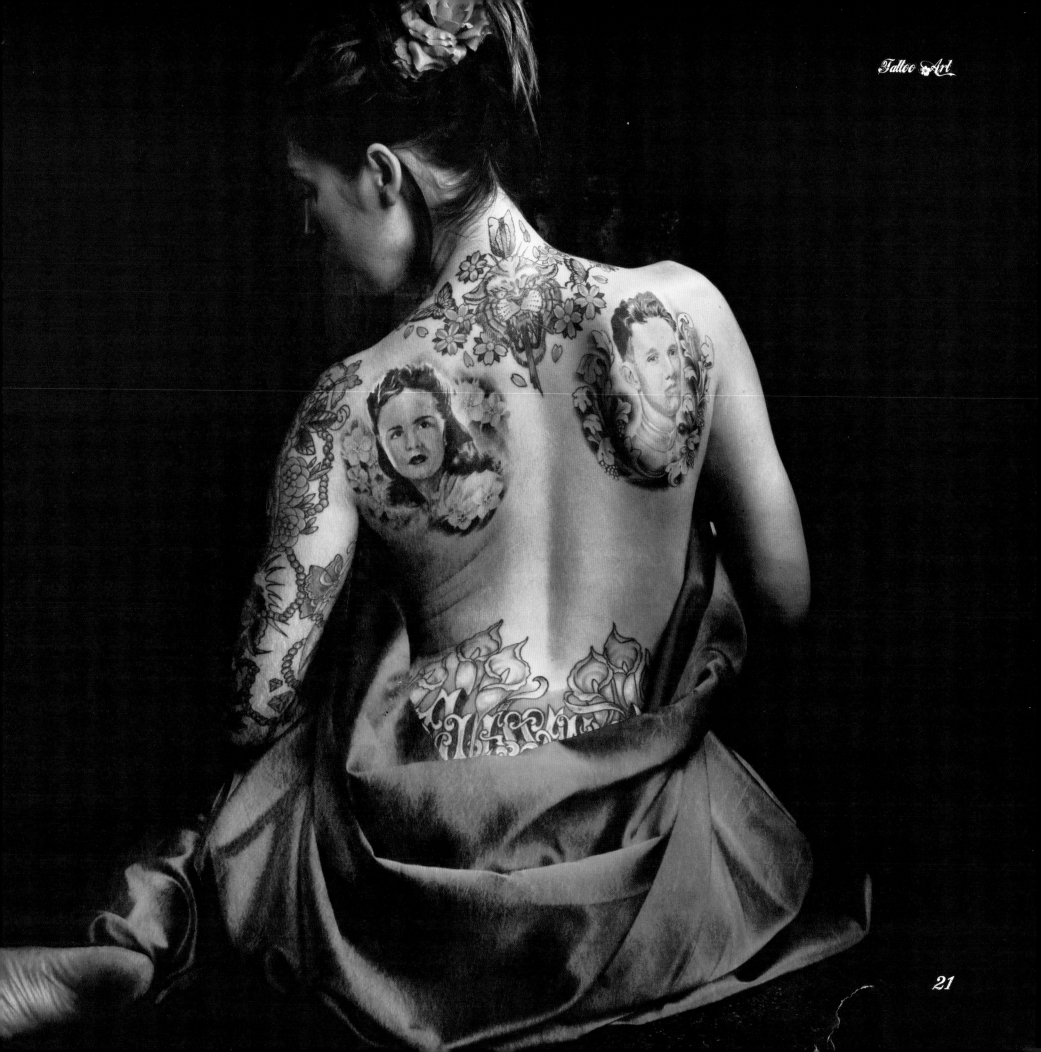

Tattoo Art

His client list was pretty enviable and included King Alfonso XIII of Spain, King Frederick IX of Denmark and England's George V. Working with his brother Charles, his image suggested a gentleman tattooer dressed in crisp shirts and vests, often working in a medical smock (great moustaches too, chaps).

Sailor Jerry

On the other side of the pond, another big name was plying his trade in ports of Hawaii. Norman 'Sailor Jerry' Collins (1911–73), also a former seaman, drew on the Japanese tattooing he saw while on Navy service in the 1940s to create his own unique style, which blended elements of traditional American tattooing with Eastern ideas of form and composition.

Sailor Jerry's work incorporated distinctive colours and shading, along with pieces that linked together and took the contours of the body into account to give them a more balanced, coherent appearance. He was also something of a technical innovator, who tinkered with his machines to get the best setup, introduced new standards of hygiene and even experimented with his own pigments to create new colours for his work.

By all accounts a tough old sea dog, Collins set up his shop in the sailor-swarmed streets of Honolulu's Chinatown and built up a fearsome reputation and growing fanbase. At the same time, he was keen to learn and exchange ideas, so he corresponded with artists around the world and trained up influential protégés, such as Mike Malone and Ed Hardy. And, yes, that's his tattoo flash on those rum bottles.

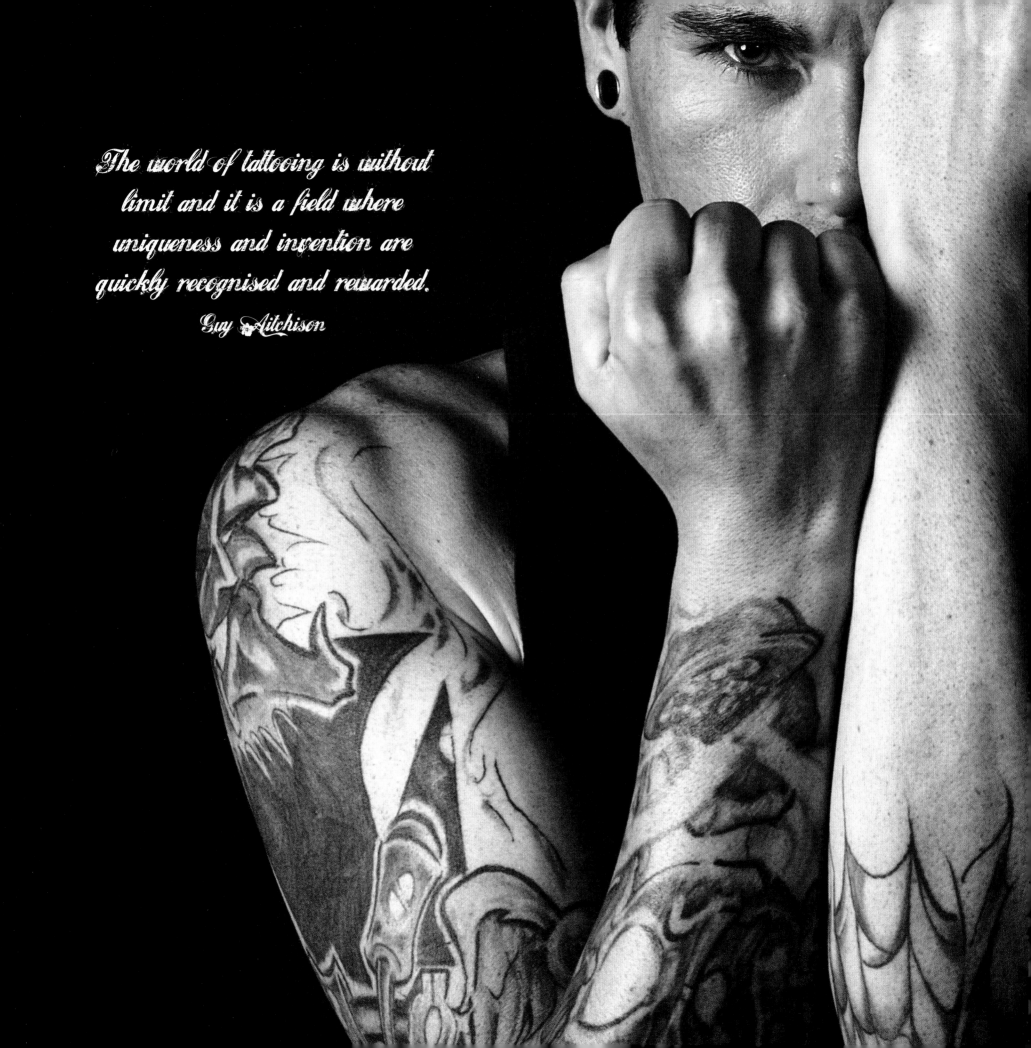

The world of tattooing is without limit and it is a field where uniqueness and invention are quickly recognised and rewarded.

Guy Aitchison

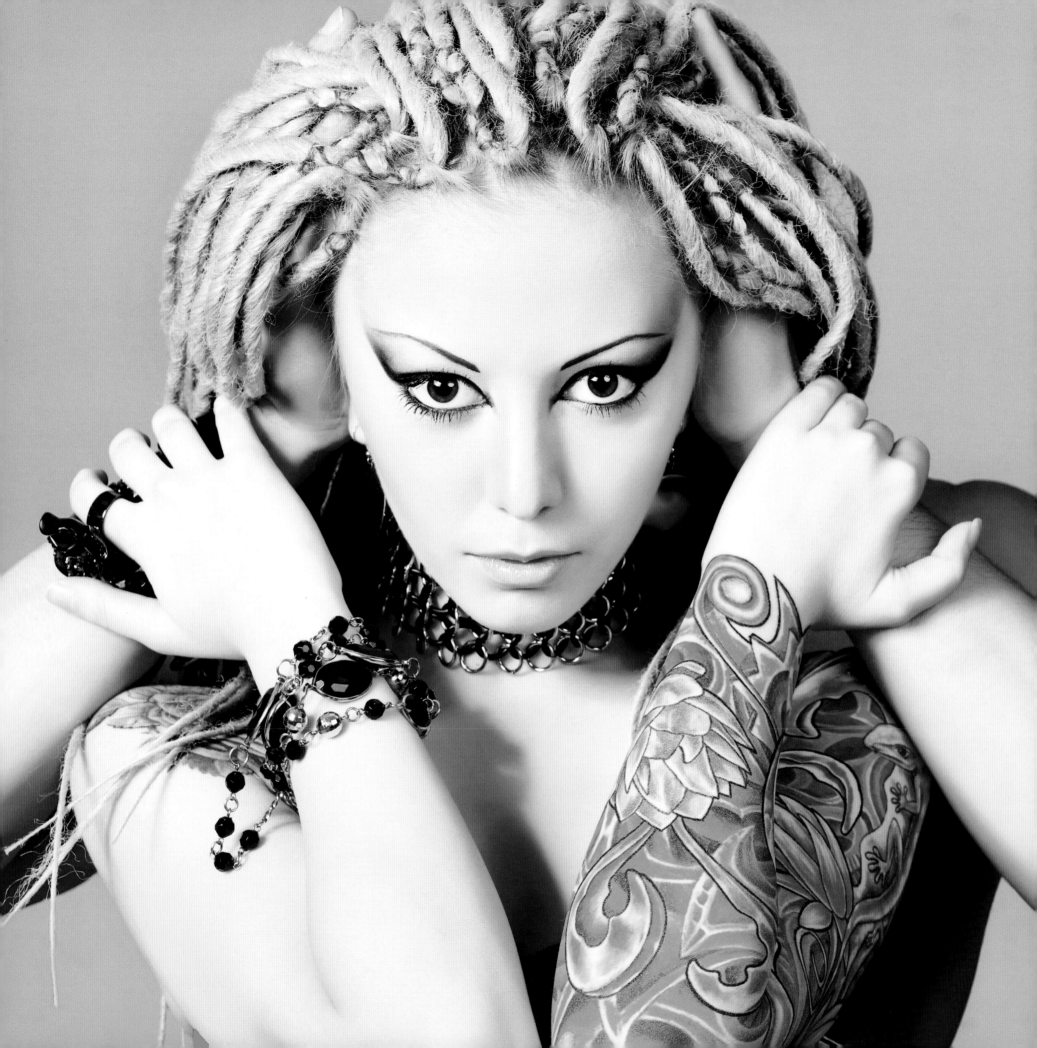

Black Eye Specialists

Speaking of tough, New York shops in the 1930s would sometimes bear a striking sign advertising 'Black eye specialists'. Nothing to do with doling out free head shots (well, not always), the signs were actually advertising a slightly different cosmetic service to the working and fighting men of the city, for whom showing up to work or returning to their ship with a black eye was the shortest way to unemployment. Anyone with a shiner could go in to have the swelling reduced (allegedly by leeches, although this could be apocryphal) and the eye made up with powder to look normal; then off to work they'd go.

Covering Up

Perhaps one of the more eccentric periods in tattooing history involves a different kind of covering up. Thanks to a US government decree stating that 'indecent or obscene tattooing is cause for rejection' amongst those applying to join the Navy but that candidates would be given the chance to 'alter the design', the 1940s saw a rush of men into tattoo parlours.

Once there, they would have their originally somewhat salacious tattoos of girls in various states of undress put right – by having clothes inked on to them. They would then be eligible for military service and could enlist to fight in the Second World War; what a difference a dress makes.

Going Underground

After the war, the world of tattooing took something of a beating in the USA. While it continued to thrive in the UK, the practice was banned in the States, thus driving artists and studios underground. As the 1950s and 1960s wore on, this created the image of tattoos as the preserve of criminals and rebels, which still lives on in some popular misconceptions relating to the history and heritage of tattoos.

However, a determined rearguard action by artists such as Lyle Tuttle saw gradual improvements in health and safety, thus removing the more terrifying practices which included communal inkpots and shared needles (yes, really). Meanwhile, the artistic community set about business as usual, creating increasingly interesting and accomplished art as the decades wore on and the 1970s and 1980s rolled around.

By the time the 1990s arrived – and Alicia Silverstone's on-screen belly button piercing in Aerosmith's 'Crazy' video effectively brought body modification into the mainstream overnight – tattoo studios were increasingly seen as legitimate places of business. Modern masters such as Ed Hardy began spreading the tattoo gospel and finding new disciples, and the stage was set to usher in the twenty-first century and a whole new age of tattooing that no one could have predicted. Least of all Ötzi, as he scraped soot from the cooking pot while the winds howled in the mountains …

Dave Fox

Tattoo Artist

Born in Philadelphia, Dave Fox has been tattooing since 1995. He started out on his own, but a lack of apprenticeships at home drove him to seek help and advice from Marcus Pacheco in San Francisco, and later from Tom Johnson back in Philadelphia. Other influences include Jeff Rassier, Tim Lehi, Grime, Mike Wilson, Guy Aitchison and Jef Whitehead during his early years of tattooing, and later Horiyoshi III and Ed Hardy. Dave describes his style as 'sort of comic-book, cartoony, creepy and funny at the same time, with a Japanese flair'. He tries to keep his artwork original without copying other people's styles. He is open to his customers' ideas, but makes them understand that the tattoos will be drawn his way. Almost all of his tattoos are done freehand, pen on skin, which allows him to get a better feel for the fit of the tattoo, and makes the whole process more personal. He also believes that drawing on skin rather than on paper gives the tattoos better movement and flow. His favourite tattoos are the ones that he has done where everything has clicked into place, where he had a lot of fun with the idea, design and the client, with no distractions. His philosophy is about working hard, enjoying life and to keep learning, growing and improving.

for more information visit his website www.davefoxtattoos.com

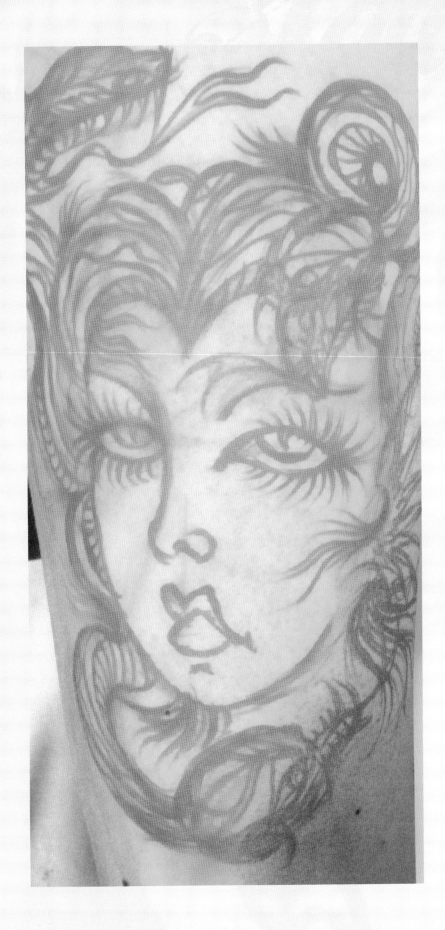

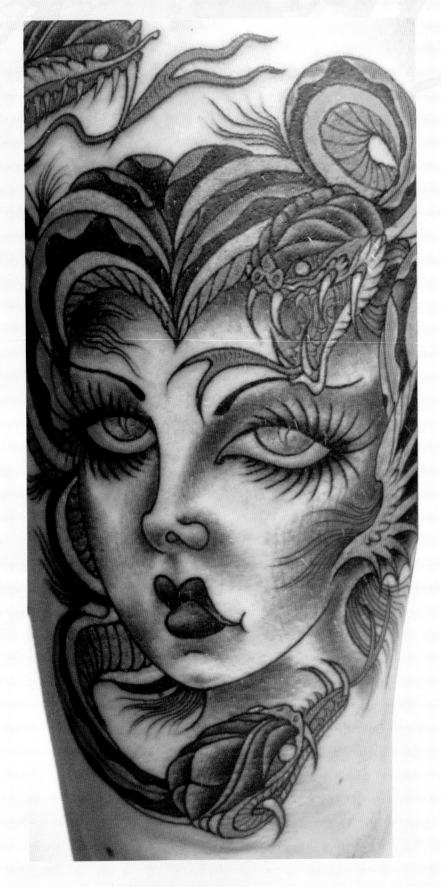

here to begin? Is tattooing in the twenty-first century the brightly lit ultra-dramas that play out in reality TV shows? Or is it the stars and spangles adorning movie stars and sports personalities? Is it bright sleeves on improbably young-looking college students or pooling blue knuckle tattoos on the crumpled-looking pensioner sitting alone at the bar?

Naturally, tattooing is all of those things and more. We live in a society that zips along so quickly that the Polish sociologist Zygmunt Bauman coined the term 'liquid modernity' to describe it – a fluid, constantly changing world that never has time to stop and solidify into something definable. How do you define Facebook, or Twitter, when the damned things never sit still for long enough?

On the one hand, something as enduring as a tattoo might be the perfect antidote to such an age, but even tattoos – born of liquid inks – cannot resist change. They spread, settle and evolve with the body,

gradually altering over time. The tattoo industry itself is just the same: steeped in history and permanence but still moving restlessly forwards with improved tools and techniques. It can be a bewildering world at times, but always fascinating – and the view is often spectacular.

Too Cool for Schools

A tattoo 'school' doesn't refer to some Tim Burtonesque angular Gothic pile where trembling apprentices are taught the wily arts of 'The Tattoo' (although it would make for an interesting place to visit). They are loose descriptions used to define the various styles that make up the spread of tattooing and include everything from the traditional 'looks like a tattoo' anchors on forearms to the very latest photorealist artwork.

Tattoo artists might work in one particular style, or they might be a jack of all trades, or they might bring elements of a few schools together in

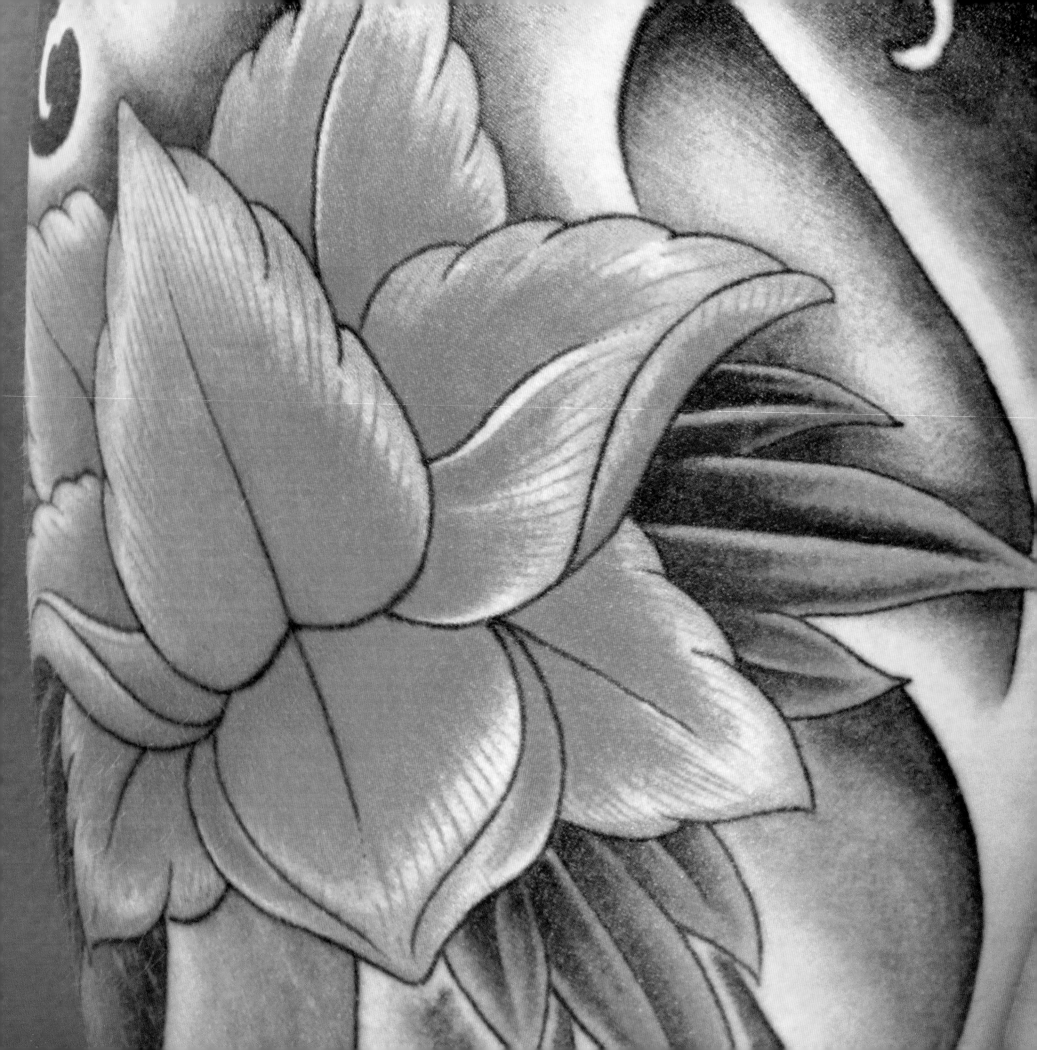

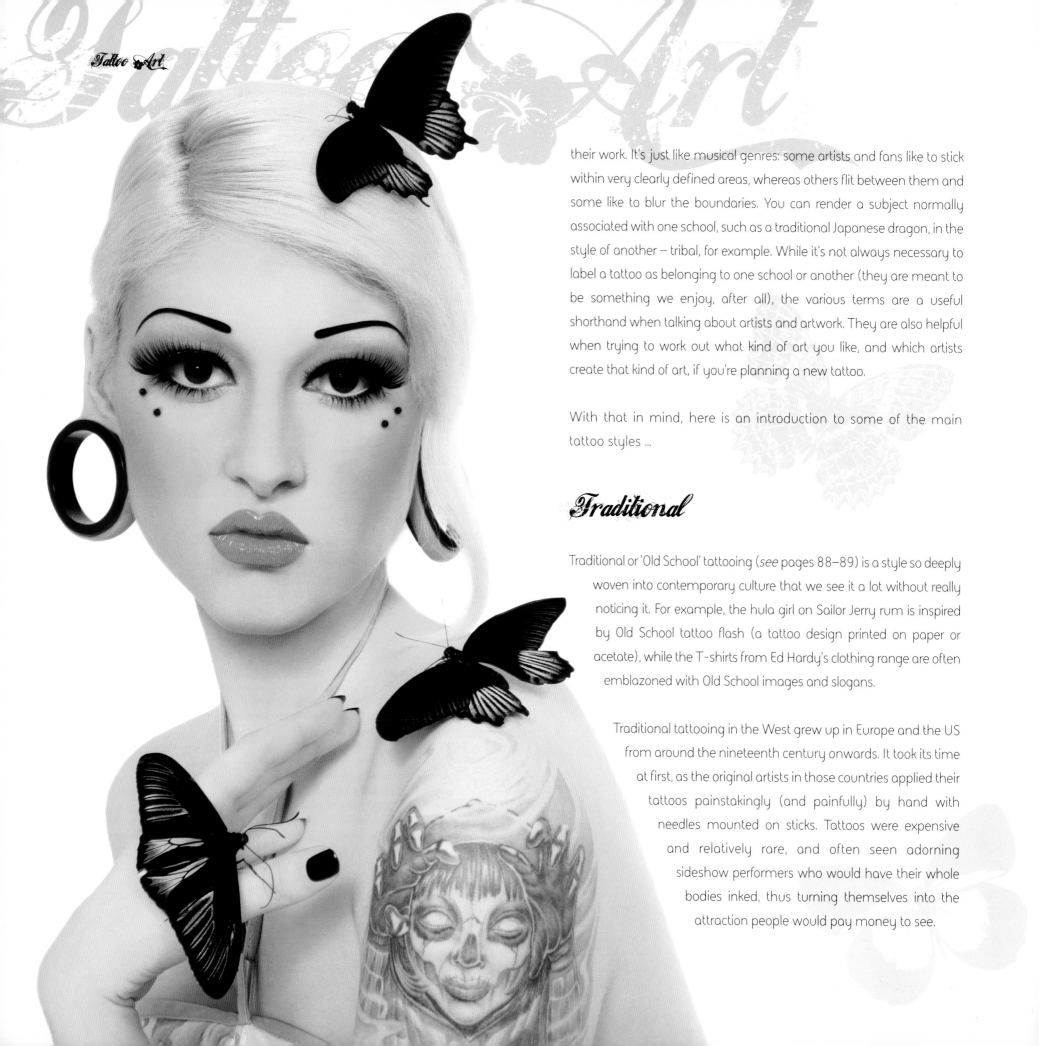

their work. It's just like musical genres: some artists and fans like to stick within very clearly defined areas, whereas others flit between them and some like to blur the boundaries. You can render a subject normally associated with one school, such as a traditional Japanese dragon, in the style of another – tribal, for example. While it's not always necessary to label a tattoo as belonging to one school or another (they are meant to be something we enjoy, after all), the various terms are a useful shorthand when talking about artists and artwork. They are also helpful when trying to work out what kind of art you like, and which artists create that kind of art, if you're planning a new tattoo.

With that in mind, here is an introduction to some of the main tattoo styles ...

Traditional

Traditional or 'Old School' tattooing (*see* pages 88–89) is a style so deeply woven into contemporary culture that we see it a lot without really noticing it. For example, the hula girl on Sailor Jerry rum is inspired by Old School tattoo flash (a tattoo design printed on paper or acetate), while the T-shirts from Ed Hardy's clothing range are often emblazoned with Old School images and slogans.

Traditional tattooing in the West grew up in Europe and the US from around the nineteenth century onwards. It took its time at first, as the original artists in those countries applied their tattoos painstakingly (and painfully) by hand with needles mounted on sticks. Tattoos were expensive and relatively rare, and often seen adorning sideshow performers who would have their whole bodies inked, thus turning themselves into the attraction people would pay money to see.

It was also popular amongst those in the military: during the American Civil War, tattooist Martin Hildebrandt was admirably neutral and inked soldiers on both sides with patriotic images and phrases. In the same way, the fashion for tattooing amongst sailors in Europe and the US never let up, gradually becoming entangled with seafaring lore and developing its very own set of symbols and meanings (more about those a little later).

Bold Will Hold

You can usually spot an Old School tattoo from across the street. Whatever the subject matter, the tattoo will feature bold, heavy, black outlines and a relatively simple design. The colour palette tends to be limited too, with prominent reds, blues, greens and yellows, plus the odd dash of purple. These are tattoos built to last; the strong outlines and hefty blocks of colour stand up well to the scrubbing effects of time, keeping their shape for a long while and not fading too much in the process. Hence the old adage amongst Old School artists: bold will hold.

Americana

Over the years, the traditional style of tattooing in the States developed its own unique cast of characters and images, to the extent that Old School tattooing from the US is often referred to as 'Americana'. Without getting too bogged down in labels and definitions (it's all just art, right?), classic Americana features lots of nautical images, plus roses, hearts, daggers and scrolls, the odd skull and plenty of gypsy women or hula girls in various states of undress.

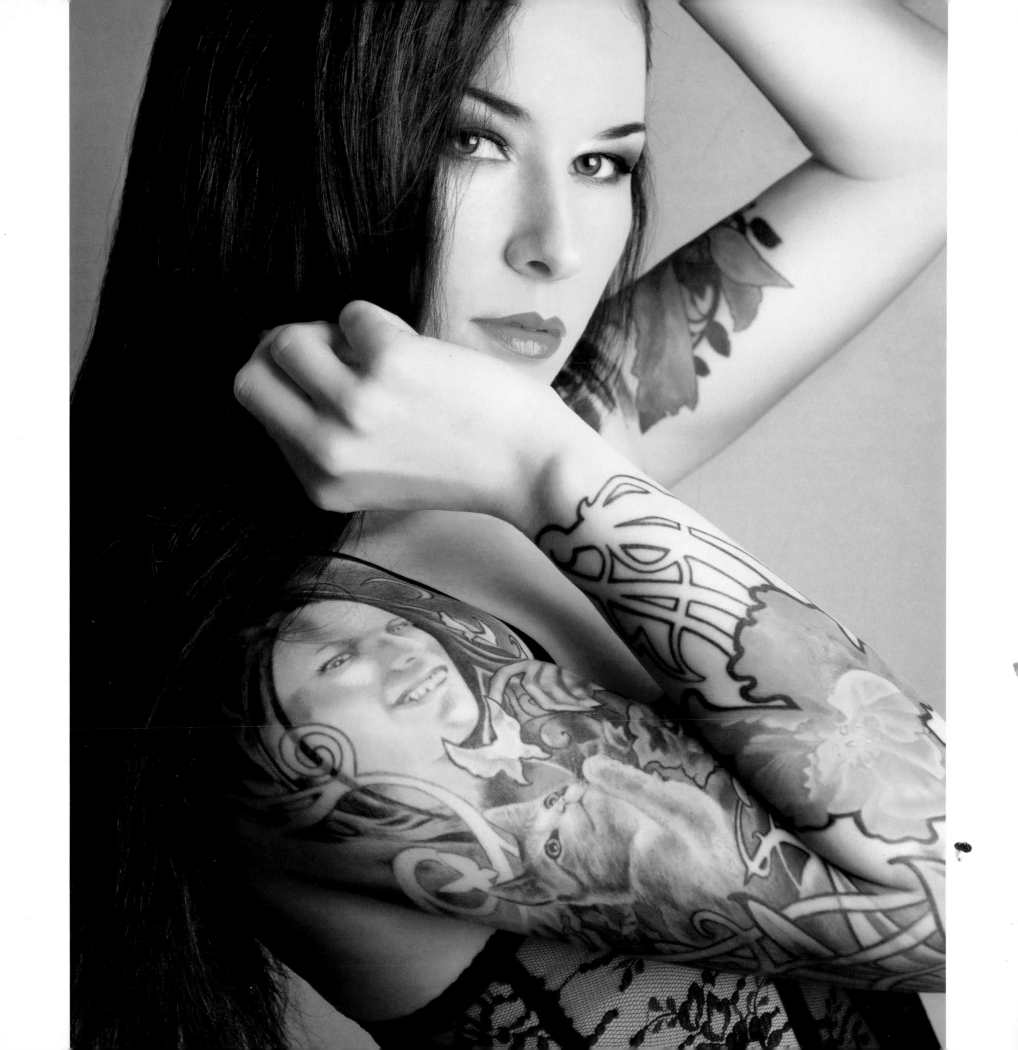

The tattoos are inextricably linked to US history; they're the biker tattoos, sure, but they're also countercultural touchstones, sailors' talismans and the tattoos worn by GIs a long way from home in the Second World War – little reminders of home and loved ones.

The style and the subjects often depicted have proven to be very seductive to tattoo collectors over the years. Maybe it's the simplicity of the art or the nostalgia it evokes – the slightly rebellious undertones or even the whiff of patriotism that goes with all those flags and eagles – but whatever the reason, the recurring themes of Americana keep cropping up in tattoo studios all over the world. Some collectors go as far as recreating old flash from the 1940s and 1950s, which are widely available online and collected by many artists, to give themselves a truly authentic piece of Americana.

Modern Traditional

The traditional style is alive and well, and it is still executed in breathtaking fashion by contemporary artists. The original precepts of uncluttered compositions with bold outlines, simple colours and shading remain, but the school didn't freeze in time in the 1950s, as shown by a comparison between art from that period and a twenty-first century tattoo. Advances in techniques and technologies, along with better inks and a readiness to apply traditional approaches to a huge range of subjects, allow artists to keep it Old School with a modern twist – but you can still get that sturdy anchor on your forearm if you need it, just like back in the day.

New School

In a nutshell, New School (*see* pages 139–140) is what you get if you feed Old School tattoos some interesting-looking mushrooms and

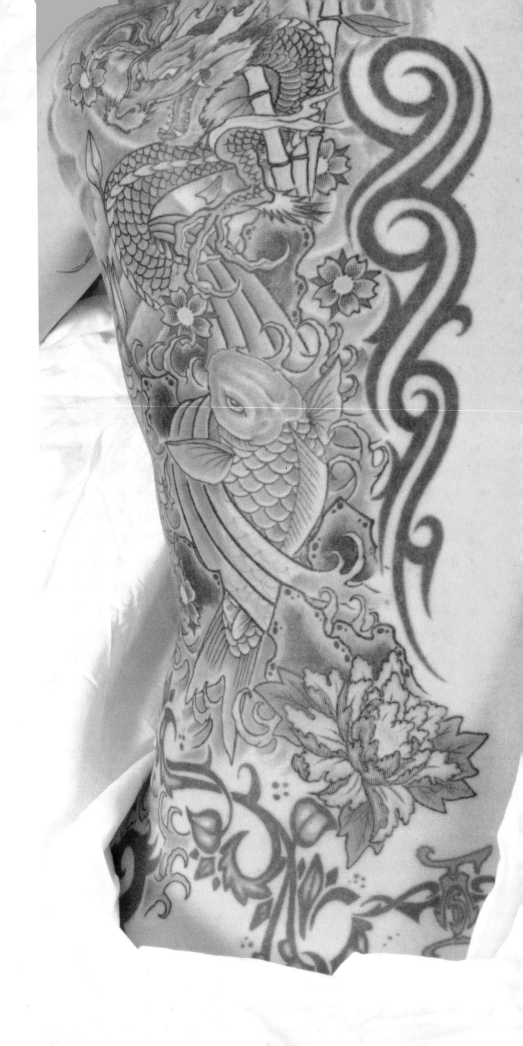

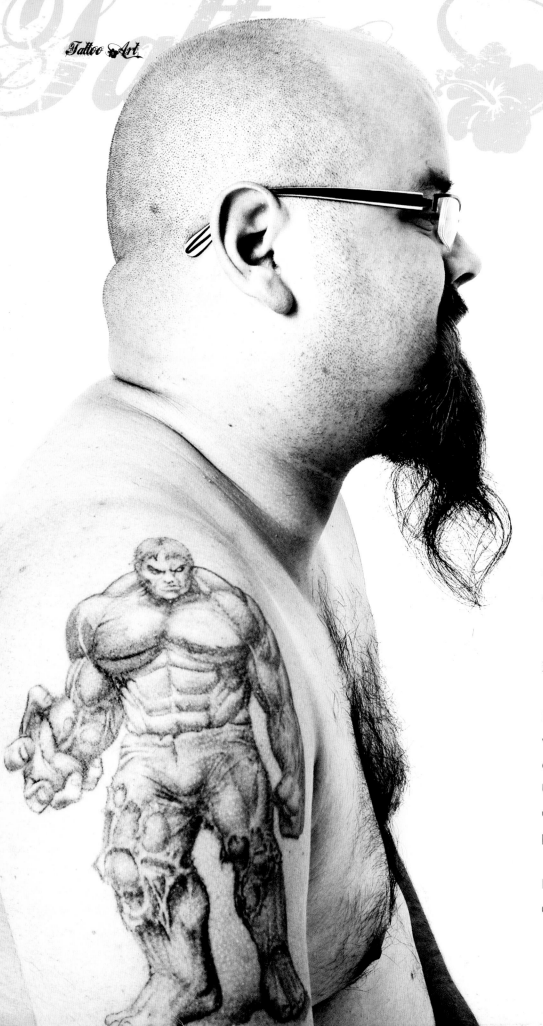

invite them to sprint through the pages of comic book art, ideally while you unleash a plague of spray paint-wielding locusts to chase them. Things are going to get messy and weird, and there are going to be some amusing results. You need your tongue in your cheek if you're going to speak New School.

While traditional tattoos in the Old School style may have grown up from battlefields, ports and the high seas, New School ink is a decidedly modern, urban creature. The artwork is a hyperactive cousin to traditional art which takes those familiar black outlines but pimps and pumps them like a low-rider until they are fatter and much more akin to graffiti – even incorporating a sniggering nod to cartoons and the more outlandish corners of comics.

Colours receive the same treatment: they are boosted into psychedelic orbits with neon brights and eye-scorching contrasts. Nothing is off-limits and the end results can be anything from a lurid take on the traditional pin-up girl to a full sleeve that seems to have lurched from the pages of *Naked Lunch*, queasy with mugwumps and other cavorting oddities.

Serious Clowning

However, just as painting your face white and putting on a silly hat won't make you a great clown, thickening up the lines and not looking at the colours you are using won't create a great New School tattoo. It takes the same kind of attention to composition as traditional tattooing and even the rigorous sensibilities of Japanese art to create a perfectly proportioned New School piece.

New School is a relatively recent development in tattooing; it has really come to prominence over the last decade or so, as more people get on

 Photographer: Keith Riley Photography

board with its quirky sense of humour and subversive wit. When it comes to actual subject matter, it's a style that reads the rulebook and then gleefully tosses it out of the window, mercilessly lampooning traditional ideas and trading on visual gags. For example, you are likely to see a traditional Day of the Dead skull rendered as a painted *Star Wars* Stormtrooper helmet, or a sleeve comprising of My Little Ponies imitating Japanese mythical creatures – or even any number of Hello Kitty figures getting up to things that were probably not on Yuko Shimizu's mind when she created the diminutive cat in the 1970s.

Making Sweet, Sweet Love

Alongside its preoccupations with making beloved cartoon characters act like deviants, New School art is also rather peckish. There is a kitsch streak running through a lot of this tattoo style that just adores cutesy food ideas such as cupcakes, sweets and hotdogs. Obviously, artists can transform anything into a New School piece, but luscious-looking cakes are definitely a recurring theme, which seems only appropriate for a style that often resembles dress-down day at Willy Wonka's chocolate factory.

It's this kind of pie-in-your-face attitude that sometimes gets the noisy brat that is New School tattooing into trouble, and fans of traditional art have been known to frown on the young upstart a little bit. But tattooing is a very broad church and there is surely room for the endearing Tigger-like bounding and yapping of New School art to liven things up, especially when the results can be so striking. Besides, this is a style that is generally accepted as having grown out of the work of artists like Brooklyn's Marcus Pacheco in the 1990s – it's brash, smart and savvy like the cities it came from; it's here for a good time, and it's not going anywhere.

Tattoo

Biomechanical

The idea of our flesh-and-blood bodies melding with artificial elements, whether real or imagined, has been with us for a while. It might be linked to the medical application of hip replacements or pacemakers, or something from the realms of science fiction, where man and machine are combined into RoboCops, Terminators, replicants or wheezing Sith Lords.

Somewhere amidst these notions of mixed-up meat and mechanisms came the spark of the idea that created tattoo art's most fringe school. Biomech embraces both man and machine and sets off down the sometimes shadowy path of 'what if?' (*see* Guy Aitkinson on pages 38–39) . Its images can be unsettlingly anatomical tableaux revealing gleaming steel cogs nestled in glistening tissue and peeled-back skin, or abstract fantasies coupling the human with the not-quite-human – and even (more recently) rippling organics which suggest mutations, evolutions or simply the musings of a whimsical creator trying out new designs for life.

There is no doubt that biomech sometimes prowls through the darker rooms of our imaginations – as you might expect from a school that toys with what might really lie within the gristle and pulsing blackness of our body cavities – but it's also a realm of great experimentation and beautiful innovation. Plus, where could the concept of man vs machine find better expression than in an art form created by the act of needles penetrating the skin?

photocredit Photographer: Keith Riley Photography • Tattoo Artist: DNA Tattoo Newquay

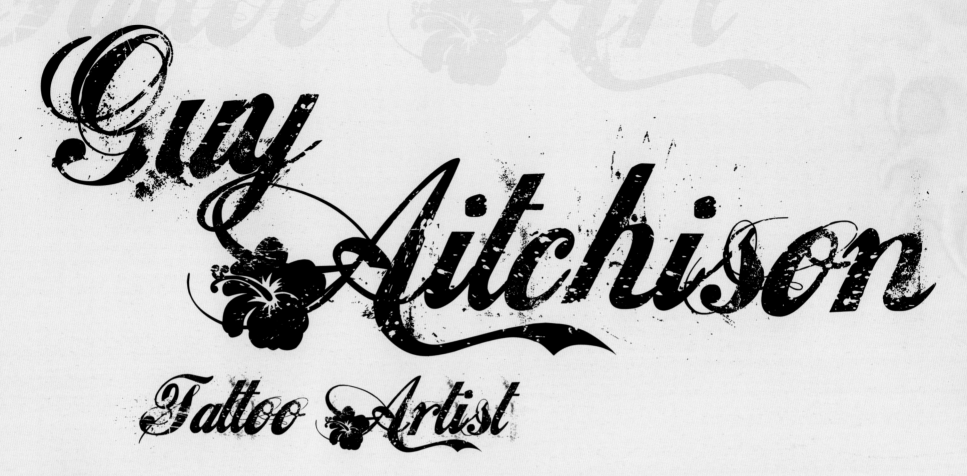

Guy Aitchison
Tattoo Artist

Guy Aitchison began tattooing in 1988 after falling in love with the art form as a teenager. This was a time when the new wave of innovative young tattooists was just starting to emerge from the subcultural woodwork of the punk rock scene, an opportunity that Guy embraced with all the energy he could. He apprenticed with Chicago's Bob Oslon, and through his work he was lucky enough to be able to travel, meet other artists and try new things. Within his first year on the job, he had already scored his first article in *Tattoo Magazine*, and he continues to publish regularly. He now works steadily on his regular clientele in a studio he shares with his wife, tattooist Michele Wortman.

Guy is best known for his abstract biomechanical tattoo work, a style that is loosely inspired by the work of Swiss surrealist H.R. Giger, but which Guy has taken in his own personalized direction. Aiming for a maximum visual impact, his style incorporates every trick in the book to imbue his work with depth, luminosity, texture, flow and realism. Although he continues to work regularly in more illustrative styles, his abstract work is the place where he can be most experimental and innovative, reducing the complex graphic equation of a tattoo down to its elemental parts. It is a realm of exploration that continues to bear fruit to this day.

Guy has taught seminars to other tattooists for the bulk of his career, and has also published a number of educational books, the most significant being his massive educational package Reinventing The Tattoo, which can be seen on his website .

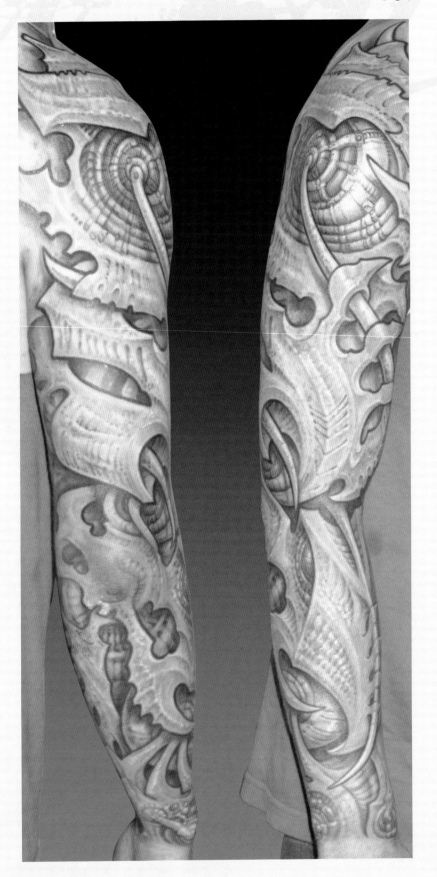

A Is for Alien...

Cyborgs and their man/machine kin have been immortalized in films since the spooky robotics of *Metropolis* in 1927; however, it took going to a place where no one could hear you scream to really jam the spark of life through the biomechanical tattooing style. Swiss surrealist H.R. Giger's work for the *Alien* films suggested a terrifying vision of metallic tissue, sinewy starships and steely extraterrestrial super-soldiers, all teeth and slavering ectoplasm ready to chase those tasty, squishy humans through a living nightmare at the end of the universe. The same themes run through his seminal *Necronomicon*: a labyrinthine exploration of the man's ideas and art, and a great introduction to the biomechanical cosmos. Don't read it alone at night, though.

...and for Aitchison

Giger's *Alien* art was one of the principal inspirations for Guy Aitchison: one of the first artists to pioneer biomech tattoo art in the 1980s, along with Filip Leu, Don Ed Hardy and Greg Kulz. Still recognized as the master of the mechanical, Aitchison drew on Giger and other artists such as Ernst Fuchs and Robert Venosa to create a style that he still finds difficult to explain, preferring to talk of it in terms of an abstract art form with a sense of depth and energy rather than anything explicitly sci-fi. However, he has always happily acknowledged the influence of Giger and co. in his work.

Going Organic

Aitchison has moved on from his early Giger-like creations, and the biomech school at large has also diversified over time. There are still the sinister pistons-and-people themes for those who want to meditate on fleshly existence in an increasingly mechanized world, but there are plenty of other avenues to explore as well.

Increasingly, for example, the developing bio-organic style features fewer cogs and wheels, and embraces a more natural look, incorporating forms that are still beyond the body but now seem to be grown – hence the 'organic' tag. The shapes and structures you might encounter echo coral or even stalactite cave formations projected on to the skin: still embracing the idea of an external medium synthesized with the human form, but allowing the artist to move out of the world of the machines and into something more flowing.

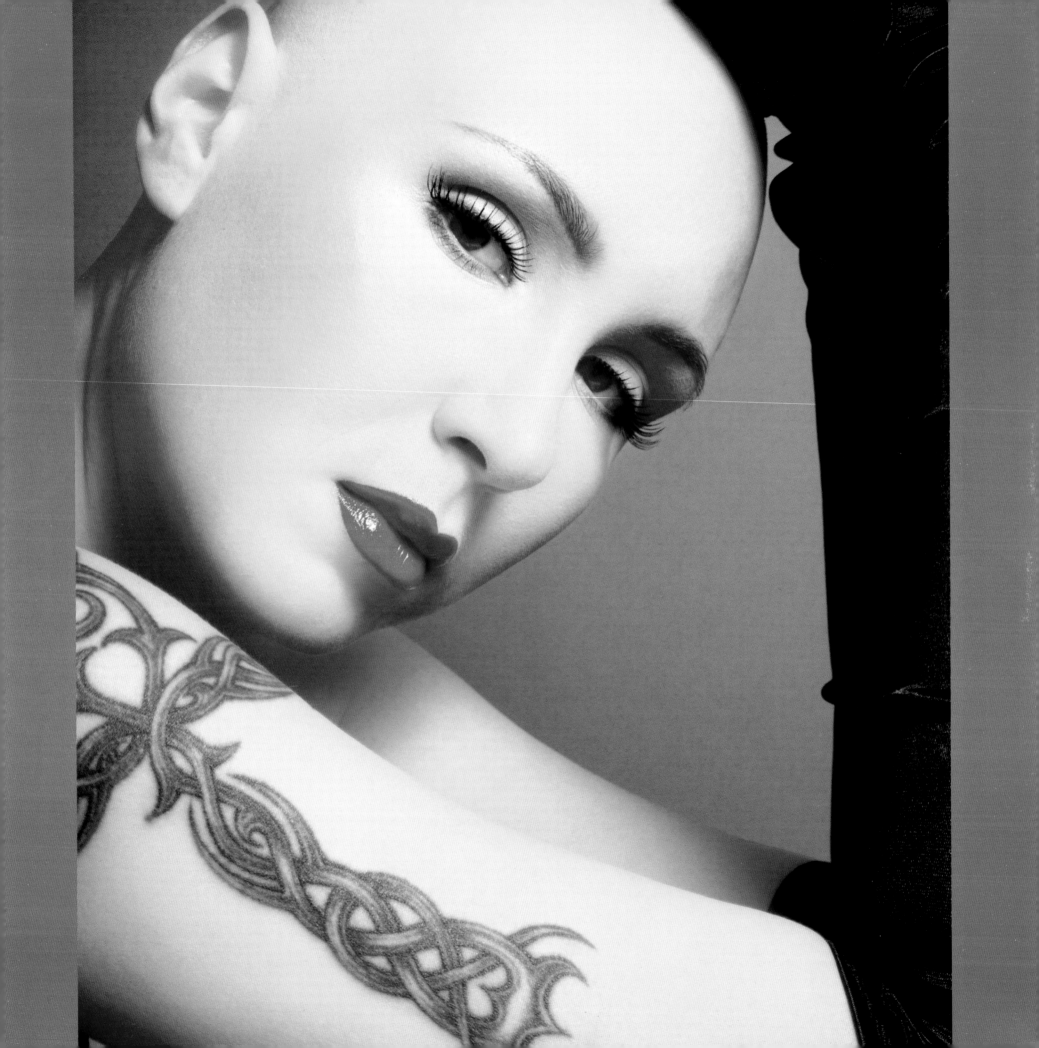

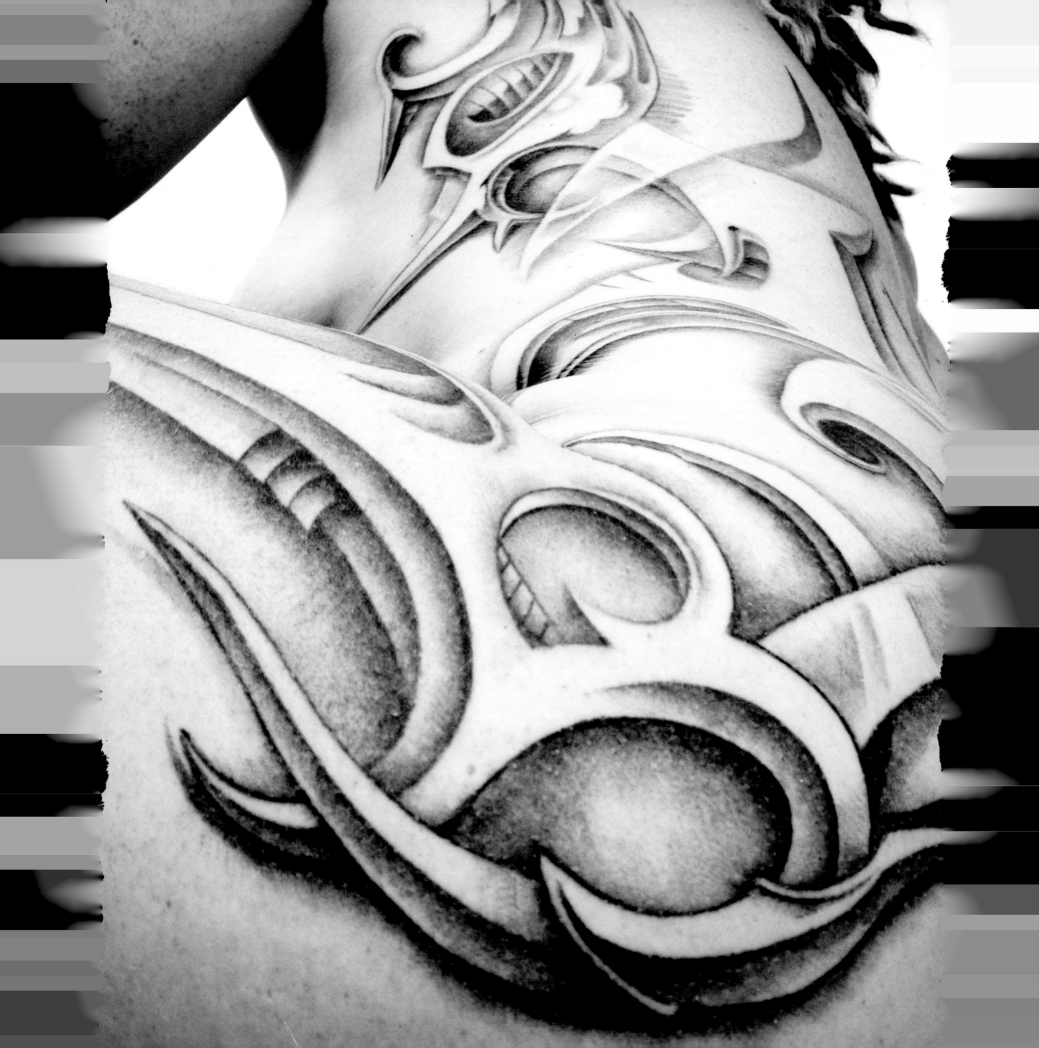

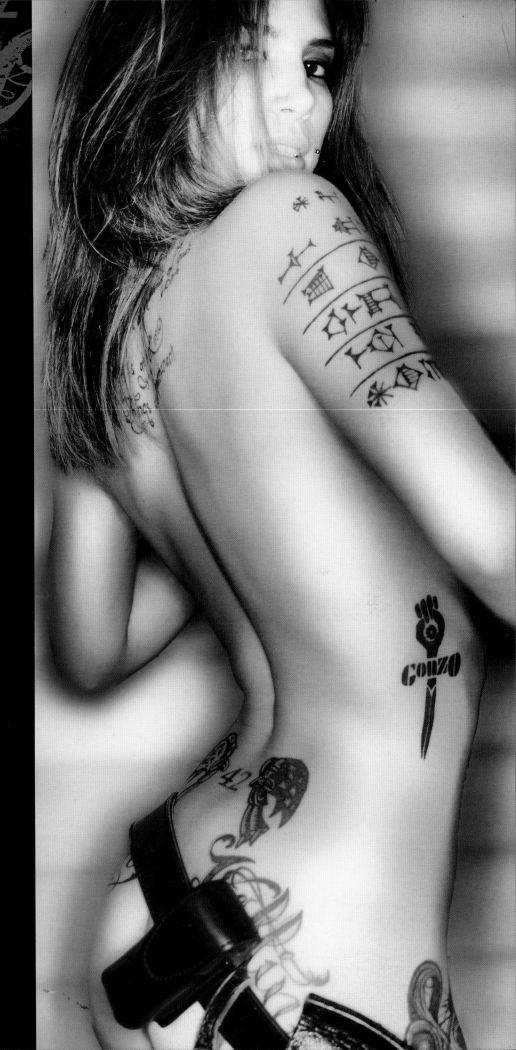

Some artists are using even more explicitly natural forms – flowers, plants and lots of suction cap-toting sea beasties – but applying the same theories of structure and symmetry as those of a biomechanical tattoo. The resulting work strays beyond realism and into some other hyper real zone in time and space, which can be very beautiful – as long as we're careful what we bring back. Look what happened to Ripley.

Tribal and Blackwork

Heading back from the future, the story of tribal tattoos is rooted in the very origins of the human practice of marking the skin. Some of the earliest existing examples of tattoos come from tribal societies and we find reference to them throughout history, from the writings of Roman historians, which suggest the Pict tribes of northern Britain may have practised a form of tattooing, to the more recent accounts and illustrations of Cook's journeys into the Pacific.

The effect that these early images of tattooed people had on Western tattoo practice is easy to see: look through any eighteen-century engravings and you'll find striking similarities between the designs depicted and some modern tribal tattoos.

Of course, this was an age when travel to Polynesia or Samoa meant perilous months jammed into floating wooden crates with a collection of unruly men, so even the most enthusiastic tattoo fan would have been hard-pressed to get one from the source. Instead, the people who did journey to those islands were Christian missionaries who frowned upon the practice of tattooing and worked diligently to wipe it out. Nevertheless, some tattooing practices – such as those in Samoa – have continued uninterrupted for thousands of years.

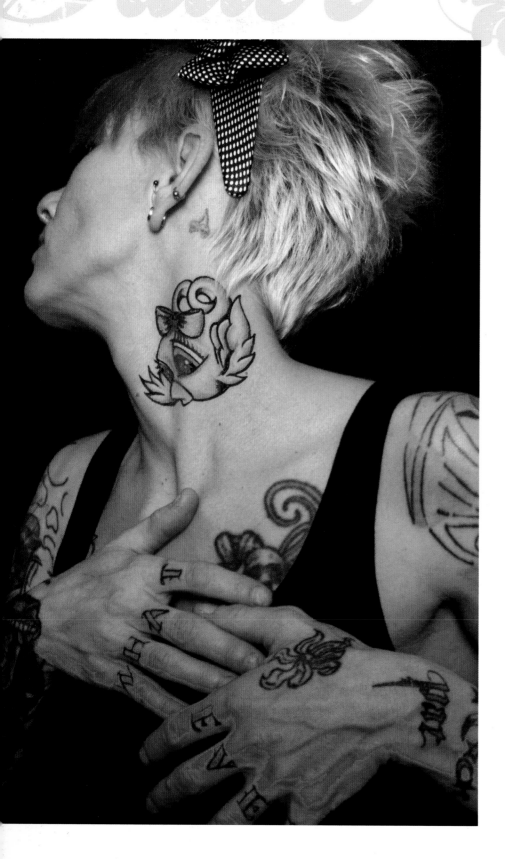

Reading the Signs

A tribal tattoo in a traditional style is very distinctive; it is usually limited to black ink and the use of simple geometric shapes, sometimes in a repetitive, symmetrical pattern and on other occasions customized to fit the contours of the body. There are exceptions to both the 'simplicity' and 'single colour scheme' rules, of course – Celtic tribal ornaments are fiendishly complex and embrace all manner of interweaving knots, while the Haida tribal art of the Pacific Northwest is all about using red, white and black to create totem animals with different roles and symbolism.

Exactly how much importance (if any) a wearer attributes to the original meanings of the symbols they sport on their skin is cause for some debate. For some, the idea that the symbols could remain relevant in such a vastly different age simply doesn't add up, just as some of the original significance of cave paintings or the information recorded in Andean *quipus* (talking knots) is largely irrelevant; it belongs to another world. For others, this attitude is a grave-robbing kind of cultural appropriation and profoundly disrespectful to the cultures that developed the tattoos in the first place; like everything else in the tattoo sphere, it's a question of personal choice.

Neo-tribal

It might be a traditional art form, but the tribal style (*see* page 117) has not stayed completely still. Artists such as Cliff Raven and Leo Zulueta have done a lot to reinvigorate tribal tattoos – the latter's approach, in particular, led to the emerging of the neo-tribal or modern tribal style in the 1980s and 1990s. It came to be the most popular type of tattoo for a while; anyone looking around the streets in the late 1990s can attest to that: spiky-looking, black tribal artwork was everywhere.

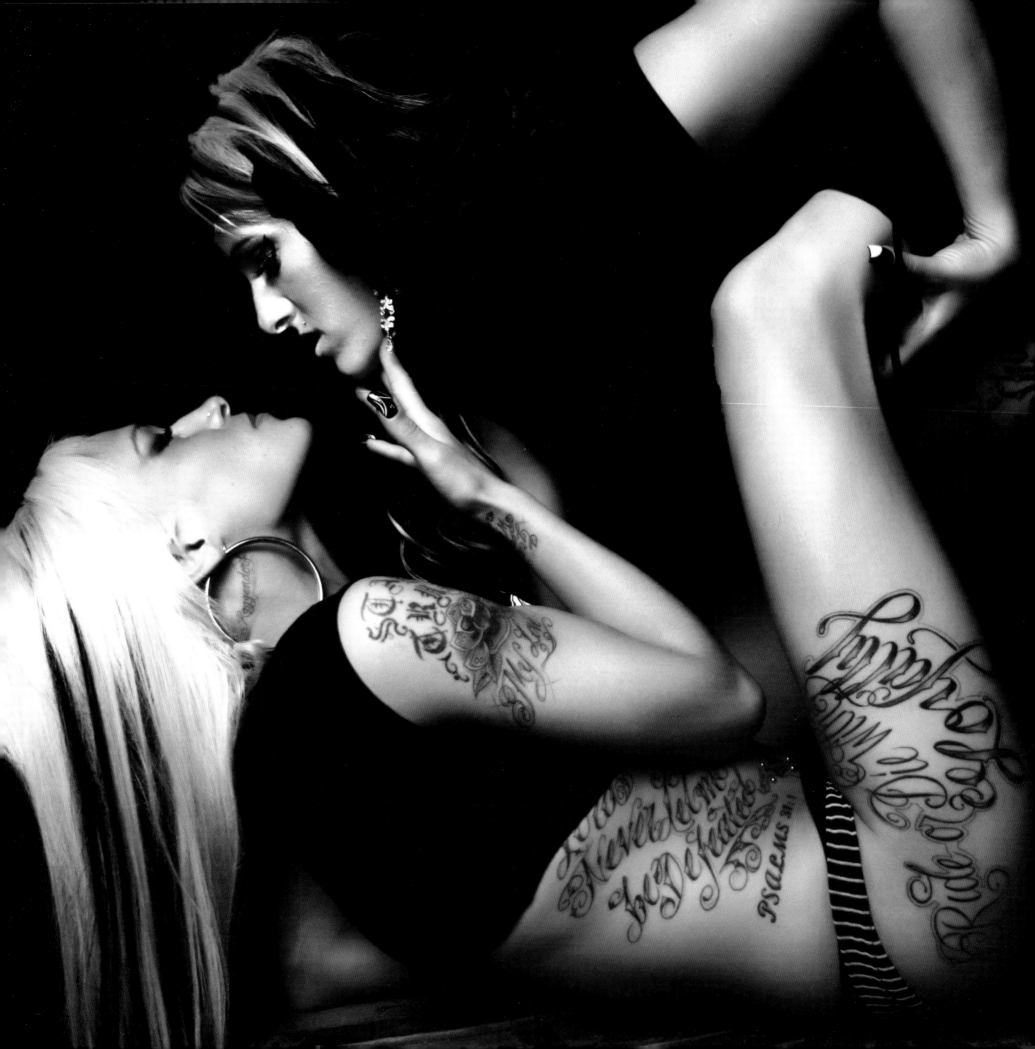

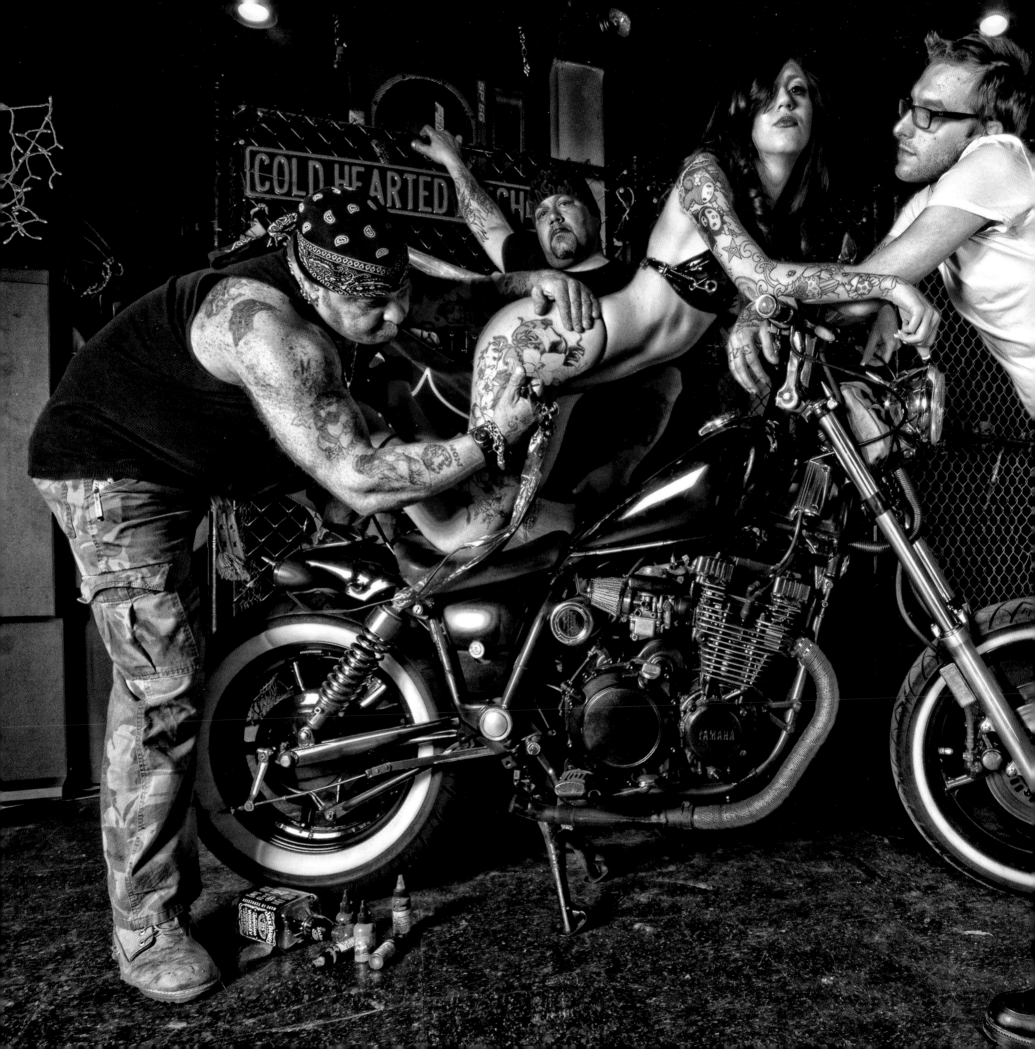

The foundations of modern tribal art are sometimes more to do with form than function. Instead of creating tattoos to show status or lineage, Zulueta focused on taking shapes and motifs from traditional tribal art and allowing his designs to complement the musculature of the body (which may be why some neo-tribal styles work so well on those who seem well acquainted with the weights section of the gym). This approach is still very much evident in the work of other modern practitioners, whether they work in dots, as Jondix (*see* pages 80–81) and Xed Le Head, or in the stocky power lines, like Matt Black.

The neo-tribal star may have waned slightly in recent years, but like all tribal tattooing it continues to fascinate and appeal to a particular part of tattooing's diverse community. Or should that be tribe?

Black and Grey

The clue is in the name with this remarkably diverse school, where artwork is rendered with black ink gradually diluted with white to create almost infinite degrees of grey shading (*see* pages 72–73). The blacks are also dialled down with water and employed as grey washes to add further texture and depth, with the addition of white highlights often ramping up the contrast and creating work that carries all the tonal variation of colour pieces but with a monochrome palette. It's a precise, often delicate style that allows for a lot of detail and subtlety and lends itself well to portraits and realism, as well as both sinister and spiritual tattooing.

Artists working in this field sometimes achieve such detail by using a single needle (occasionally because they are being detained at the state's pleasure – *see* page 48) and create fine-line work; it's a different approach to a more regular machine, which carries several needles bunched together and has the advantage of being faster. Sometimes

Tattoo Art

called 'black and white' tattooing in the past, this school has been truly popular since the mid-1970s, when artists such as Jack Rudy (himself an advocate of the single needle technique) started creating eye-catching pieces that captured the public's imagination.

Art Behind Bars

Still, black and grey work is by no means a brand-new art form. Simple, single-colour tattoos that existed beyond tribal frames of reference have been with us for centuries, like the Coptic crosses inked on to medieval pilgrims under the walls of Jerusalem or the pyramid-like marks that denoted Egyptian assassins. These were rough-and-ready tattoos applied quickly and sometimes clandestinely – a practice that also continued inside prisons throughout history.

Prison tattooing requires guile and patience, as guards are not known for their laid-back attitude to full-time tattoo studios based in the cells. Historically, they would be created with whatever was available – metal shards, sewing needles, soot – and after the advent of the electric machine, they could be cobbled together with cassette player motors, using guitar strings for needles and purloined biros as an ink source.

In the twentieth century, the tattooists naturally attempted to recreate the full-colour style outside the walls using whatever was available and the results could be crude or masterful, differing significantly from tattoos found on the outside, as they relied on that single needle. No dabs of white ink or grey washes here: artists would work the needle with a whipping motion to mix blood and ink to create different tones.

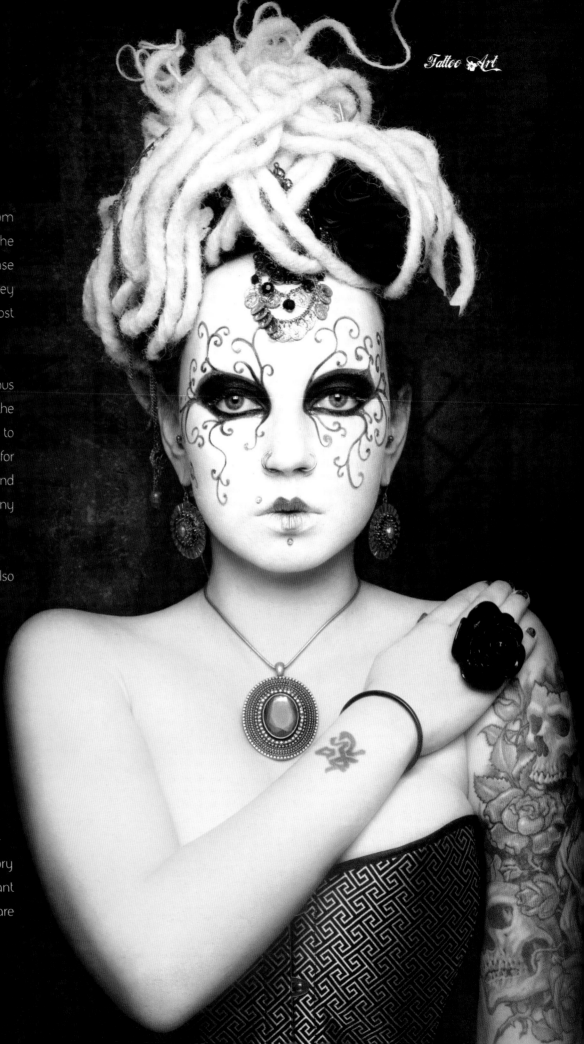

The Hallowed and the Heathen

Gradually, the single-needle black and grey style was liberated from the cell blocks and began to take off in the wider world. Once free, the subject matter quickly put some distance between itself and the dense iconography of custodial art (covered a little later) and black and grey proved to be a chameleonic technique capable of rendering almost any subject beautifully.

But it was — and remains — especially effective when tackling either religious or horror imagery. In the case of the former, this might be because the style's subtle shading gradations allow artists to work with skin tones to recreate the luminous appearance of renaissance Christian art, for example; or perhaps the austere monochrome presentation of black and grey work simply fits well with spiritual pieces. (There is a piquant irony about a style born of crime working well when capturing saints, too.)

A little distance away from heaven, black and grey horror work is also wildly popular, thanks to the gnarled detail that it delivers to the nightmarish creations of masters such as Paul Booth. Unearthly flesh and wicked corruption find vivid expression here and have made black and grey the go-to school for horror and (by extension) heavy-metal fans and musicians for many years.

Fine Art and Fringe Freaks

If there is any part of tattooing that explodes the notion of strictly defined schools or styles, it's the work being done on the avant-garde fringes of the industry. Here you'll find all sorts of contradictory philosophies, approaches and techniques: there are artists who want their tattoos to be simply tattoos for their own sake and then there are

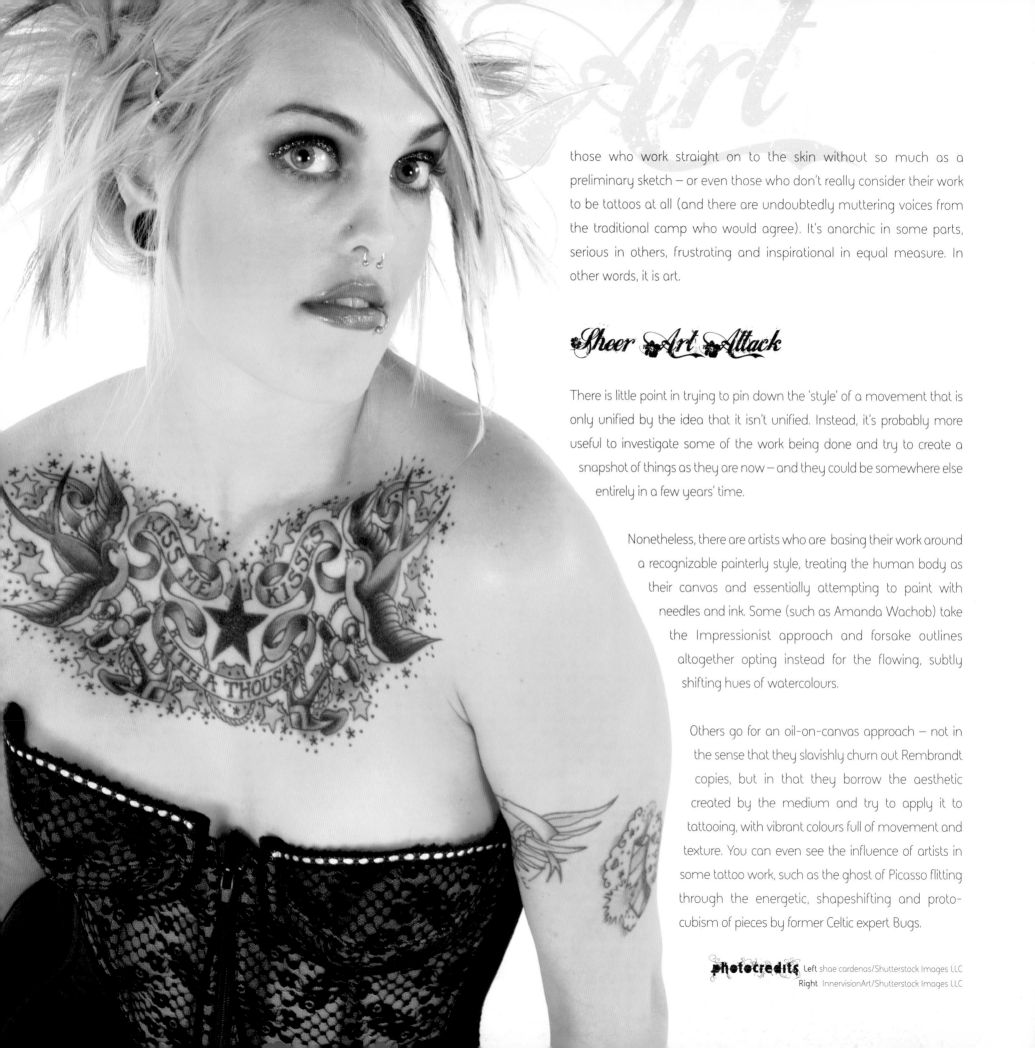

those who work straight on to the skin without so much as a preliminary sketch — or even those who don't really consider their work to be tattoos at all (and there are undoubtedly muttering voices from the traditional camp who would agree). It's anarchic in some parts, serious in others, frustrating and inspirational in equal measure. In other words, it is art.

Sheer Art Attack

There is little point in trying to pin down the 'style' of a movement that is only unified by the idea that it isn't unified. Instead, it's probably more useful to investigate some of the work being done and try to create a snapshot of things as they are now — and they could be somewhere else entirely in a few years' time.

Nonetheless, there are artists who are basing their work around a recognizable painterly style, treating the human body as their canvas and essentially attempting to paint with needles and ink. Some (such as Amanda Wachob) take the Impressionist approach and forsake outlines altogether opting instead for the flowing, subtly shifting hues of watercolours.

Others go for an oil-on-canvas approach — not in the sense that they slavishly churn out Rembrandt copies, but in that they borrow the aesthetic created by the medium and try to apply it to tattooing, with vibrant colours full of movement and texture. You can even see the influence of artists in some tattoo work, such as the ghost of Picasso flitting through the energetic, shapeshifting and proto-cubism of pieces by former Celtic expert Bugs.

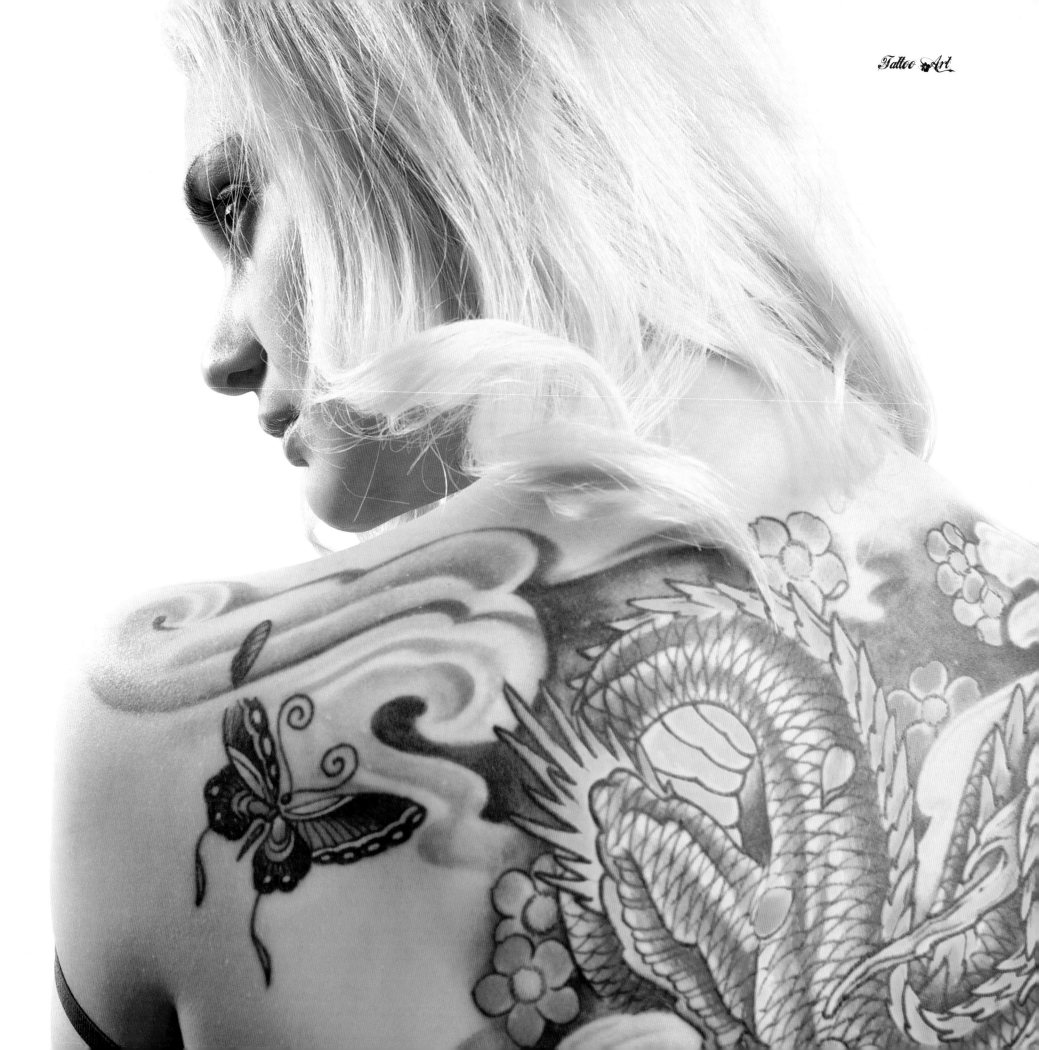

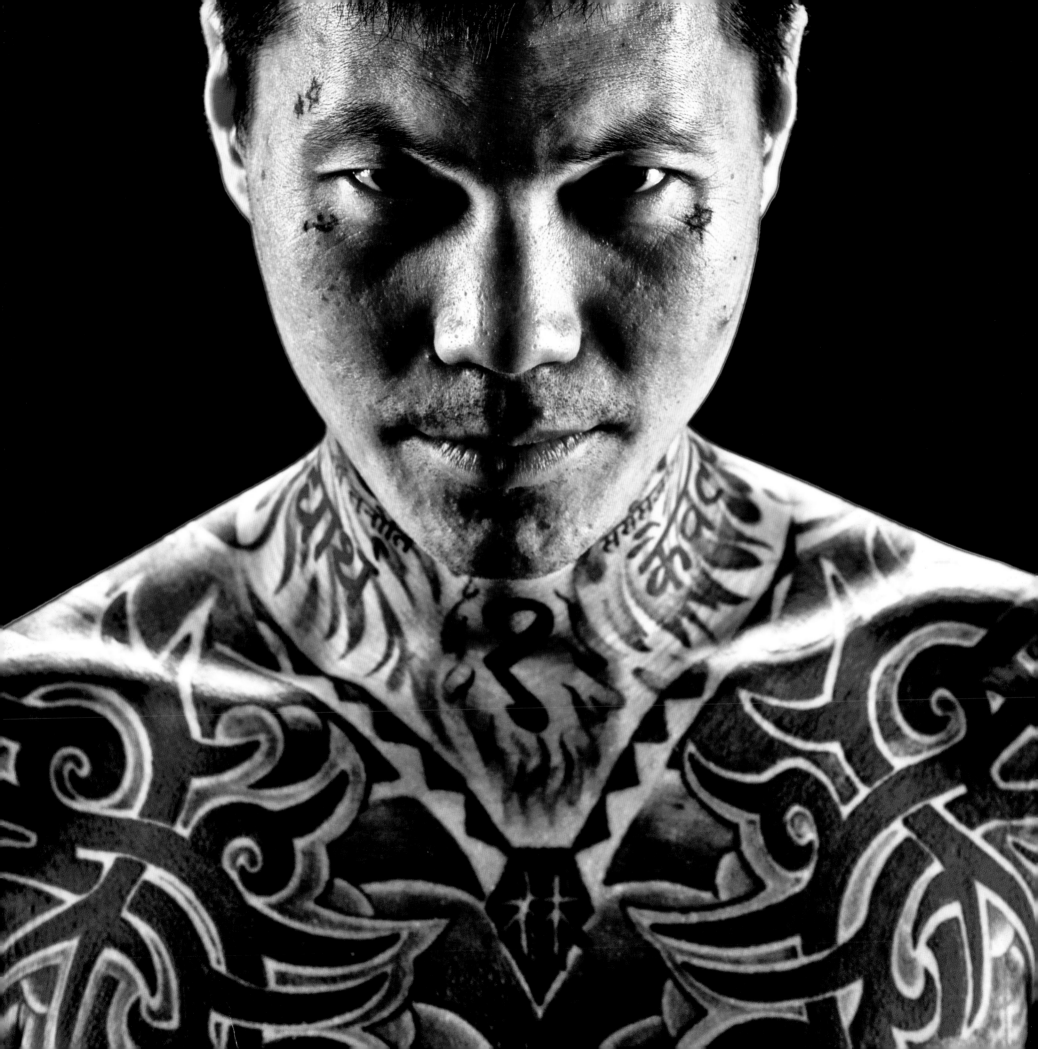

We Don't Need No Education?

It's certainly not a universal truth, but there is little doubt that the advances made on the fine art fringe are due in part to the arrival of classically trained artists into the tattoo industry. Some have pragmatically pointed out that fine art (or whatever you choose to call it) is tricky to turn into a business, whereas tattooing can offer commercial success. Not that it's all about the money, but ink isn't free and even the most committed claret-slurping boho dilettante has to eat sometimes.

The art college approach has certainly paid off for artists such as Jeff and Kostek (of the Boucherie Moderne studio), who met in Brussels while studying art, Simone and Volko of the Buena Vista Tattoo Club, and the itinerant Mr Halbstark, who spent time studying graphic art before starting to create abstract tattoos that look like, well, graphic art. Their work (and the work of their peers) is determinedly different: a collision of illustrations, slogans, digital graphics and hectic paint swooshes all stacked up one on top of the other; sometimes it looks like a page from a mag designer's sketchbook. Others like a skull-smashed Edgar Allen Poe hallucination, but this wilful juxtaposition is what gives their tattoos such a curious allure: a sense of lawlessness and undiluted creativity turned loose on the skin.

Sit Still and Shut Up

As a matter of fact, the artist you choose for your avant-garde/modernist/art brut/lunatic tattoo might determine whether you have much choice in what you get. Some artists (such as Simone and Volko) see the tattooing process as a fine art commission: you are hiring their talents to create an original piece, and that's as much input as you're allowed.

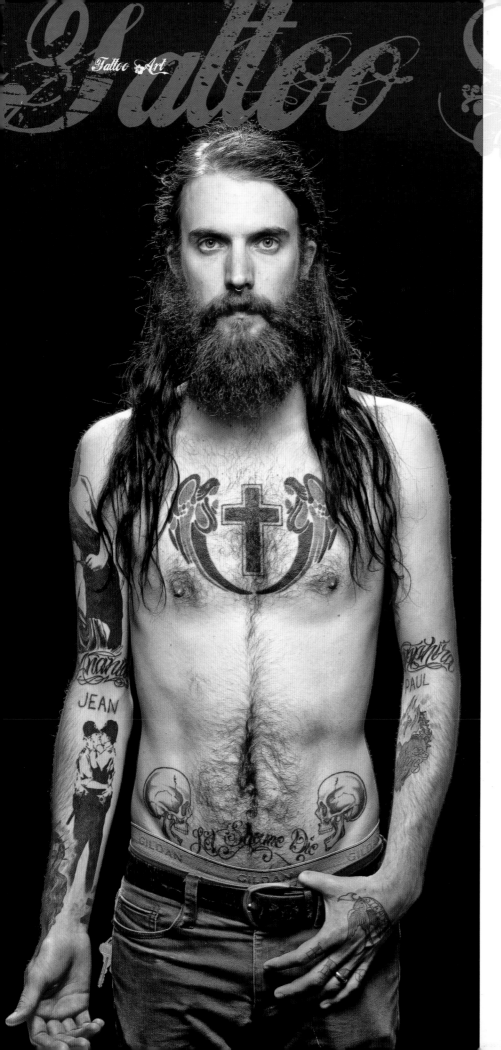

However, whether you prefer the sparse lines of the minimal but masterful NOON (*see* pages 144–145), Xoil's graphic collages or Ran Maclurkin's weird little monsters, you know you'll be charting the wild frontier of contemporary tattoo art – and we all know how great it is where the wild things are.

Japanese Tattooing

Wild things are also intimately bound up within traditional Japanese tattooing (*see* page 74) – and in more ways than one. The subject matter can deal with gods, monsters and other mythical creatures but the practice has other murky associations with the more savage side of society as well.

Early incarnations of tattooing in Japan existed simply to brand criminals, even detailing what their crime was and where it was committed. This punitive practice eventually abated and for a while tattoos were more widely accepted, drawing inspiration from the stately art of the Edo period and the serene perfection of *ukiyo-e* ('floating world') woodblock prints.

Keeping it Gangster

Unfortunately, the growing proficiency of artists (often woodblock artists who trained themselves in the art of *irezumi* – or needling ink under the skin) and their cast list of fantastic beasts had much more appeal to the criminal class than symbols naming them as 'dogs'. Gradually, tattooing became so popular with members of gangs that the Japanese government outlawed it entirely.

Not that this troubled the consciences of *yakuza* gangsters; the Japanese equivalent of the Mob was thrilled by the nefarious associations tattooing now had and, under their patronage, the style flourished as they sought larger, more imposing and ferocious-looking full body tattoos with which to intimidate the rest of society.

photocredits Left Photographer: Wayne Hoecherl • Model: Matty Devenish

Suit Up!

Their tattoos took the traditional form of the *horimono*: the full bodysuit that would take many painful sessions to obtain. Originally, the work was carried out by using *tebori* – needles mounted on sticks – with which the artist would poke the designs by hand. This style, sometimes in combination with a machine, is still used by many artists, including the revered Horiyoshi III – regarded as the greatest living master of the traditional style.

Being able to sit for the gruelling sessions that a bodysuit demanded was one of the ways in which the *yakuza* gangsters demonstrated both their individual strength and the strength of their loyalty to their gang and its boss. Compared to other practices, such as removing part of their finger (a ritual known as *yubitsume*, still carried out by modern *yakuza* just as much as *irezumi*) as penance for an error, it seems almost genteel....

Intriguingly, a loophole in the law allowed Westerners to be tattooed with impunity in Japan even under the ban. Tattooing is now legal but the strong associations with *yakuza* activity remain, to the extent that anyone with heavy tattoo coverage might still be frowned upon and even denied entry to a Japanese bathhouse.

Turning Japanese

A traditional bodysuit is created in adherence to many rules of composition and form that must be obeyed to create a truly balanced piece, whether that's in the images it contains or even in the shape.

There should be an open channel of bare skin down the chest, for example, so that the wearer can still wear an open shirt without revealing the tattoo.

The elements that make up the tattoo should work in harmony as well. Seasonal plants should lie together – no spring cherry blossom next to an autumnal tree, for example – and the artist/wearer should carefully consider the subject matter and its symbolism, in case they inadvertently paint a permanently negative picture of their character and beliefs. There is room for a dab of humour, though; bodysuits can incorporate *kakushibori*: humorous or even erotic images tucked away in the armpit where no one but the wearer will know about them.

But it's in their structure and placement that Japanese tattoos might be said to have had the most influence. Their use of negative (un-inked) space, the flow of shapes, and the balance of foreground and background images had a huge impact on traditional artists, such as Sailor Jerry, and continues to inform other schools to this day.

Unleash the Dragon

As a full bodysuit represents a vast commitment of time and money, it's not for everyone. Japanese tattooing has moved beyond the traditional *horimono*, though, with modern artists creating smaller pieces informed by the traditional Japanese aesthetic, such as leaping koi sleeves, matching Foo Dogs on calves or larger pieces that stick to the back and don't stray down the arms and legs.

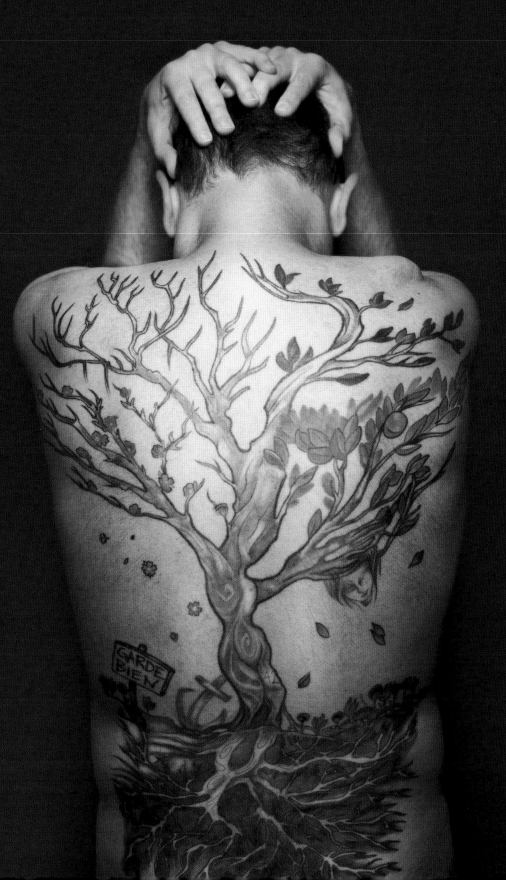

There is still a lot of room for experimentation and maverick talent within a field that seems to have so many rules. Some artists develop a softer approach, while others infuse their work with Old and New School influences to create pieces in screaming technicolour; you might encounter levels of detail and layering that seem impossible or illustrative pieces that seem to have walked straight from the original pages of the adventure novel *Suikoden*.

For every traditionalist, there will also be an iconoclast, putting conventions to the sword just as the ancient *yakuza* originally turned a blind eye to the law; or you might pick an artist who successfully imbues their work with a Japanese feel without being dementedly attached to the 'rules'. Centuries in the making and still going strong, Japanese tattooing really can still be a world of myth, magic and mystery. And sexy armpits.

Realism

A different kind of magic is being wrought in the modern tattoo world by artists working in the field of realism. It's a style that is rapidly developing, as artists strive to push the medium ever further, experimenting with bold new techniques to create staggering results on skin.

Realism (or photorealism) isn't hard to define: it's about creating art that looks as natural and as lifelike as possible (*see* John Anderton on pages 92–93). To make that happen, artists need to be even more concerned than usual with colour and how they choose to line their artwork, creating a sense of depth and perspective within their pieces — even contemplating the play of light within the image itself.

If that seems improbable, it's worth thinking about the starting point for a lot of realist pieces: photographs. The style itself arose in some ways

photocredits Photographer: Pooya Nabei/www.pooyanabei.com

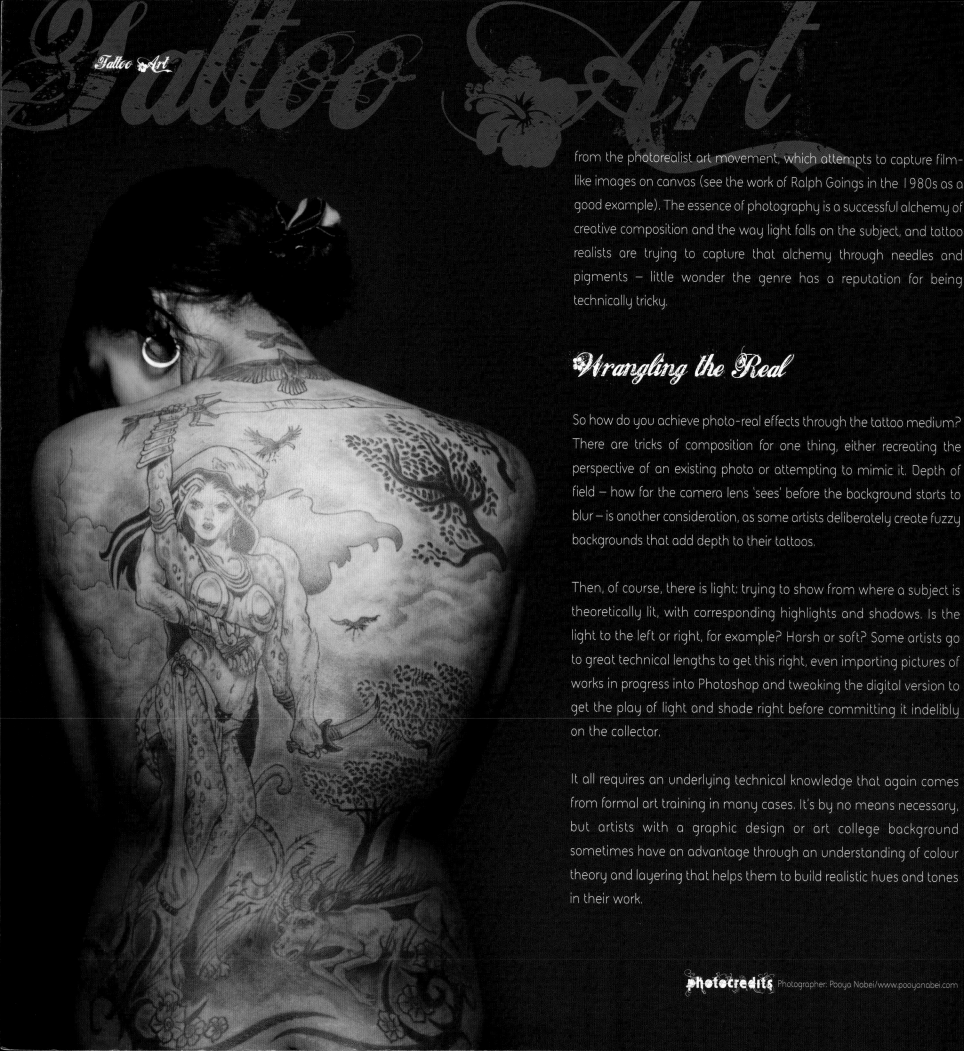

from the photorealist art movement, which attempts to capture film-like images on canvas (see the work of Ralph Goings in the 1980s as a good example). The essence of photography is a successful alchemy of creative composition and the way light falls on the subject, and tattoo realists are trying to capture that alchemy through needles and pigments – little wonder the genre has a reputation for being technically tricky.

Wrangling the Real

So how do you achieve photo-real effects through the tattoo medium? There are tricks of composition for one thing, either recreating the perspective of an existing photo or attempting to mimic it. Depth of field – how far the camera lens 'sees' before the background starts to blur – is another consideration, as some artists deliberately create fuzzy backgrounds that add depth to their tattoos.

Then, of course, there is light: trying to show from where a subject is theoretically lit, with corresponding highlights and shadows. Is the light to the left or right, for example? Harsh or soft? Some artists go to great technical lengths to get this right, even importing pictures of works in progress into Photoshop and tweaking the digital version to get the play of light and shade right before committing it indelibly on the collector.

It all requires an underlying technical knowledge that again comes from formal art training in many cases. It's by no means necessary, but artists with a graphic design or art college background sometimes have an advantage through an understanding of colour theory and layering that helps them to build realistic hues and tones in their work.

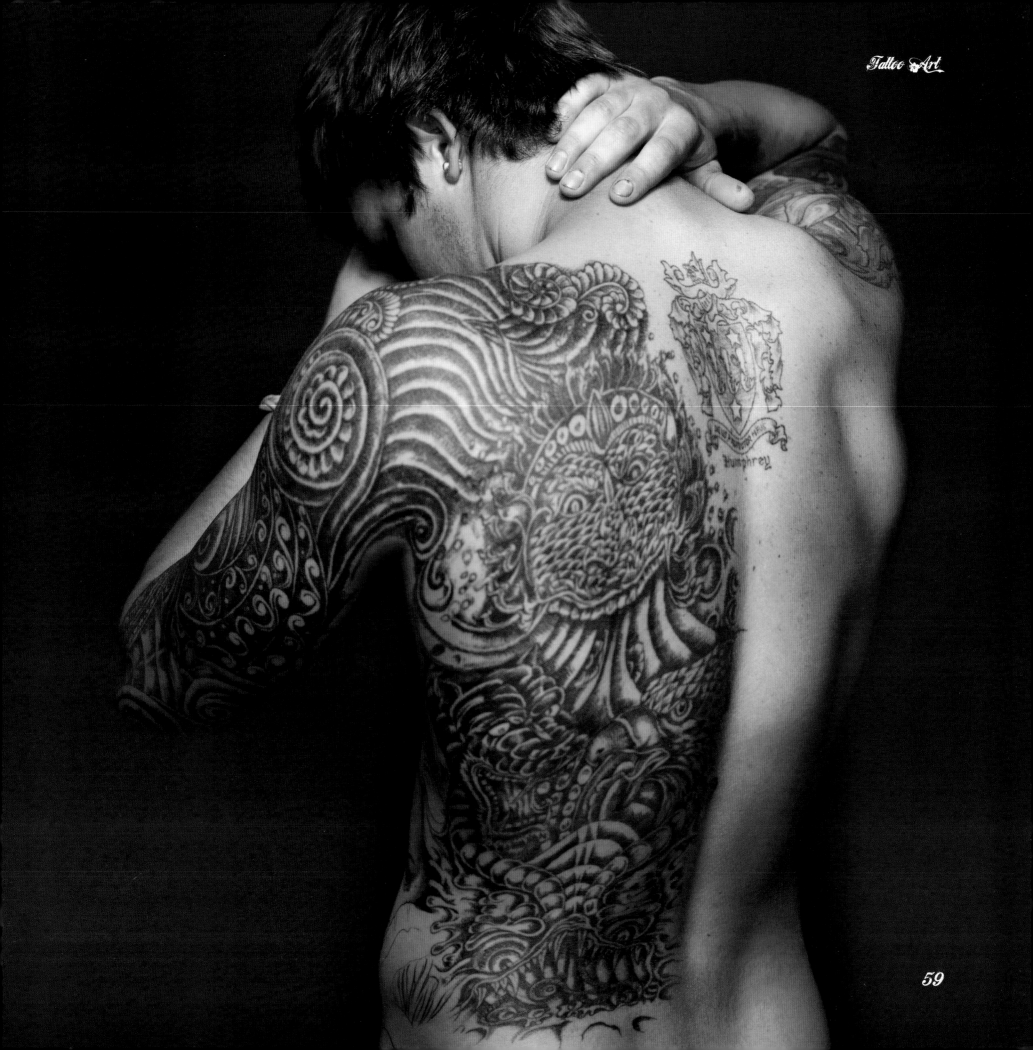

Ivana
Tattoo Artist

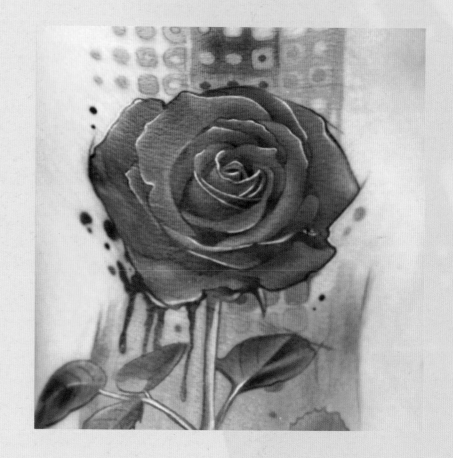

Ivana is from Trencin, Slovakia. She loved art as a child and drew all the time, then in her early teens she would cut out pictures from magazines and ask her brother to draw the patterns on her using marker pens. After finishing school with no particular career in mind, she accepted a job from a tattoo artist friend who had opened a new shop. She had no idea how to tattoo, so she tried out a small tribal design on her friend, and from that first time she was hooked, and knew there was no other job she wanted to do. She is driven by her passion for the arts and regards tattoos as both beautiful and sexy.

Her style is constantly evolving, and she believes she learns something new with every tattoo she does, but there is similarity in her work when it comes to colours. She started with black and grey tattoos using only two types of needle, but then she met Joe Capobianco who advised her that a different type of needle would allow her to create colourful tattoos, and after this she was able to reach a whole new level. She does custom and original designs, and likes to mix realism and fantasy together, but most of all she likes to start with an idea of what her client wants and then have the freedom to create her own design.

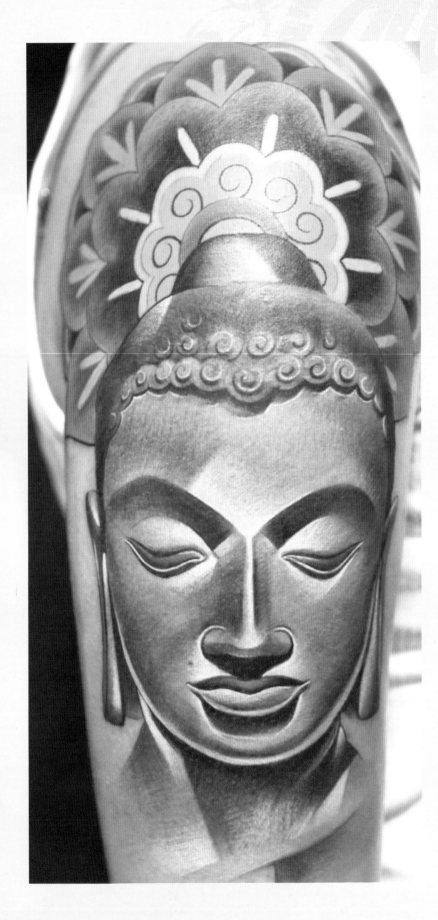

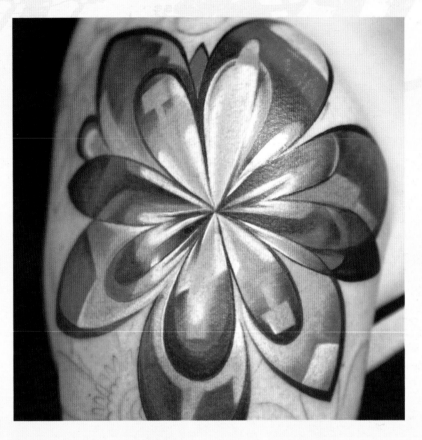

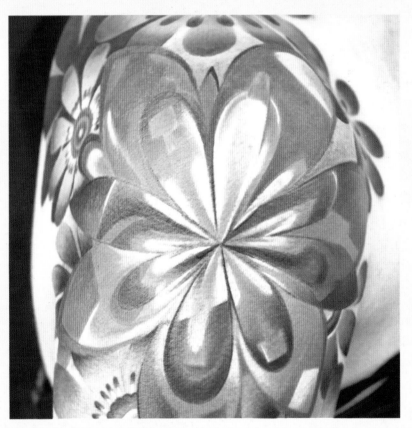

The Colour and the Shape

Beyond the theoretical, the physical act of tattooing can also be different when working in the realist style. Sharing ideas with fine art and abstract tattooing, some artists shy away from heavily outlining their work and opt instead to let the colours do the talking. The intriguing part is that, as this style and approach is still so new, there are very few 'old' photorealist pieces, so no one knows how they will age compared to a 30-year-old traditional piece – which just makes it more interesting, of course.

Colour gets a different treatment too, often building up in layers rather than being packed in as tightly as possible in one pass. This helps to make shading and textural changes more gradual and less noticeable to the naked eye.

As for subjects, anything goes: landscapes, still life, the natural world and so on, but often portraiture best allows artists to flex their creative muscles as they wrestle with skin, hair and all those little qualities that make a face interesting. For the collector, it's a chance to carry a permanent photo gallery of loved ones or family pets, famous icons and heroes. Or even a picture perfect image of Yoda – 'realistic' doesn't have to mean 'real', after all.

Scripts and Symbols

All those realistic pictures can be worth a thousand words, but sometimes the art still needs to be accompanied by (or consist of) words – memorial tattoos and quotations are two good examples. Although strictly speaking lettering isn't a 'school' or style of tattooing – it appears in artwork of all styles – it's still an important discipline in its own right.

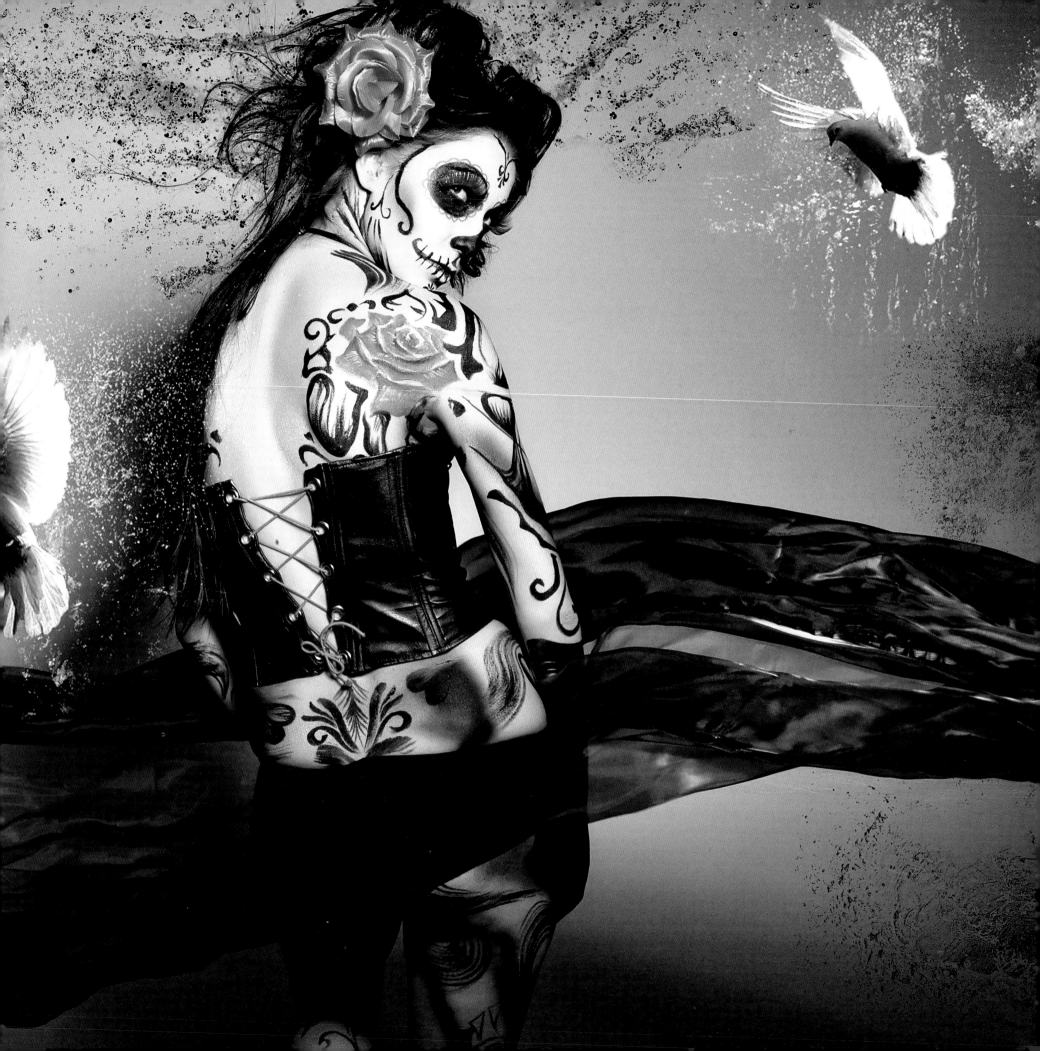

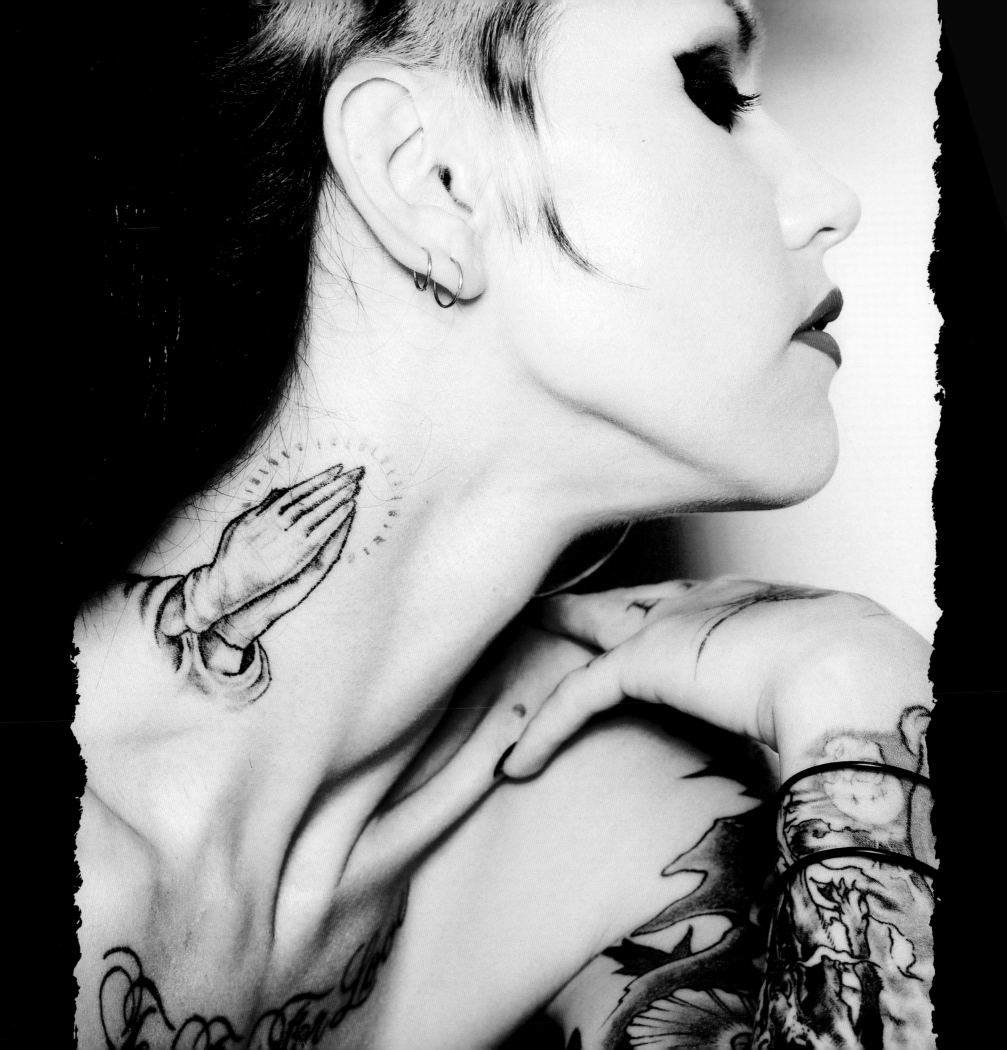

Tattoos have featured words for generations for any number of reasons, such as 'hold fast' on a sailor's knuckles to help him grip the rigging, for instance. In the early days they were simple, hand-lettered affairs, whereas these days there can be more to it than that.

More than Words

Interviewed for the *Alphabets and Scripts Tattoo Design Directory* (Vince Hemingson, Quintet Publishing, 2010), the venerable tattoo historian Chuck Eldridge joked that most artists hate doing lettering. 'It's like math. It's hard. (...) The spacing and the sizing, making it look good on the skin are all difficult to do.'

This problem is at the heart of text tattooing. Finding a great-looking font on a computer that prints beautifully and has lovely edges is great – for print. But the body isn't a flat piece of paper and will distort a mathematically perfect typeface, just as surely as the ink will spread over time and blur even the sharpest edges.

Some artists and designers suggest getting around this with typewriter-style fonts, which we expect to have softer edges and more imperfections due to their creation; they are hammered on to paper by metal plates – not a million miles from tattooing in a way – so when turned into ink they can be a little more forgiving and create a 'weathered' look as they age that suits their appearance. However, since that is not appropriate for every design, another tactic is to develop a freehand style that can be adapted to the individual and to the specific design they have chosen.

Spacing Out

Graphic designers and those who build fonts and typefaces spend hours agonizing over the smallest elements of the way a font works – the spaces contained within the individual characters, for example, the gaps between them (also referred to as 'kerning') and even the way the different serifs curl at the ends of the characters.

Paying attention to those elements is important in body art as well and competent artists will take that into account (for example, serifs will always soften and go too small on a piece of script, and the spaces might fill in over time, rendering the words illegible). Whether they are freehanding a piece of calligraphy, rendering an elaborate typeface or even busting out a complex graffiti-themed motto, effective lettering requires an artist with a feel for spacing and the ability to keep individual characters, words and phrases in perfect proportion.

One artist who manages this delicate balancing act is black and grey maestro Jack Rudy, whose lettering is an integral part of his style. He has previously cited comic book artists such as Greg Irons as an influence, which makes sense – putting words into Batman's mouth is an art in itself, as comic book letterers have developed unique textual 'voices' to distinguish one character from another. The lettering is just as visually important as the action.

Read All About It

Obviously, the message conveyed by a phrase, mantra, quote or symbol is important too, and the placement matters when it comes to help that along. Big is usually better, as with most tattoos, and specific placement can also make a difference – some languages (such as English) are written to be read horizontally and left to right, so vertical text in tattoos is tricky for the eye and brain to decipher.

Likewise, the actual site of a piece of writing is worth considering – high on the body for sacred texts, for example, so that they are nearer the head and the heart, and therefore more powerful.

Flash! (Ah-ahh ...)

One of the places you'll often find examples of the kind of lettering that works well in tattoos is on sheets of flash. In the midst of the current passion for custom work, flash art – ready-made tattoo designs usually displayed in books and racks – might seem to the casual observer to be the poor cousin of the tattoo industry, lacking the glamour and even the artistic merit of its fame-draped relative.

However, that's not really the case. Flash had a critical role in the development of tattooing in the West and it continues to be an important part of today's industry, useful to artists and collectors alike on their journey into tattoo art.

Walk Right In

In the tattoo booths jostling for position around the naval yards of the 1940s, flash was king and payday would see scores of sailors sprint ashore to pick their pin-up girl from the sheets of drawings on the wall and get it inked on in a jiffy. Some things haven't changed: modern artists working near military bases tell similar stories of customers queuing to get their tattoos, still picking ready-made art from the walls.

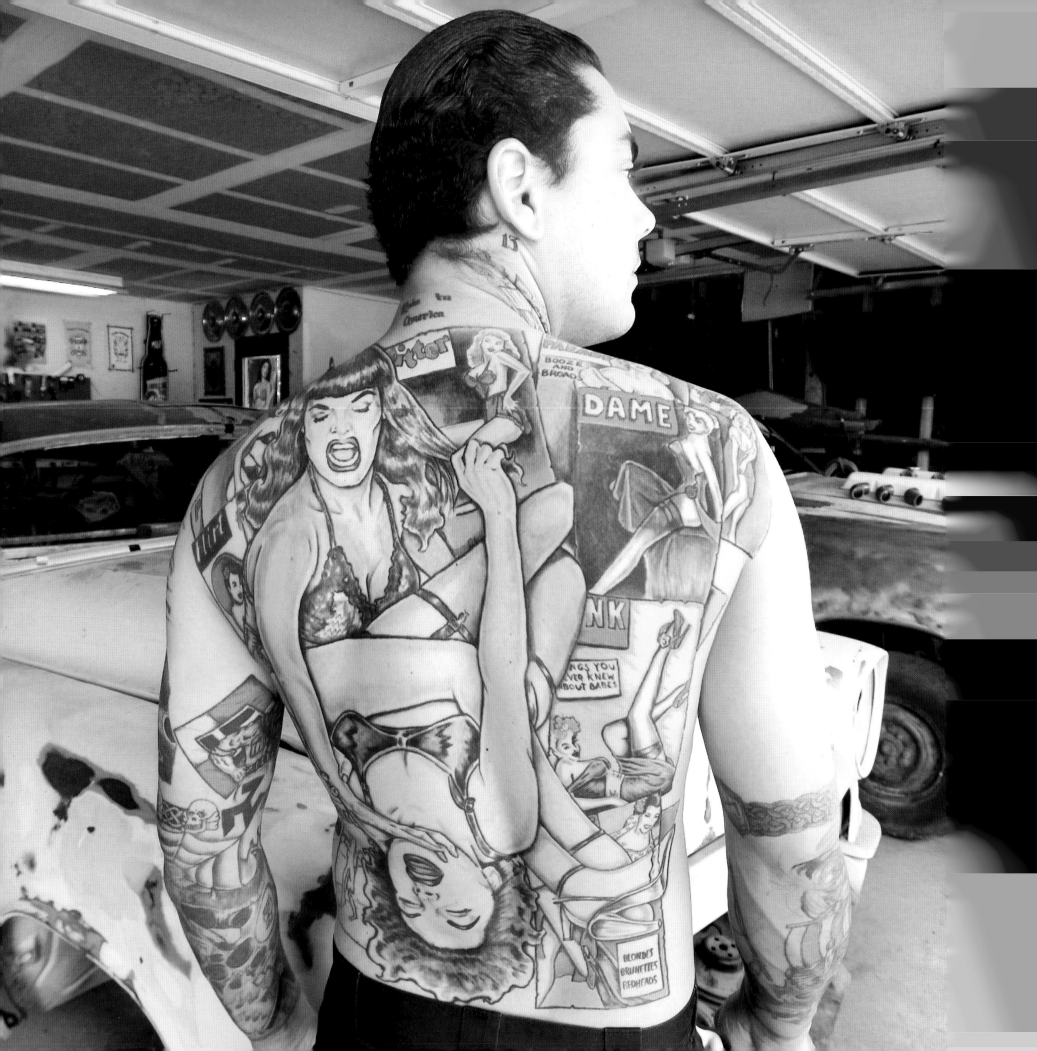

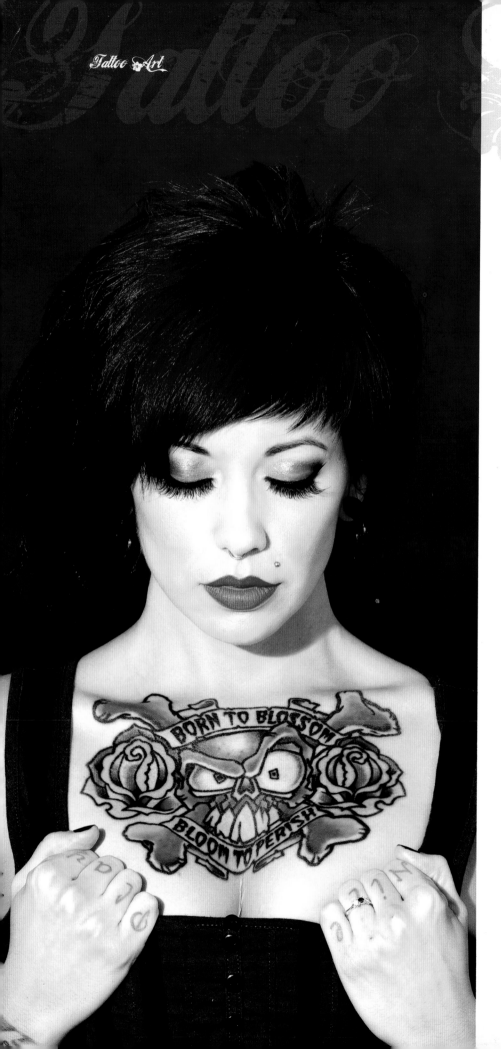

The walk-in industry is a vital part of the modern tattoo world. Not everyone is ready for a giant custom piece first time around, and for some that heart and scroll design chosen from a flash sheet is the only ink they'll ever need. It also allows for a little spontaneity – a carefully considered tattoo is usually the right way to go, but that doesn't mean that a spur-of-the-moment decision to get some ink can't turn out beautifully.

Working with flash benefits the artists too. Constant repetition of any activity will help a practitioner improve, whether that's a martial art or a musical instrument, and the technical skills required for tattooing are no different, so banging out a lot of flash work can be a solid starting point for many tattoo artists.

Getting Flashy

Flash represents a unique, fixed point in the shifting tattoo business. Some people are content to remain tattooists (rather than custom tattoo artists) and dedicate themselves to creating great flash-based art, sometimes augmenting it and shifting it up a little to add variety; they might order it in from other flash artists or create their own.

Meanwhile, some custom artists draw flash-style pieces to help inspire clients looking for a new design or even as a purely decorative piece of art, while others collect vintage Old School flash to decorate their studios – wherever the industry wanders, flash is still right there at the core.

Custom Art

While flash is unlikely to ever disappear due to its rich heritage (and sheer convenience for artists), at the start of the twenty-first century custom art is indisputably where it's at. All of the artists featured in this

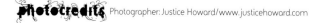 Photographer: Justice Howard/www.justicehoward.com

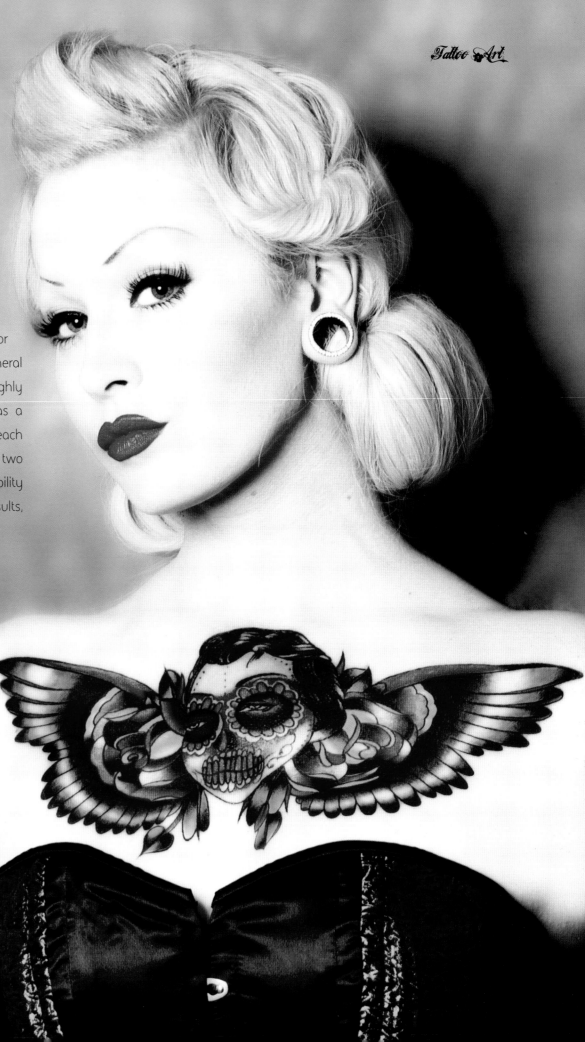

book produce custom work and that's all you are likely to see in magazines, on TV and in convention booths the world over.

Custom art may not be intrinsically 'better' than flash in terms of its inherent worth as an art form, but it does pose unique challenges and opportunities for the artist and the collector alike that lead to it being regarded as the ultimate expression of the tattoo artist's craft.

For a start, custom work begins with a blank slate. What the collector and the artist bring to that slate might vary hugely, from a general philosophical concept (such as 'regret' or 'belonging') to a highly specific idea rooted in an artist's particular specialism, such as a Japanese-style back piece. The relative degrees of input that each person has will vary every time and might not be the same for two different clients visiting the same artist. It's a realm of infinite possibility that can generate some truly astonishing and unpredictable results, whatever the starting point.

Sketching It Out

A custom piece usually begins with a conversation between client and artist. It might be short, sweet and face to face or, in the age of far-reaching global communication, it might take place via email over several months, from two different corners of the globe. The aim is to build up the idea of the piece and work out where it's going to go so that the artist can start drawing up some options — sometimes clients

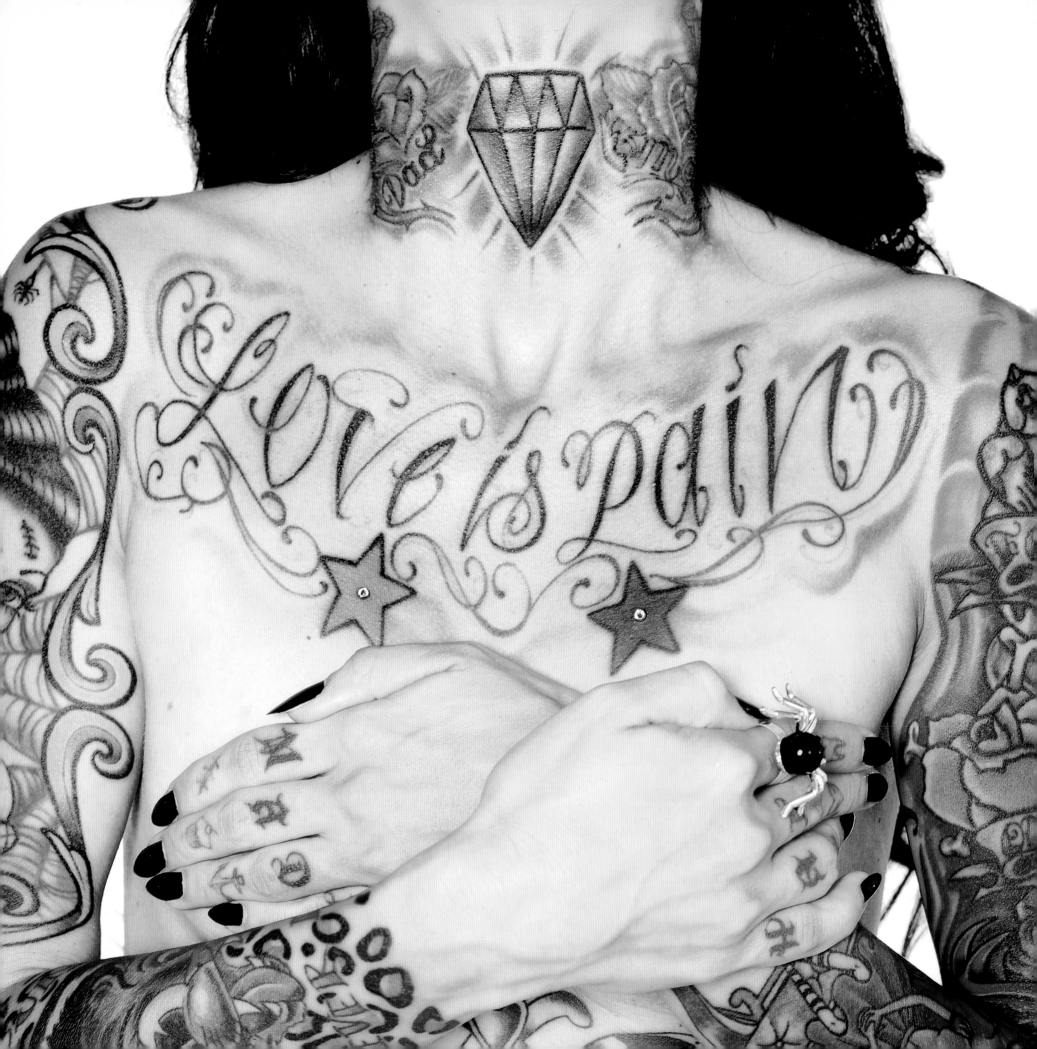

bring in elements that inspire them (from photographs to other tattoos), whereas other times they'll leave it entirely up to the artist and see what happens.

Improv!

However, as the best laid plans can often go awry, there are artists out there who prefer not to plan at all, creating their custom work off the cuff. They might draw straight on to the skin based on a client's suggestions or they might start tattooing and see what happens. Needless to say, this particular form of permanent improvising doesn't appeal to everyone, but it has an in-the-moment energy and sense of risk that can satisfy some collectors — so while it's about as appealing as naked lion taming to some, others will gladly strip off and say, 'Here kitty, kitty.'

Tattooing Sans Frontières

For anyone planning a custom piece or just looking into the world of tattooing for the first time, it's a great moment to be beginning the journey. The media in one form or another has

contributed to the spread of tattooing in the West since Captain Cook's *A voyage to the Pacific Ocean* carried illustrations of tattooed natives in 1785 (and maybe even before then), and now there is an unprecedented range of publications, websites and resources available.

The rise of social media and other facets of Bauman's liquid modern world also make navigating even the smallest tattoo backwater easier. Gone are the creaky shacks and faded flash of seaside tattooists or even the super-niche biker magazines, where some artists originally promoted their work. Instead, you can see the work of up-and-coming artists on their websites, get in touch with them in moments and, in some cases, even watch them tattoo live via webcam. (Really.)

It's possible that all of this exposure has added a different dimension to tattooing. Since you can now easily follow the fortunes of an artist or studio in a country you'll never visit, it has become almost a hobby and lifestyle for people in the same way as movies or anything else in the cultural diaspora. Determining whether that's a good thing or not leads to lively debates among some in the community, as you'd expect.

Healthier and Happier

What is less contentious is that the industry is now a more sanitary place in which to work. Tales of mutual ink pots and shared needles or grainy pictures of wartime tattooists bending over their clients with

*I always felt that my whole career
was going to be judged
by each tattoo I did.*

Lyle Tuttle

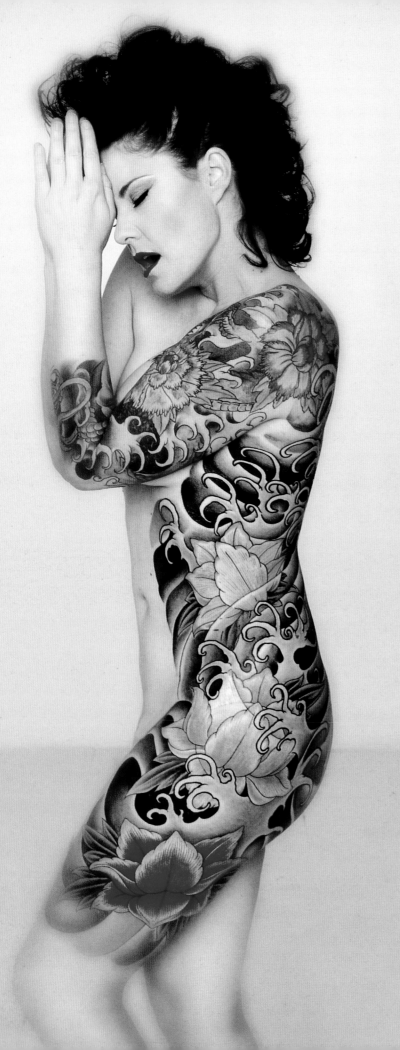

cigarettes dangling from their lips may have contributed to the rough-and-ready character of tattooing in the old days, but the modern studio is often cleaner than a medical facility.

In some areas, there is a certain nostalgia for the grungy glamour of the old days, and the scuzzy, disreputable tattoo shop is far from extinct. But for all the devil-may-care chic of backroom tattooing (and it definitely has its appeal, as many things that are bad for us do), the realities of infected tattoos and blood-borne nasties are far from pleasant – and far from good for business in a competitive industry. Sailor Jerry knew that: he promoted hygiene long before the advent of autoclaves and other sterilizing equipment. (Smoking his pipe may not have helped much, but hey, nobody's perfect.)

Nowadays, collectors can – and should – expect cleanliness as standard from custom studios and convention stalls alike. Gloves, fresh needles from unopened packs, sterilized machines – they all help ensure that the only thing a wearer takes away is a great tattoo.

Tattoos on TV

Once tattooing evolved and became more businesslike and better at promoting itself, it was inevitable that TV would come calling, as the 'reality' craze wound itself up into a frenzy of housewives, big brothers and families with names that sound like *Star Trek* villains.

Tattooing had all the right ingredients for TV: colourful characters creating art, personal stories from collectors and, of course, a unique visual element underpinning it all. Small wonder that one tattoo show wasn't enough and we ended up with several *Ink* shows based in cities – Miami, LA, New York – that still hold an exotic appeal to viewers worldwide.

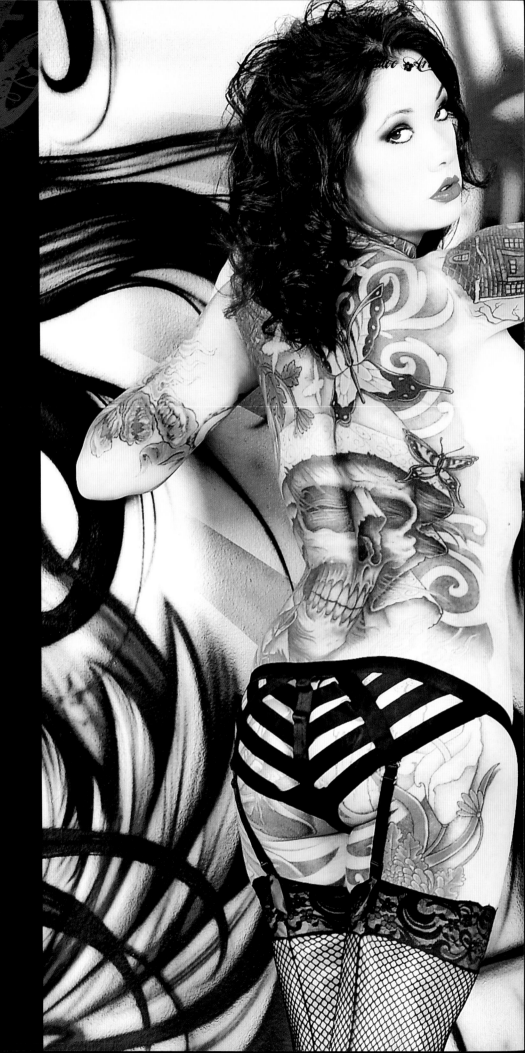

Good TV, Bad TV and Beyond

Miami Ink and its spin-offs are reviled in some circles, but their success and the change of fortunes they have brought to tattoo artists can't be ignored. The shows blend heady escapism with a presentation of tattooing – however accurate it may be – that made people check out studios, consider tattoos and help spread the message of tattooing as art, rather than something that was lazily dismissed as only suitable for criminals and errant youths.

On the back of these shows, some indie documentaries have offered real insight into the industry – Vice TV's *Tattoo Age* series and Marcus Kuhn's ongoing *The Gypsy Gentleman* projects are just two examples of a different kind of tattoo show that focuses on artists and their work, offering glimpses into tattooing's past as well as investigating its present.

Perhaps the next evolution will take place on the silver screen, where the use of tattoos as a visual shorthand for 'bad guy' is changing thanks to more conspicuously inked actors (think Angelina Jolie, Dwayne Johnson and Tom Hardy) and characters drawn in more than one dimension; girls with dragon tattoos and noble, conflicted cage fighters with ink (*Warrior*) may herald another turning point in the tattoo's mainstream odyssey.

The Other Kind of Ink

As has been the case for *that* girl and *that* dragon tattoo, of course, it's fiction that initially heralded the change. Herman Melville used the heavily inked islander Queequeg to explain that a man 'can be honest in any kind of skin' as early as 1851's *Moby Dick*; since then, ink has featured prominently in work by Roald Dahl, John Burdett and Academy Award-winning (and bestselling novelist) John Irving among others.

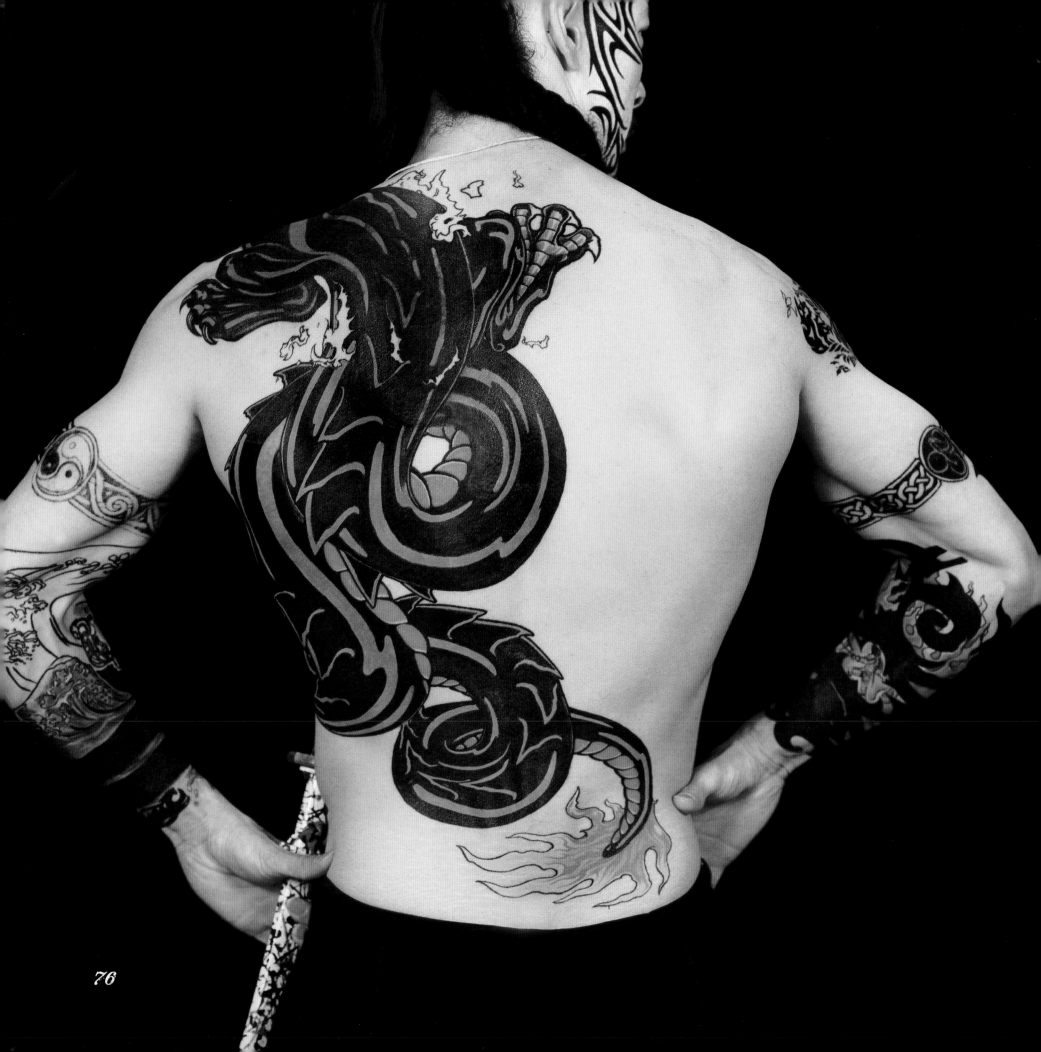

Larsson's creation of Lisbeth Salander in his Millennium Trilogy presents the tattoo collector many would recognize, though (murders, gunfights and other scrapes aside): picking some tattoos for the art alone and others for their personal significance.

Who Gets Tattooed?

Pondering on the changing presentation of tattoos and tattooing in the media at large soon leads to the 'who gets tattooed and why?' question. It's not a new one, and the short answer, of course, is: 'Whoever wants to – and because they can.' There are no rules and no tests you have to take (other than producing ID) before getting a tattoo.

Yet the question continues to fascinate people. Those without tattoos might still remark, 'You are the last person I'd expect to have a tattoo,' which just goes to show that some of the old associations with the art – crime and running with the wrong crowd – still linger.

What You Make of It

That's in part because a wholly legitimate reason for getting a tattoo is to put that message out there. Some people choose tattoos that explicitly state gang affiliation or that tap into a countercultural mode of expression; they *want* tattoos that look mean and intimidating.

But that's just one drop in the ocean. Tattoos can just be about the art, or they can grow from the complex semiotics that a wearer has created to express their lives. Many historical figures have been tattooed, including princes, politicians and – reportedly – presidents. The simple fact is that there isn't a 'kind' of person who gets tattooed – and there never has been.

Becoming Conventional

In order to illustrate perfectly the wide range of people who now choose to get tattoos, turn to the global tattoo convention scene. In the UK alone, it's estimated that there is at least one convention a week, somewhere, often with artists attending from all over the world.

Walking around the bigger conventions, one of the striking aspects is the diversity of the crowds. The heavily inked brethren are generally out in force, suitably tricked out with full bodysuits and multiple piercings, but it's just as common to see families, ink virgins and even mothers and daughters getting their first tattoos together.

All Together Now

While there might be some doubt as to exactly how many tattoo shows the industry can sustain going forward, their popularity and increasing slickness are testament to the broad demographics that now find tattooing attractive. Like music festivals, there are shows designed to appeal to particular crowds, from extreme body art freakouts to more family-friendly affairs.

And if the crowded event halls and wasps-in-a-tin-can buzz of conventions show anything, it's that tattooing has come through interesting times and is now riding high. There are artists creating great work, more people than ever wanting to wear it and plenty of options for everyone. Is it all too much? Will it last? Who knows? But in the fluid modern tattoo world, the surf's definitely up.

photocredits Photographer: Justice Howard/www.justicehoward.com

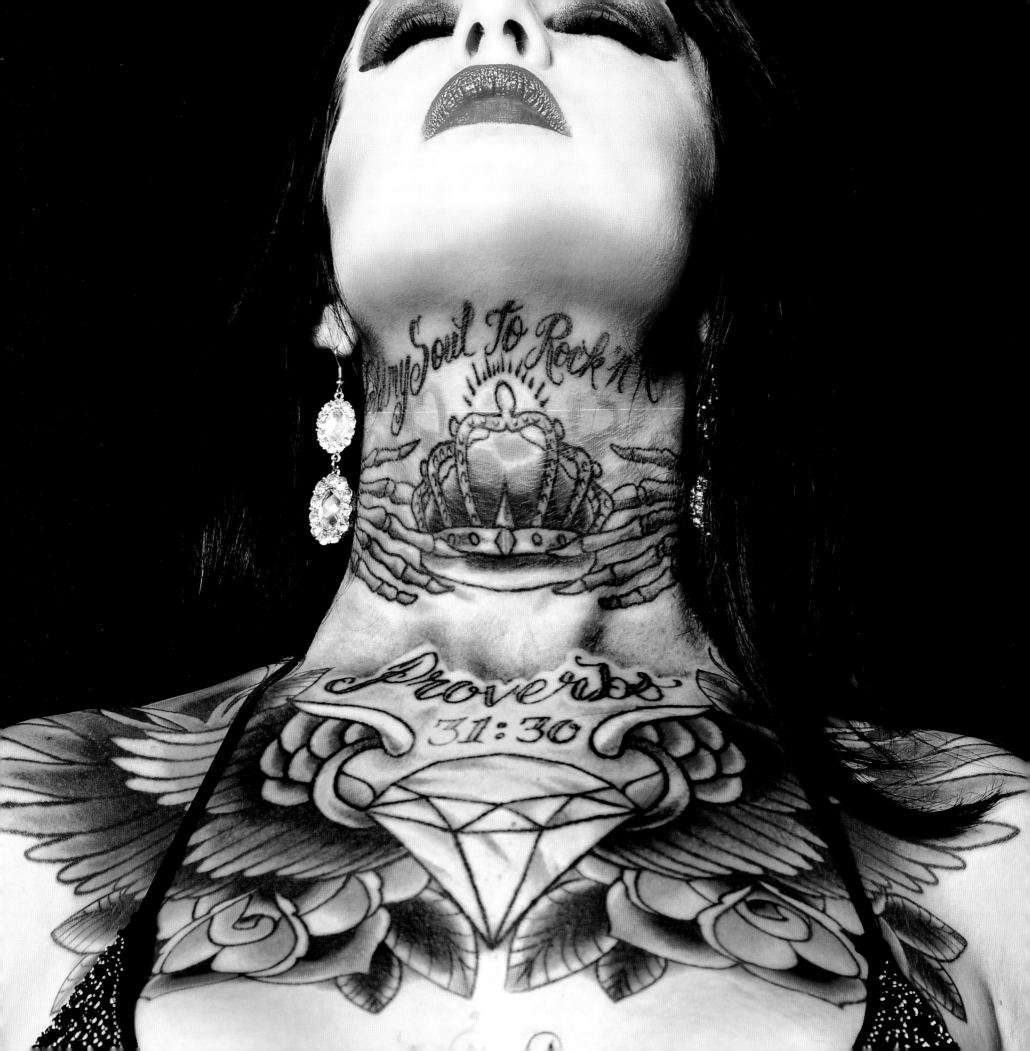

Jondix

Tattoo Artist

Born in Spain, Jondix attended architecture school for seven years while also developing his skills as a tattoo artist. He was taught by Tas and was an apprentice to Mike the Athens, and worked at LTW Barcelona. He is famous for his detailed mantras, geometry, knots and mehndi-influenced patterning, and also for his Buddhist or Tibetan style, techniques he learned while he was in Thailand and northern India. His designs include auspicious symbols, Buddhas, Bodhisattvas, deities and ritualistic objects. He feels that his previous experience as an architect has helped in his work, which is refined, whether the design is detailed or simple. Jondix enjoys painting as much as tattooing, and creates T-shirt designs, artwork for record covers and original commissions. He likes to tattoo or paint what he thinks is right for that moment – he has to feel it. He has worked as a guest artist in London, Paris, New York, Switzerland and San Francisco, and attends the best conventions around the world. He has also written books, and plays guitar in a band.

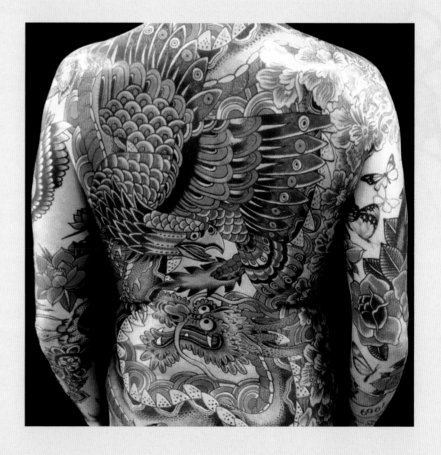

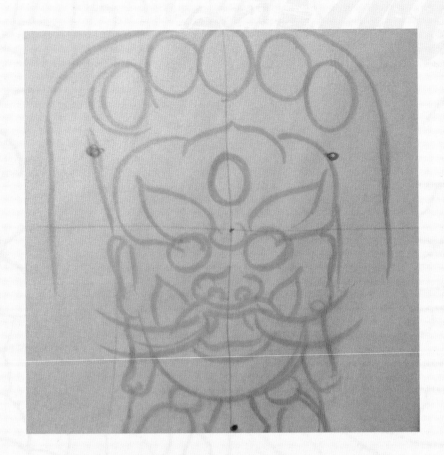

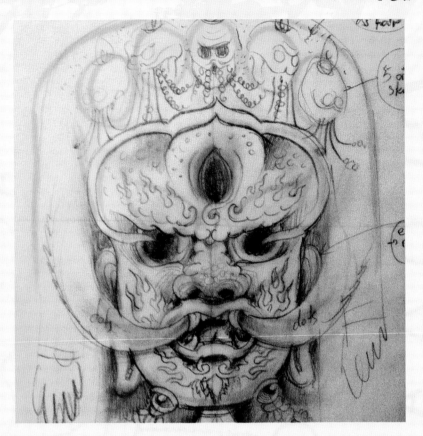

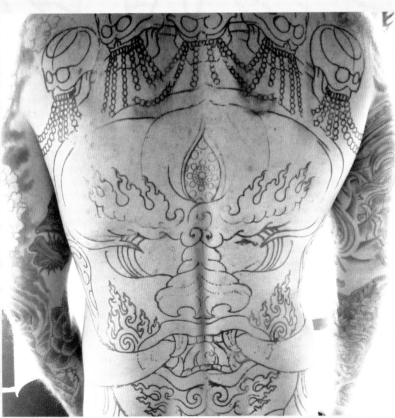

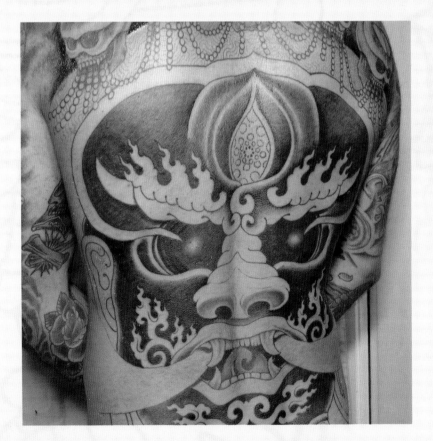

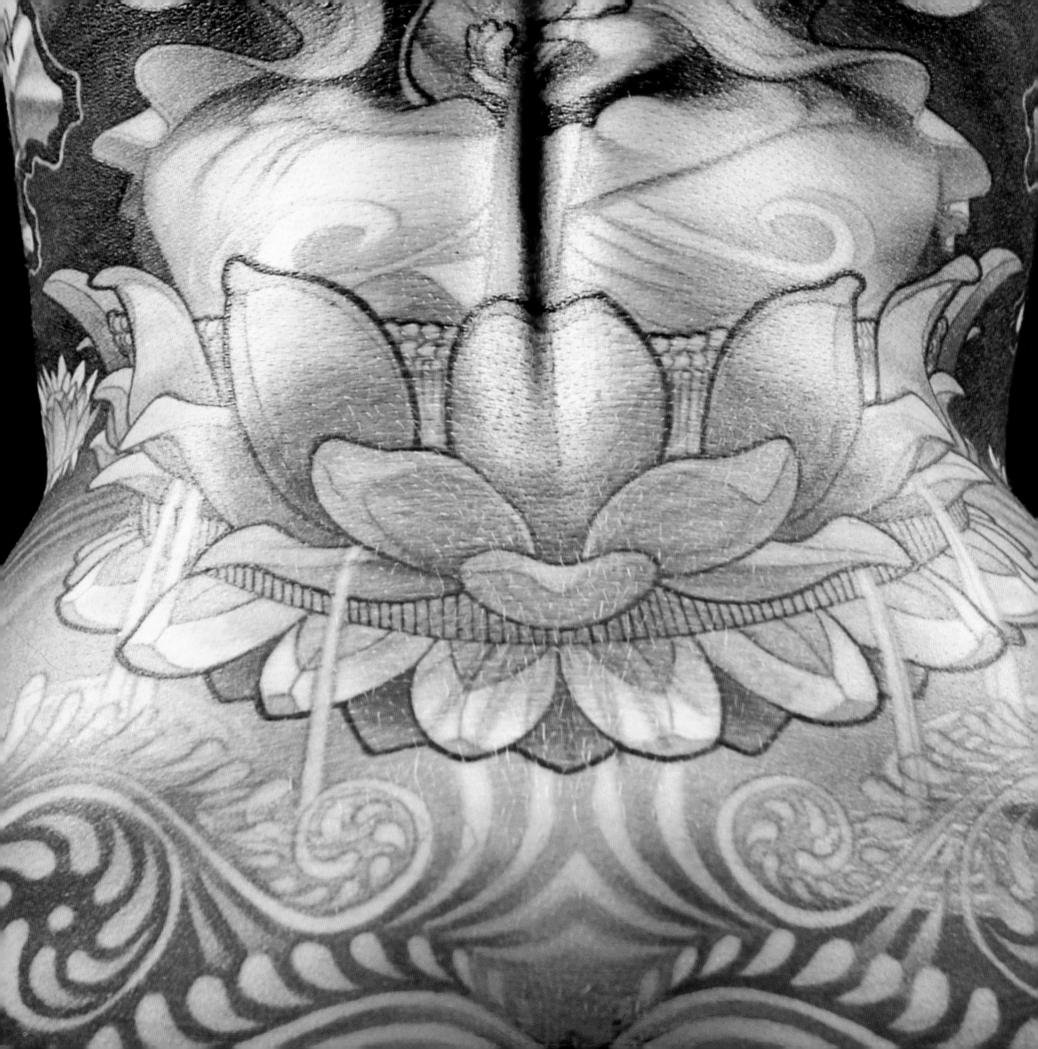

Introducing the Tattoo

Ray Bradbury's 1951 collection of short stories *The Illustrated Man* featured a tattoo origin tale where the unfortunate narrator received a series of tattoos that predicted the future as well as his own demise.

The ink work was given to him by a witch whose eyes were sewn shut, which should really have given him a clue that all was probably not entirely above board with his body art. But it's easy to make mistakes when getting tattooed, particularly when it comes to understanding the nature of the beast. What is a tattoo? And how does it get there? (Reminder: witches should not, as a rule, come into it.)

Defining the Tattoo

The etymology of the word 'tattoo' has taken a few diversions from its original meaning until it finally reached today's multiple definitions. As mentioned previously, one of the earliest uses of the word was in reference to an insistent, rhythmic drumming; the Oxford English Reference Dictionary lists this use as coming from the seventeenth-century term 'tap-too', which is itself an embellishment of the Dutch 'taptoe' – literally meaning 'close the tap' of a cask.

The word also has military associations, referring both to a bugle call used to recall soldiers to barracks and a marching performance by troops in full dress uniform, with much pomp and ceremony, such as the Edinburgh Tattoo.

Its use in the body adornment world may have stemmed from Cook and co., who adapted the 'tattoo' word they knew to fit with the skin-marking rituals they encountered in Tahiti. It's possible that it may have different origins altogether, but it seems fitting that previous definitions encompass both the sensory aspect of the modern meaning (the sounds of the tattoo machine) and its showy overtones. No matter

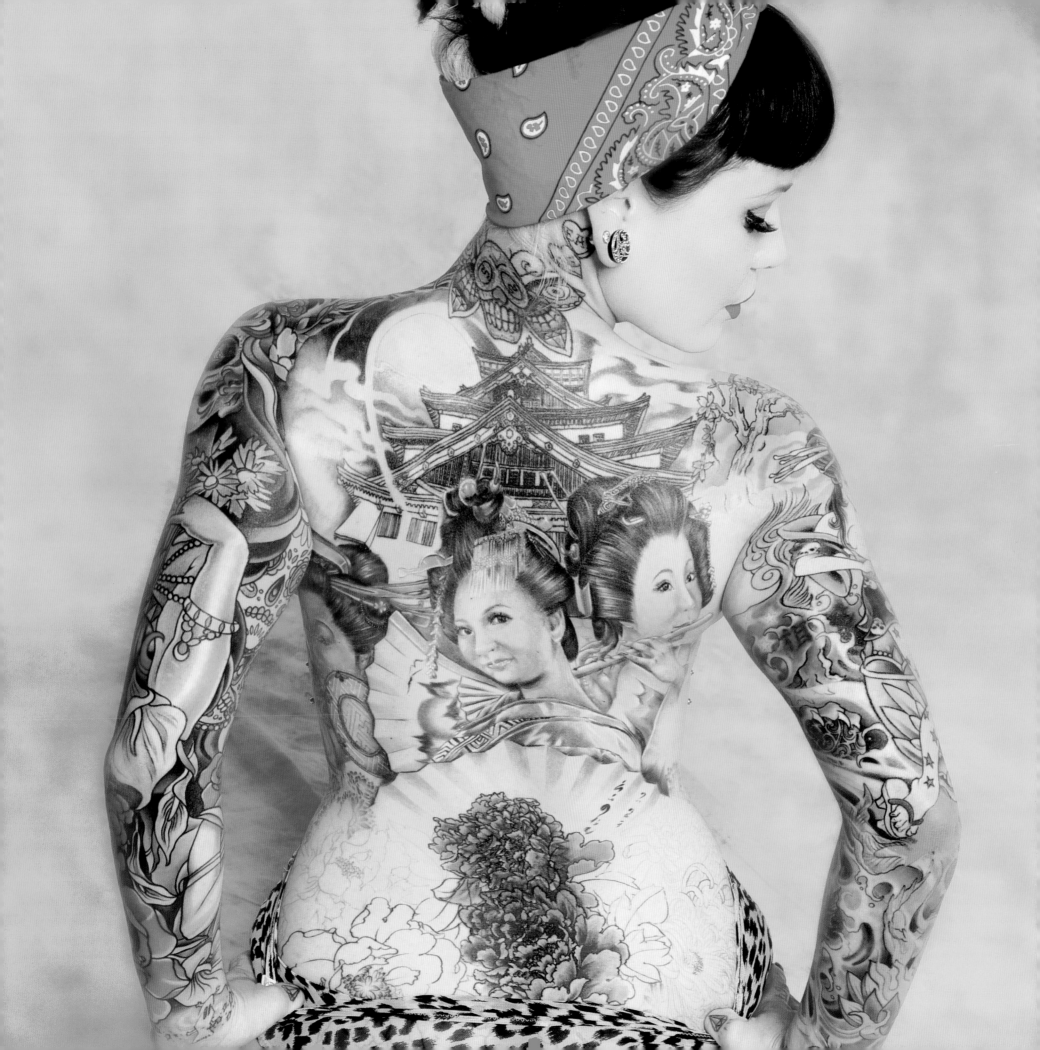

what reasons people give for receiving and wearing a tattoo, at some point along the line it's natural to hope that the end result looks good and commands attention.

Through a Glass, Darkly

Central to understanding how a tattoo works — and perhaps to appreciating the skill involved in creating a good one — is grasping what we are actually looking at when we view one. It's not on the surface of the skin; much like those Japanese 'floating world' *ukiyo-e* woodblocks, the image is suspended — in this case, between two separate anatomical layers.

When we are looking at a tattoo, therefore, we are seeing an image that lies submerged beneath the upper layers of the skin, and the exterior of the body itself is acting as a translucent surface through which we can spot it, like the glass in front of a gallery portrait (if you've gone to the right artist).

The Science Bit

A tattoo is created by using needles to insert pigment under the skin, forming a permanent image. The skin is by far the largest human organ, clocking in at around 1.85 m (20 sq ft) for the average adult and comprising multiple layers, which include the epidermis, dermis and hypodermis.

The epidermis is the outer layer of skin and is made up of several different strata (or sub-layers), which together create the waterproof seal we all come wrapped in. The cells of the epidermis are created at the lowest *stratum basale* and gradually work their way upwards and

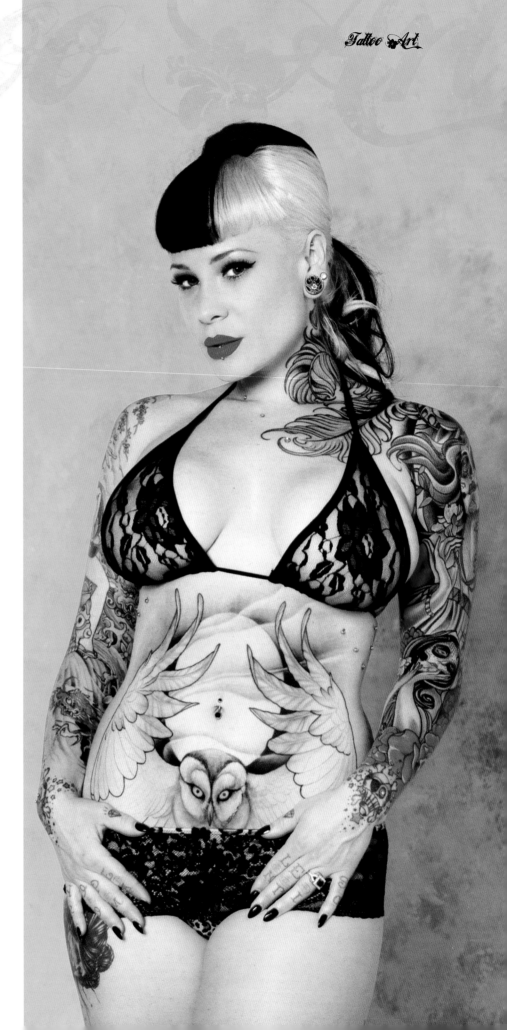

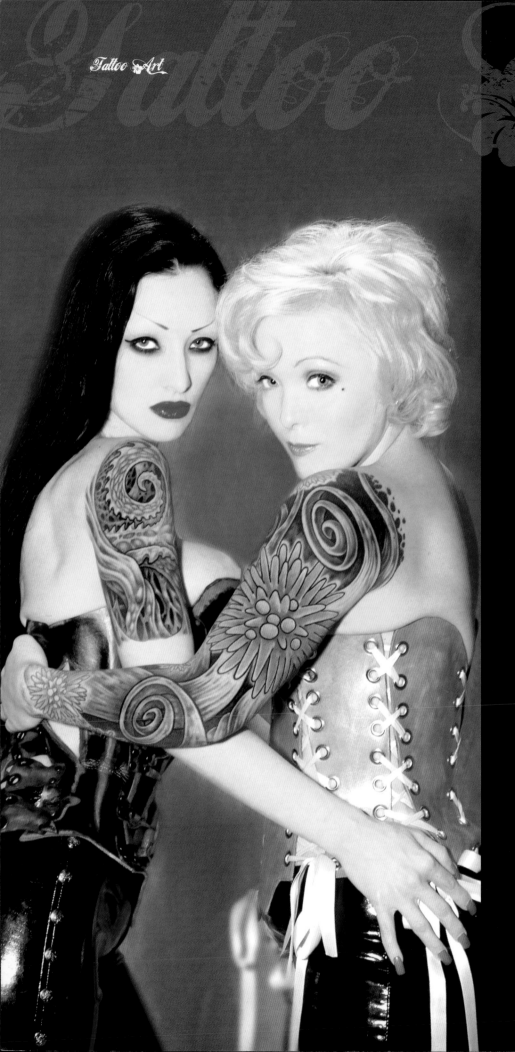

Art

outwards. The topmost layer is dead skin cells which we are constantly shedding; the entire outer layer is replaced every month. That's why it's good to vacuum at home.

Tattoos don't simply peel away with the dead skin cells because they are inserted between the epidermis and the dermis (the hypodermis isn't strictly part of the skin, acting instead as an anchoring structure to attach the skin to bone, muscle and ligaments) – away from the constantly migrating epidermal cells. Once in place, the pigments stay trapped amongst the architecture of the lower skin, which includes hair follicles, the gooey-sounding subcutaneous glands and various lymphatic vessels.

Staying Put

Tattoos take advantage of the body's self-defence systems to hold their position. At the point of insertion, the body reacts – accurately – as if it were being boarded by external forces and rushes defensive white blood cells to the breach. Once there, they will carry off or devour any small, invasive particles, or potentially harmful ones.

However, if the pigment they encounter is inert and non toxic, a particular kind of white blood cell (macrophages) will begin to form scar-like granulation tissue. The dermis gradually heals thanks to collagen growth, while the battle-scarred epidermis simply flakes away; meanwhile, the ink pigments settle into a single layer and the tattoo is in place (held by the excellently named fibroblast cells). Applied correctly, the tattoo will look bright for some time but will inevitably fade as the pigment layer sinks further towards the base of the dermis, also losing some of its definition – hence the softened appearance of decades-old tattoos.

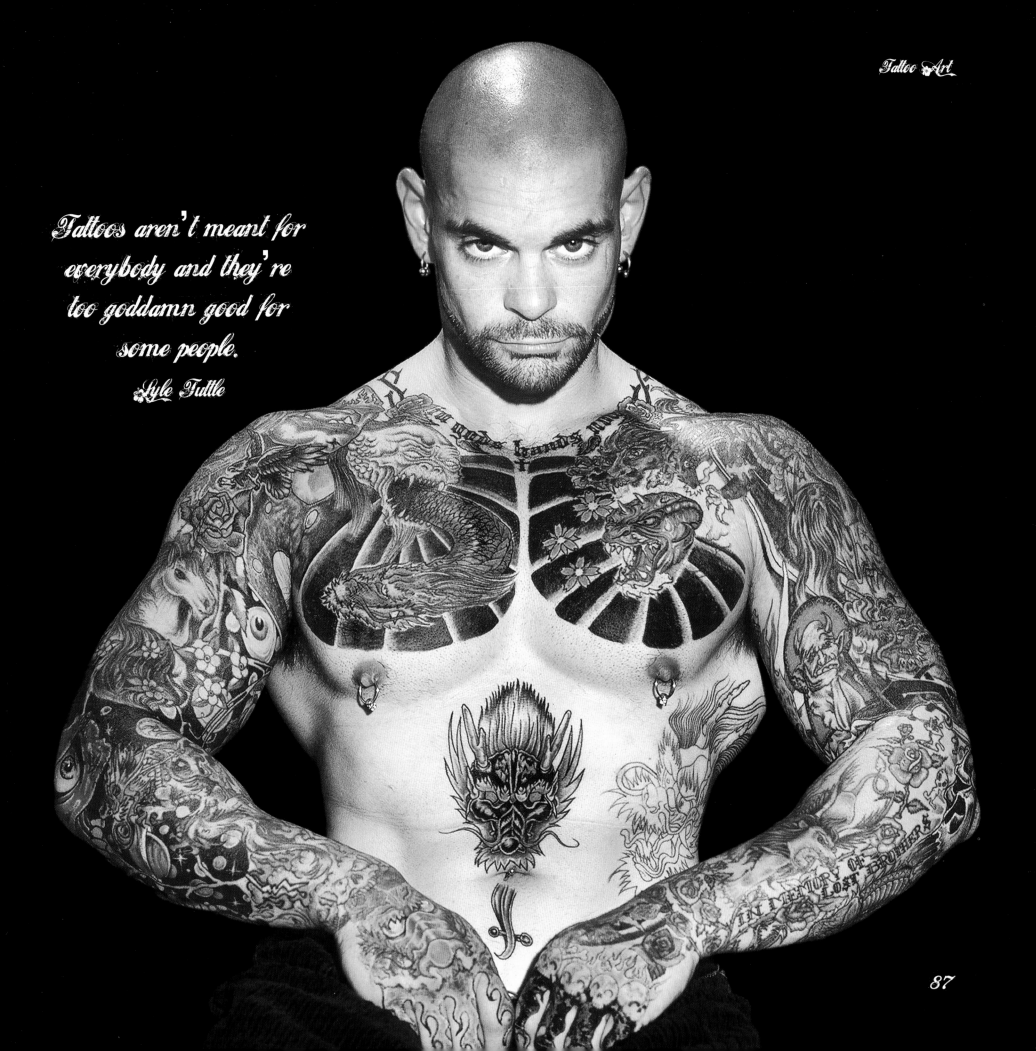

Tattoos aren't meant for everybody and they're too goddamn good for some people.

Lyle Tuttle

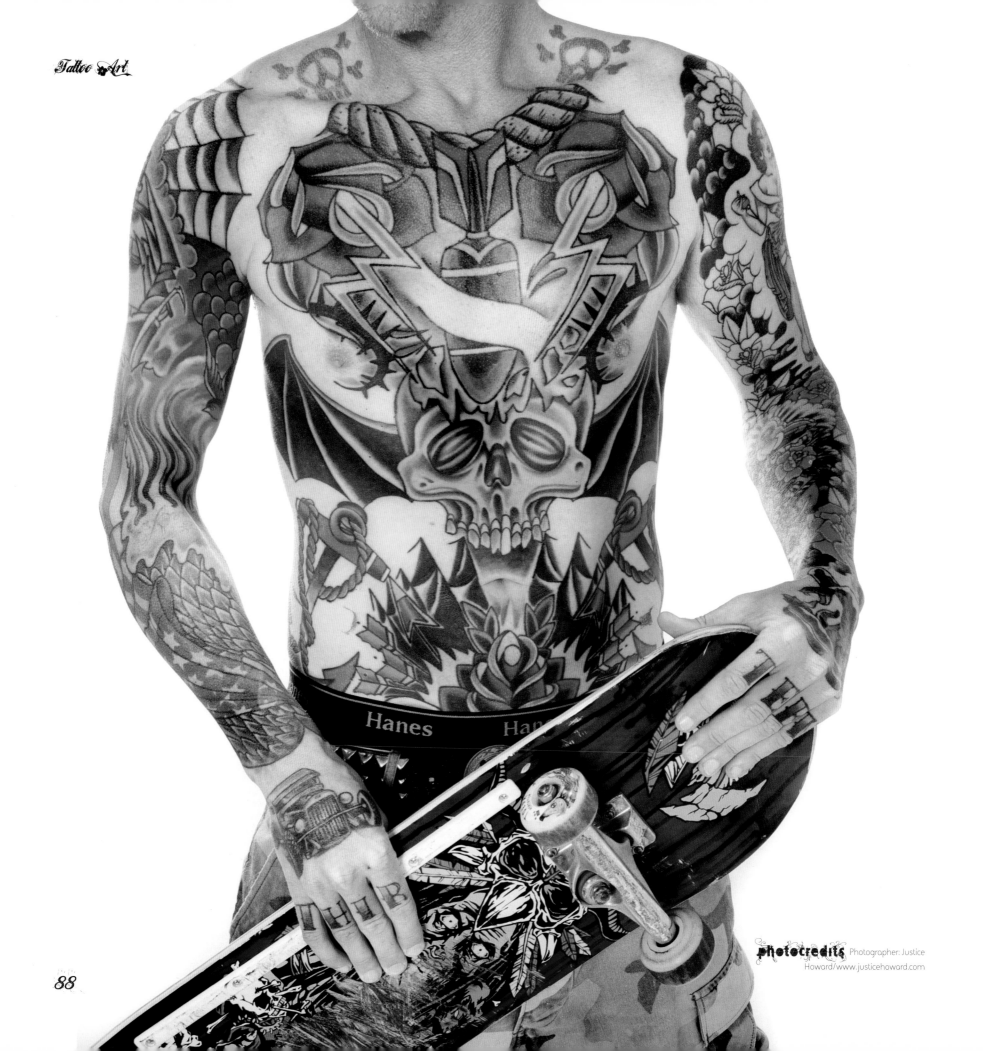

photocredits Photographer: Justice Howard/www.justicehoward.com

Invisible Ink

Much of the tattoo industry is regularly placed in the spotlight, from artists and studios to the art they create. One thing that tends not to get as much attention, though, is the ink. Considering it is something so fundamental to the tattooing process, it keeps a surprisingly low profile.

The earliest tattoos were created from soot and burned remnants to formulate carbon blacks, such as those found in the skin of Ötzi the iceman. They were simply rubbed over the skin once pinpricks or incisions had been made with sharpened sticks or stones; the Ainu people of Japan used a similar process to mark their lips.

Later, inks began to come in more exotic forms – a supposed Roman ink recipe called for pine wood bark, vinegar and gall from insect egg deposits (marking slaves, soldiers and gladiators with tattoos was a common Roman practice). In Hawaii, coconut oil and kukui nut ash were combined to create a dark pigment, whereas it's thought that the Picts may have used either woad (a blue dye produced from the leaves of the *isatis tinctoria* plant) or copper to produce their distinctive markings – if, of course, they really were tattoos (and not body paint as has sometimes been suggested).

Marvellous Medicine

Since some tattooing practices were supposed to contain magical elements designed to heal, protect or embolden the wearer, those applying the tattoos might have given the ink a little extra kick. In traditional Thai tattooing, for example, the tattoo is applied with a needle-tipped bamboo pole as part of an elaborate ritual

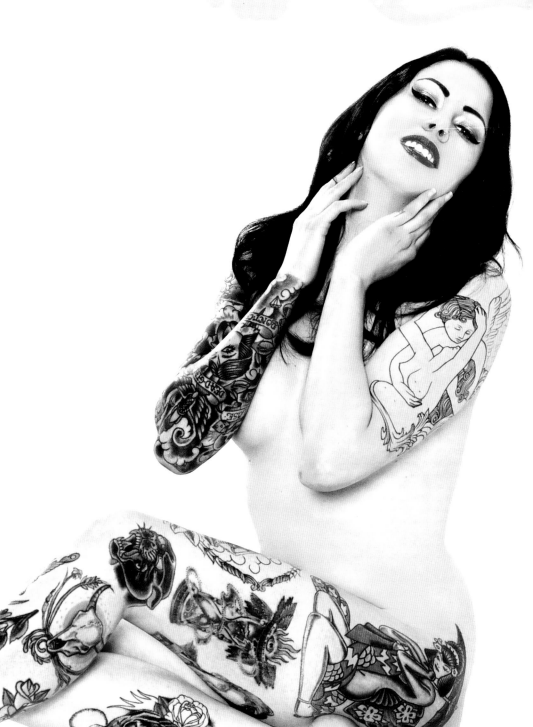

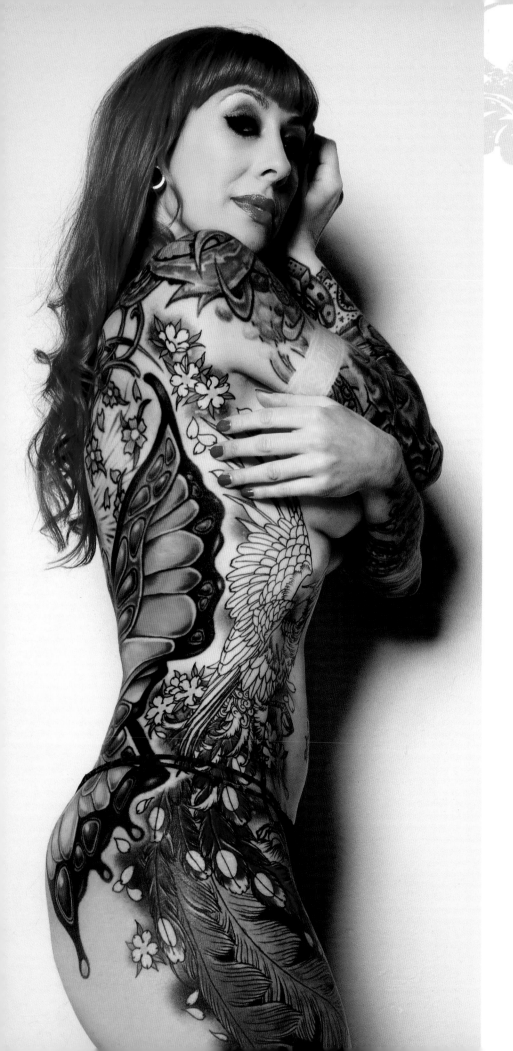

and the ink itself might be pimped with spices and even snake's blood. The convulsions, fevers and acts of extreme oddness perpetrated by those on the receiving end could be to do with the magical forces at work, but there is a chance the ink has something to do with it too.

Inside the Inkpot

The inks you'll find in a modern studio are hopefully a little different to their exotic Asian cousins, although they do share the same basic make-up: the colour pigments that create the actual tattoo are suspended in a carrier fluid that allows for the smooth application of the ink with an even density.

Old-time carrier fluids might indeed have included snake's blood, as well as anything from water and sugar cane juice to – yes – urine. These days, they might be anything from ethyl alcohol, purified water, Listerine, glycerine or witch hazel. Pigments were once all natural but are now overwhelmingly synthetic, although burnt animal fats might be used to create blacks; vegan inks using vegetable dyes are also available.

Other pigments can use metal salts or oxides to create colours – titanium oxide to create white, for example – and it's possible that plastics are also present. In the past, artists would mix their inks from solid pigments and liquid carriers but generally they are now supplied premixed and offer a huge range of colours (up to 180 from some manufacturers); there are even inks for creating blacklight tattoos which only show up under UV light. Groovy, man.

Unknown Inks

The diversity and sophistication of today's inks is a definite bonus to artists and collectors in terms of the art that can be created, but there is a note of

caution to sound: we don't always know what's in them, and we don't know exactly what they are doing to us.

Without over-dramatizing, the simple fact is that ink manufacturers don't always list their ingredients and to date there has never been a comprehensive long-term study of the effects of tattoo pigments on the human body. Research is ongoing and tattooing will, of course, continue no matter what, but it's in everyone's interests to keep an eye on the situation.

Machine Tattooing

The vast majority of tattoo artists and studios operating today use electric tattoo machines to create their art. They might also be referred to as irons, rigs or, occasionally, guns (a term frowned upon by some artists), but essentially these are all different names for the same thing.

The earliest tattoo machines created by O'Reilly actually owe a little of their origins to Thomas Edison's electric pen, patented in the US in 1876 and designed as an office tool for duplicating documents. It was heavy and slow and never quite caught on (maybe it was the jars of acid required to create the batteries for the machine), but O'Reilly recognized its potential application for tattoos and used it as a starting point for his machine.

The first electric machines were crude and cumbersome; Thomas Riley of London created his from the guts of an electric doorbell, which he enclosed in a brass box — the resulting machine was so heavy it had to be supported from an overhead spring. Over time, though, with refining from Riley, Wagner and others, a configuration with twin coils mounted in a small frame arrived, which looked strikingly similar to the machines used in contemporary studios.

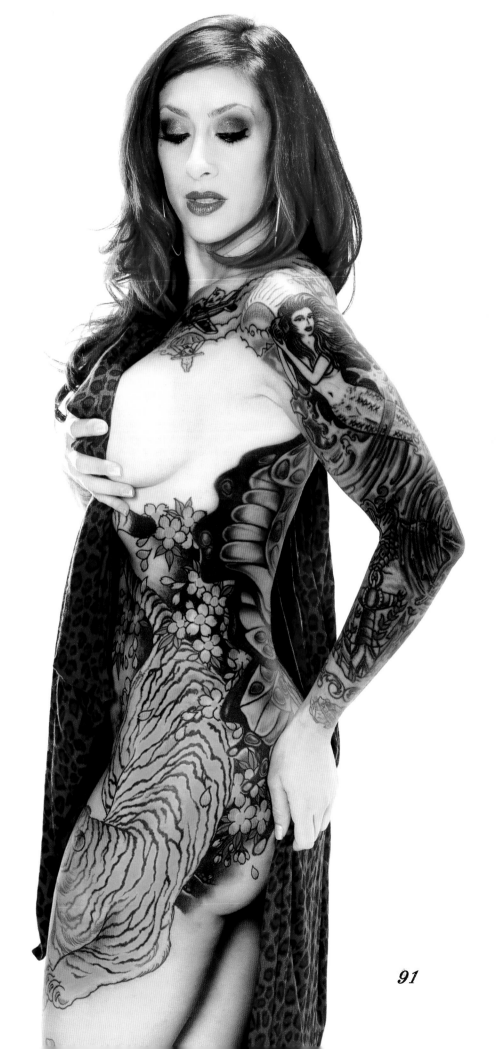

John Anderton

Tattoo Artist

John Anderton has been tattooing for about four years. Some really bad tattoos inspired him to believe that he could do better himself, and although this wasn't true at first, he had already fallen in love with tattooing, and after two months he was offered a spot in a studio.

A self-taught tattoo artist, John believes he has no one particular style; indeed, he chooses to take on a number of different styles of work rather than concentrate on one specific type, because he gets bored easily. He admits to being disorganized and will wait until the day of the tattoo before he does any preparation, and he will only take on work when he thinks he can do a good job. This is also something he admires in others: one of the artists he has been influenced by is Bez

(Triplesix Studios) who, John believes, is able to take on almost any style and do an amazing job. In a similar way, John's ultimate aim when he completes a tattoo is to be able to look at it and know that he could not have done it any better.

For anyone who wants to get involved with tattooing, John's advice is to go and get tattooed. He believes this is the best way to get help or tips from an artist you like, and you get to go home with a cool tattoo at the end of the day!

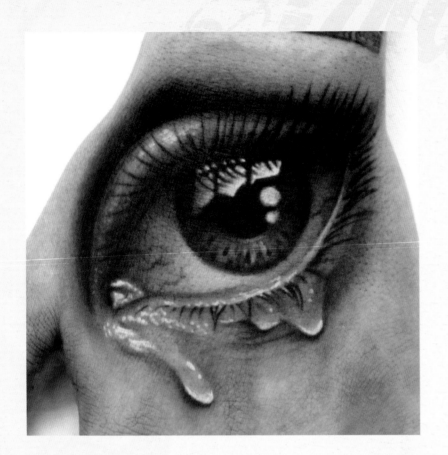

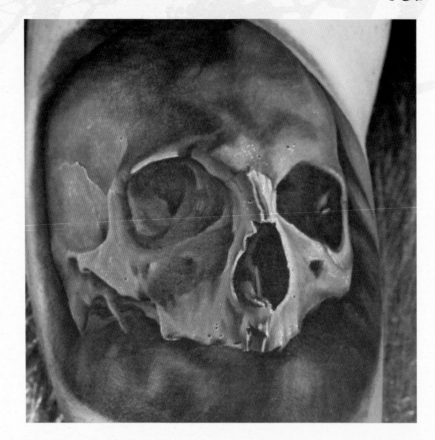

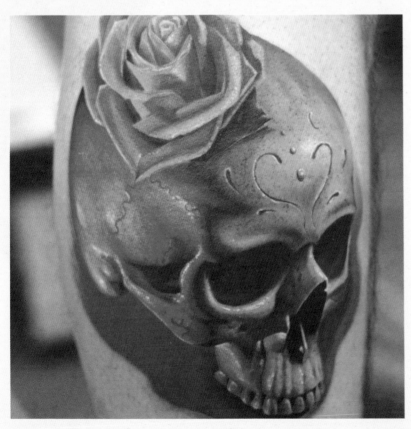

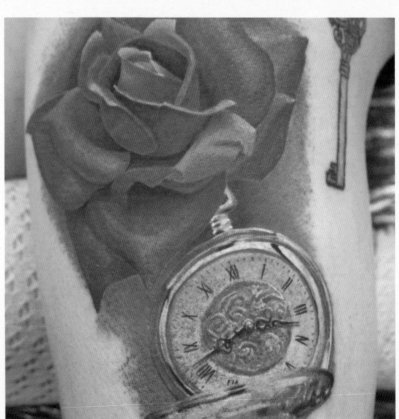

Rules of Attraction

The first rotary machines used an electric motor to drive the needle. In the most common modern setup, though, tattoo machines work their magic thanks to a simple electromagnetic circuit. The twin coils are made up of metal wires wrapped around metal cores and, when a current is applied, they generate a magnetic field, which in turn moves a spring and lever assembly to drive a bar up and down, to which needles are attached; the up-and-down motion allows the needles to puncture the skin.

Every artist will vary their setup slightly, but a standard one generally includes machines for outlining and shading and a power supply (controlled with a foot pedal) that clips to the machines; that's the trailing lead sheathed in plastic you'll see disappearing from sight during your tattoo sitting.

It's a straightforward concept but there is lots of room for tweaks and individual settings. Artists tune their machines to suit their style and the kind of piece on which they are working. You might also see strategically applied elastic bands wrapped around the machine – it's not for decoration (well, not always) but a means of holding the needle-bearing bar snugly against the back of the tube which guides it, giving the machine a smooth action.

Custom Rigs and Compressed Air

As it is the main tool of their trade, artists can take their machines seriously. Like cars, it's possible to buy a showroom model or spend time creating unique custom units; it can be a workmanlike piece of kit or a further expression of an artist's particular aesthetic. Also, artists can opt for a basic durable tool or one that seems to be sculpted from bone and alien skin.

When the designs are chosen with care, tattoos have a power and magic of their own. They decorate the body but they also enhance the soul.

Michelle Delio

Tattoo machines need to be as hygienic as needles and are usually stripped down after a tattoo so that parts can be sterilized in an autoclave along with the tubes — the metal sleeve that fits through the hand grip and guides the needle, also containing a scooped ink reservoir at the tip.

The twin-coiled electromagnetic machine is the industry standard, but there are other options. Evolved versions of rotary machines are on the market and pneumatic machines, powered by compressed air, are also available (and have the advantage of being easy to sterilize in a single piece, without disassembly). They vary strikingly from the twin-coiled machine — the exposed innards and Frankenstein-like oddments are replaced by streamlined single-piece units that weigh less. In some cases, they can switch between air-powered and electric modes, and can look a little like something from *Star Trek* — only without the 'set to stun' option.

Machine-free Tattooing

Considering that the electric machine has only been with us for just over a century, what did artists use before? The answer is: whatever was at hand, really, depending on where they were based. Some museum artefacts suggest that sharpened stones and thorns may even have stepped up as tattoo needles in some cases.

Tahitian, Samoan and other tribal artists used sharpened shells, sharks' teeth and bones as needles, which they embedded in wooden rakes, for example, and then tapped or hammered into the skin. Japanese *tebori* needles and Thai instruments share a similar construction: bamboo poles or short sticks varying slightly in length (the Thai ones are longer) hold the needles and the artist creates the poking action while an assistant stretches the skin taut to facilitate its piercing.

The *uhi* tools for creating the Maori *ta moko* are different again; they act more as a chisel that actively carves furrows into the skin, as well as inserting ink beneath the surface. This process gives the tattoos their distinctive textured appearance (and definitely contributes to how painful they are) and explains the strikingly creased, heavy lines adorning the faces of Maori elders in photos from the early twentieth century.

It's Oh So Quiet

The advent of machine tattooing didn't put an end to the traditional practices and it's still possible to receive tattoos by hand. Artists from Samoa and beyond attend conventions all over the world and give people the chance to receive tattoos in the tribal fashion, albeit without the attendant ceremony (it's generally difficult to get a crowd of people at conventions to sing supportive ritual songs, which is an integral part of the Samoan *pe'a* tattooing process).

The practice of machine-free tattooing is not limited to tribal inking, though, and some modern practitioners (such as Boff Konkerz, *see* pages 12–13) choose only to tattoo by hand using a short stick and needle. The procedure differs in many obvious ways from the machine process and reports of whether it hurts more or less than electric tattooing vary from collector to collector, but one unifying element is the sound – or lack of it – attached to the process. A machine-free tattoo is silent.

This can provoke a few different reactions. Some collectors find the peace and quiet so soothing that they fall asleep during the tattoo; for others, it charges the experience with a kind of spiritual significance and they are aware of an energy transfer between them and the artist, as well as a connection resonating right through the history of tattooing – the earliest tattoos were lines and dots, after all.

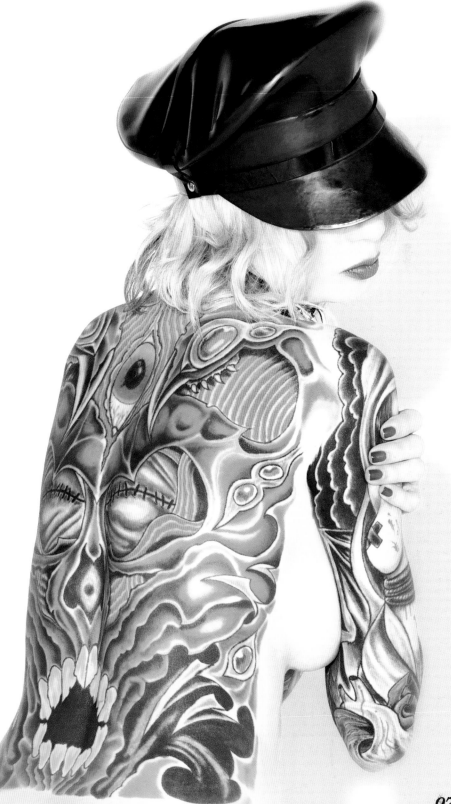

Going Dotty

The possibility of the tattoo process becoming a meditative or spiritual event leads many people to choose a religious, spiritual or mystical subject for their hand-poked tattoo. Without the clattering of an electric instrument nearby to disrupt their thinking, they can focus on the philosophical connotations and faith-based elements of their design as it unfolds on their skin.

Not that this is mandatory — other collectors choose the machine-free route due to its unique appearance or because they simply want to explore a different aspect of tattoo art. Hand-poked tattoos can generally create any kind of design but they often appear as dotwork, which lends itself as much to pointillist-inspired art and abstract geometry as to mantras and lotus flowers.

The process of applying dot outlines and shading without a machine naturally means that it takes longer — the human hand is great for many things but falls short of recreating the several thousand rpm generated by a tattoo machine. Generally, the tattoos stick to black ink and develop their depth and tonal range through the ebb and flow of the dot patterns over the skin. The reductive idea of a complex shape or image that shrinks to individual dots as you examine it, leading the eye (and perhaps the open mind) to new places both distinct and connected to the whole, is just another compelling part of dotwork's appeal.

The Needle

Machine, hand-poked, traditional Thai ... Whatever method a modern artist uses, the needle is going to come into it somewhere. Tattoo

photocredits Photographer: Justice Howard/www.justicehoward.com

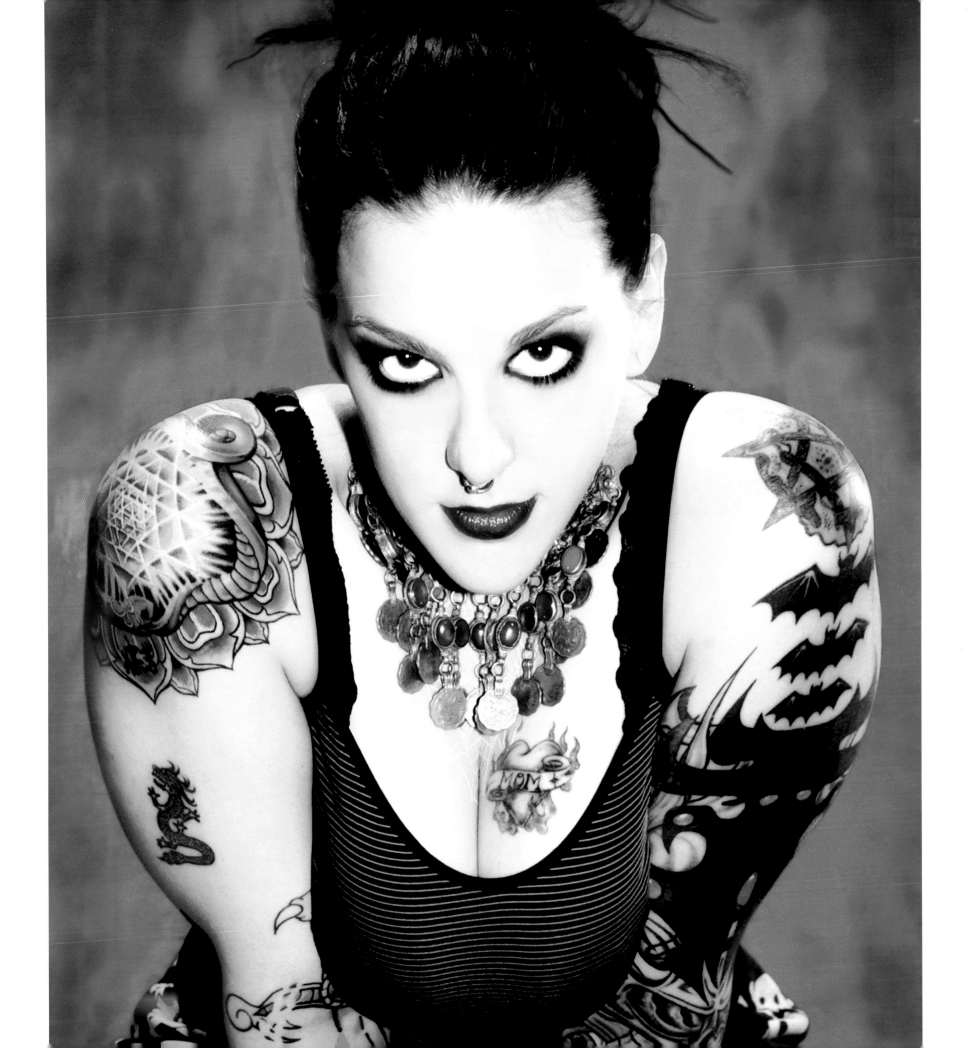

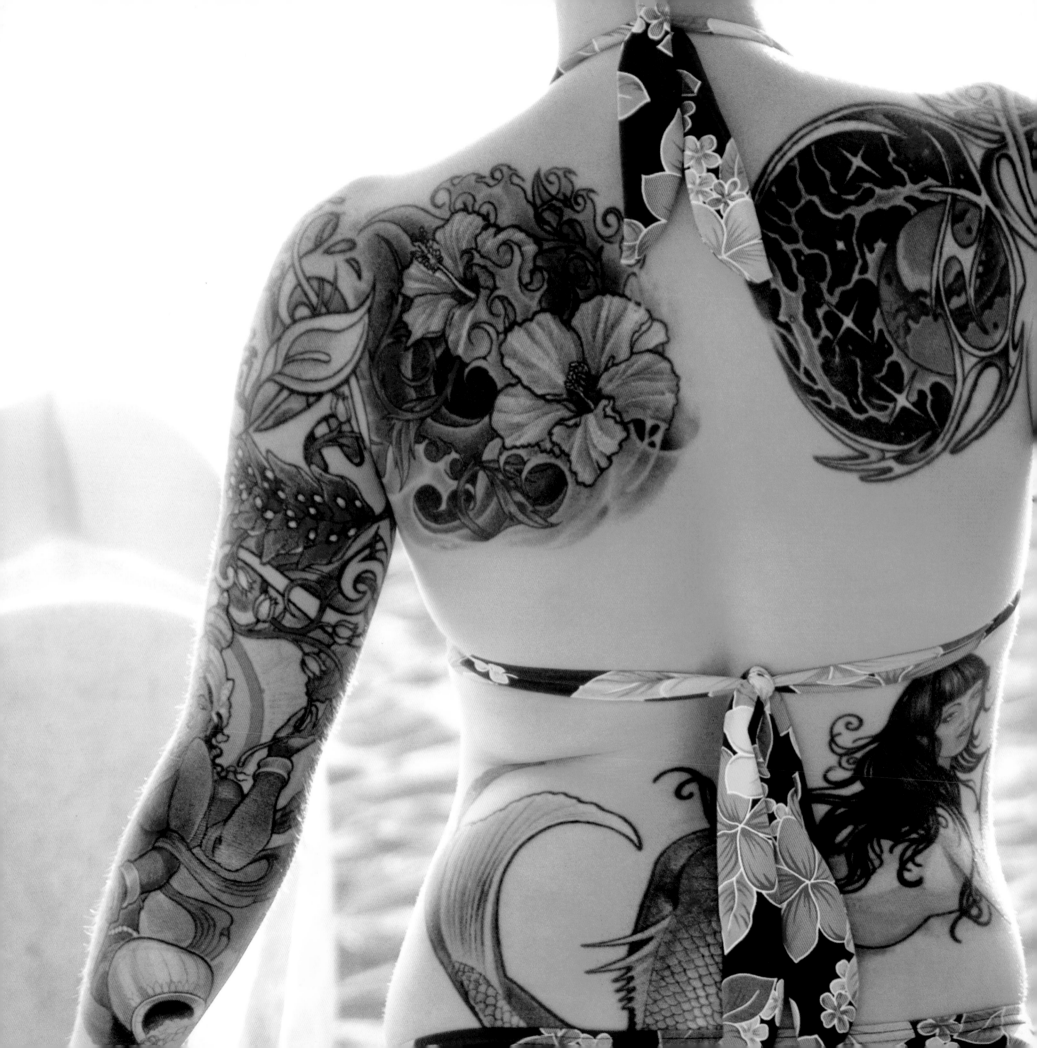

needles aren't hollow like those on hypodermic syringes, as ink isn't injected under the skin. Instead, they are more like paintbrushes that are dipped in ink – the thicker-than-water consistency of tattoo ink helps it adhere to the needles.

Needles fall into two broad categories: those for lining and those for shading. Since they are different shapes and sizes, the machines used to work with them vary too – liner machines tend to be more compact and shading ones might be set at an angle to help work the ink into the skin (as opposed to sitting vertically to create the outlines of the tattoo).

Single needles are used for some tattoos, especially black and grey pieces requiring fine lines, but generally the term 'needle' actually refers to a clump of needles set together on a bar. Liner needles are round, whereas shading ones are flat. Artists have their own preferences as to the exact configuration they use – those working in a New School style and demanding beefy power lines for the black outlines will have more needles in their liner cluster to create a bigger line, for example.

... And the Damage Done

On a tattoo machine, the needles are really working like a combination of a plough and a seed drill – there is an element of tearing the skin, as well as creating multiple punctures. As the needle drags across the skin, it creates a channel beneath the surface for the ink to be 'seeded' in; how noticeable this drag sensation is depends on the setup of the machine.

Since this process is traumatic to the skin, artists have to be careful not to overwork the needle – too much action will create a lot of scarring. This explains the warped appearance of pieces by inexperienced tattooists and is another reason why artists practise off the body first – and why going to a professional tattoo artist is so important.

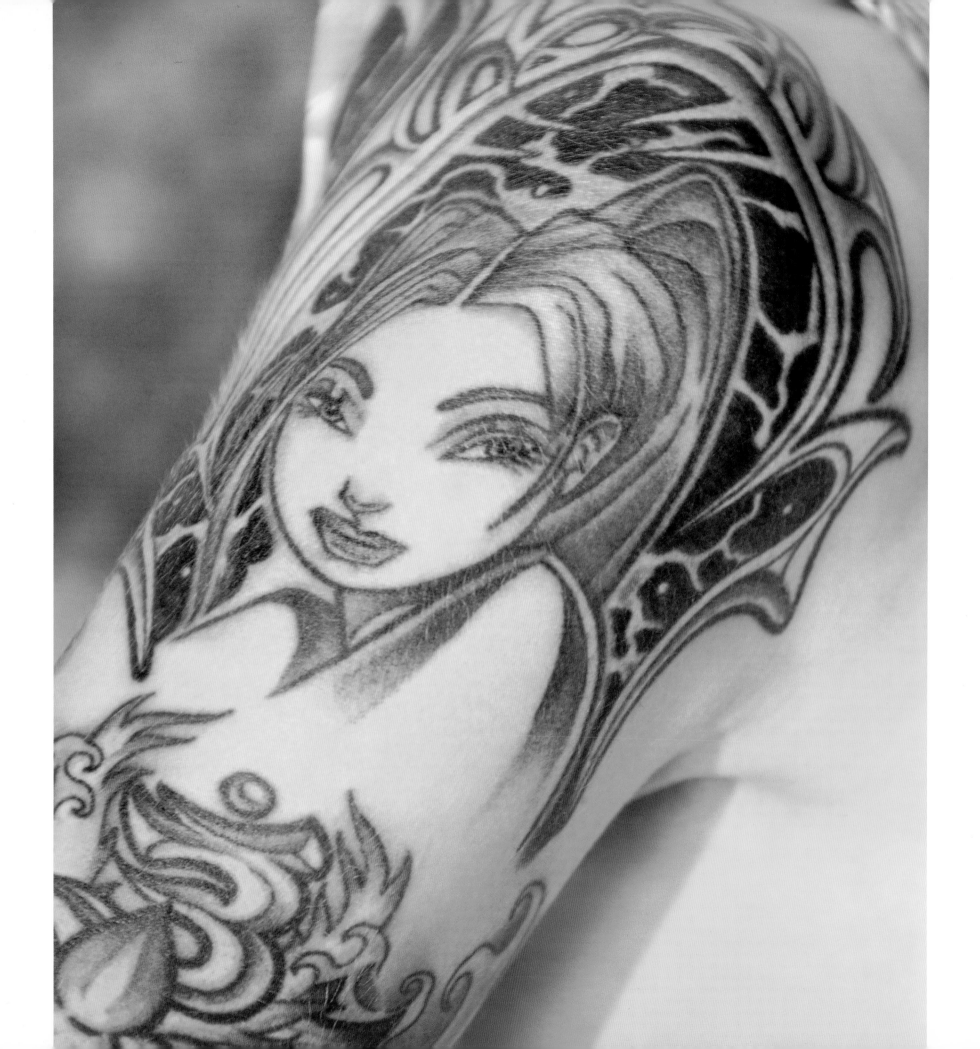

The sensation of being tattooed by a machine is unique but was described by the inked author John Irving as feeling 'like a sunburn' – a simile that does get close to the mark. Machine-free tattooing is slightly different. Each mark is an individual dot created by one poke from the artist, which means there is no dragging motion. Some artists in the field say that this is less traumatic for the skin, meaning faster healing and better tattoos; there is no guarantee it hurts any less, though.

At the Sharp End

Artists used to make their own needles (many still do) and it was an important part of many a tattoo apprenticeship. The process involves soldering individual needles to a metal block attached to a bar, which then clips into the tattoo machine; the single needles might have been bought ready-made or created from steel wire that the artist sharpened.

The practice still goes on (it's an integral part of tattooing for some) but most artists now work with prefabricated needle setups that arrive in sterile blister packs. This has the advantage of speed and lets the client see that a fresh needle is being taken from a sealed pack right in front of them.

It goes without saying that working with needles in an environment where they come into contact with blood and other bodily fluids requires the strictest adherence to health and hygiene rules. A competent artist will be schooled in the risks of cross-contamination and how to minimize them, and will scrupulously sterilize their material and always dispose of their needles in the same way as a medical facility would. Happily, this shouldn't ever be in an issue in any modern studio and getting a tattoo can just be about the art – provided your artist isn't a blind witch, that is.

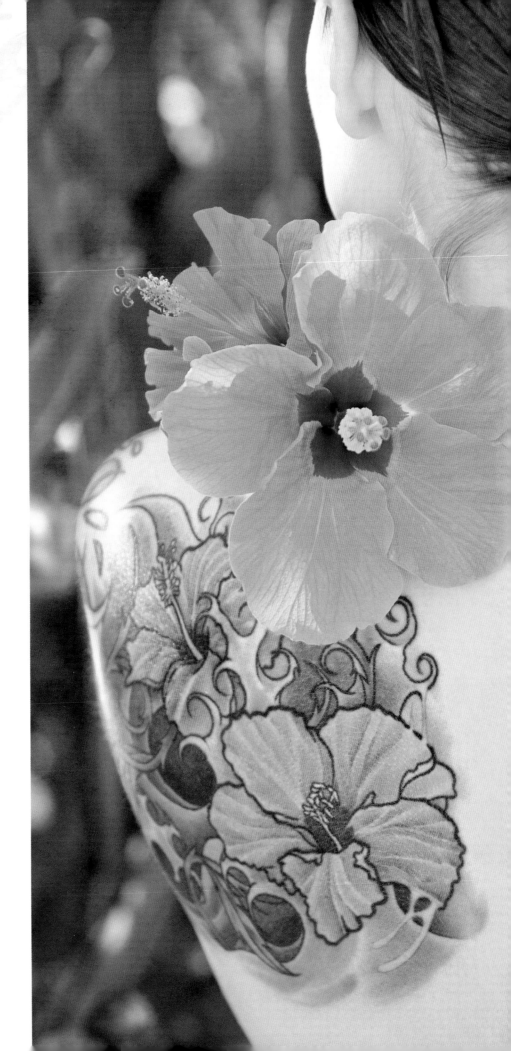

Mark Bode

Tattoo Artist

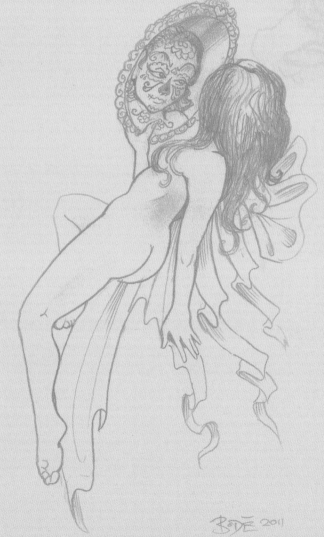

ark Bode is a second-generation comic artist from Utica, New York. His late father Vaugn was one of the pioneers of adult comics in the United States, and has had a huge impact on spray-can culture all over the world. Mark attended The Art School in Oakland, California. He was a Fine Art major at The School of Visual Arts in New York City and studied animation and etching at San Francisco State University. Mark has been lucky enough to make a living from his art all his life, continuing the Bode legacy set forth by his father. Unlike his comic art, which he has been doing professionally since he was a teenager, Mark began spray-can art and tattooing later in his career, and in time has come to embrace both as his own. Mark tells the story of a dream in which his father came to see what he was doing. Looking through Mark's tattoo portfolio, his father exclaimed, "Mark, this isn't on paper", to which Mark replied, "No Dad, that's on people." His father then said, "I never would have thought of doing that with my work!" Mark has been doing custom tattoo work on the human body for over 13 years; he is now tattooing in the greater San Francisco Bay area, California. Mark prides himself on being as versatile an artist as possible, which for him is the key to making a stable and well-rounded living from the arts.

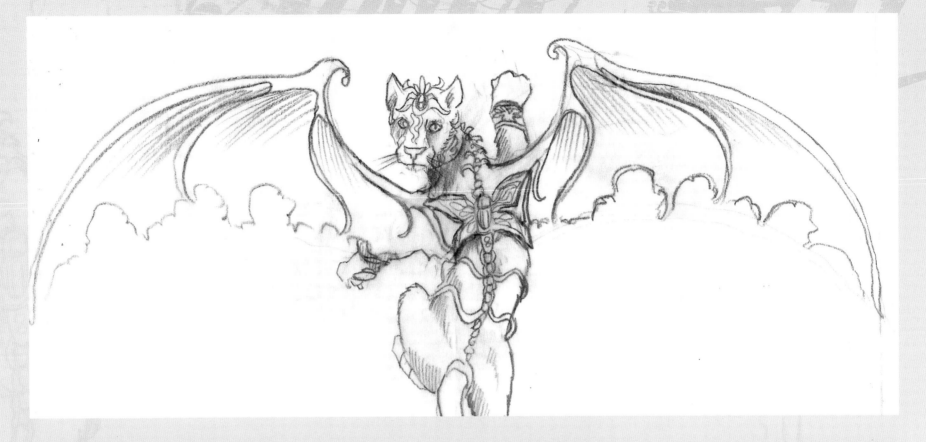

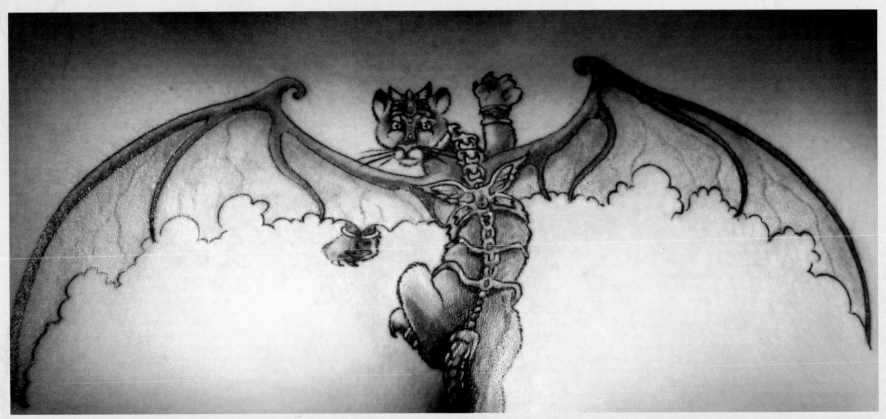

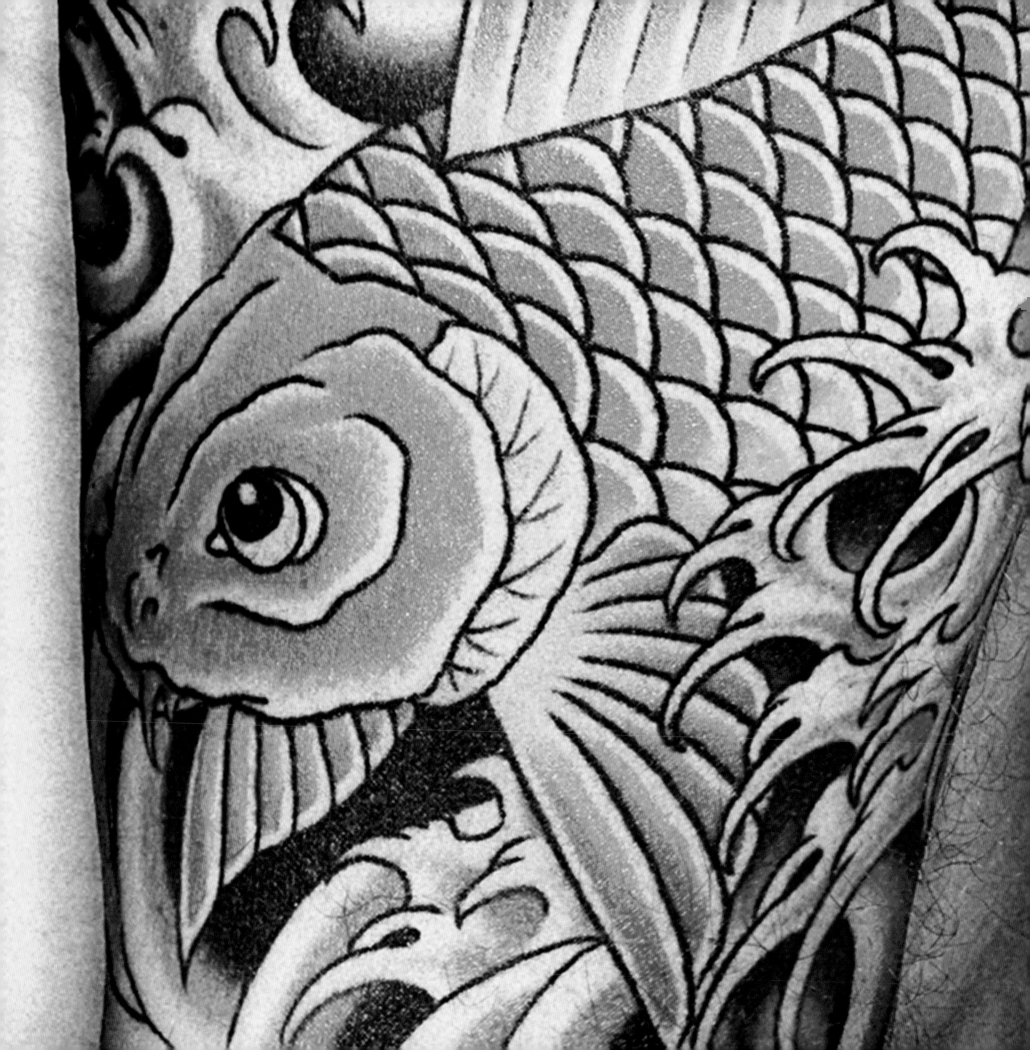

Life Behind the Needle

As the variety of tattoos on these pages suggests, there are a lot of different artists out there with strengths in a wide range of styles. Some specialize, whereas some prefer to be all-rounders working across many different styles.

Artists find their route into the business in just as many ways too, and there is rarely a similar background story between them. But despite that, there are a few common areas they all share, such as the struggle to learn their skills, the constant drive to develop their art and, of course, the one medium with which they all work: the human body.

The Living Canvas

Simply drawing on skin can provide challenges, as anyone who has ever tried hastily to put on eyeliner can attest (you know who you are,

gentlemen). However flowing the lines of the human form might seem to be, they are still full of inconsistencies and irregularities.

This is the challenge of tattooing. Artists begin with a 2-D sketch on a flat piece of paper and must then transfer it to a 3-D surface, while also trying to add extra depth within the image itself and still keeping it in proportion with the frame of the individual they are tattooing, often adapting the design as they go along according to a person's shape. Strangely, not everyone gets it right first time.

Art That Moves You

On top of that, there is the fact that people tend not to remain as still as a canvas mounted on an easel – particularly not when they are being repeatedly jabbed by a sharp needle buzzing at 2000 rpm and beyond.

photocredits Photographer: Brian Cummings Photography/www.briancummings.com

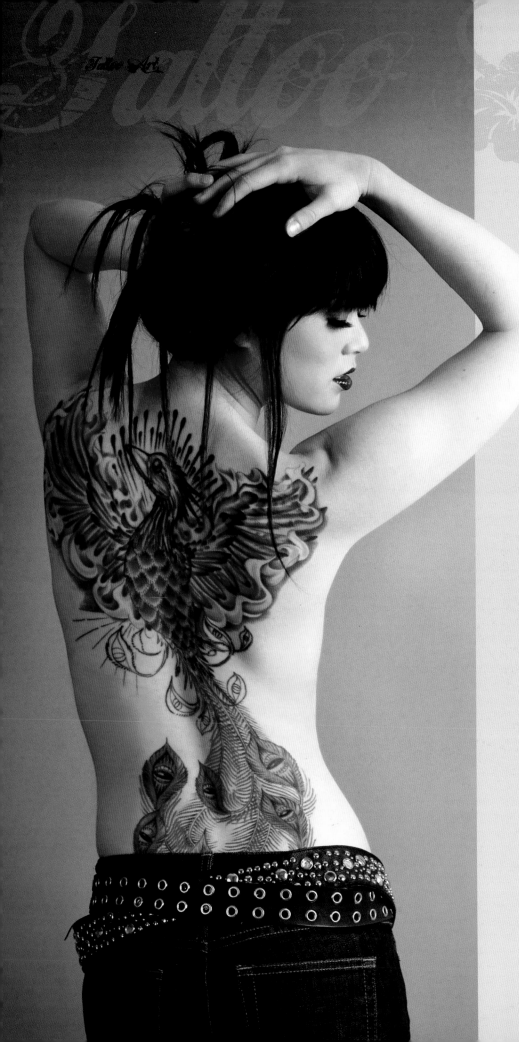

However good a person might be at sitting for their tattoo (and there is no guarantee when it comes to who will take it well and who won't), there is always going to be some movement to contend with, so artists need a deft touch and sometimes fast reactions to whip the needle away when an unexpected sneeze arrives – it's either that or have a stray black outline zipping away across the skin.

Back in Black

Another consideration is the nature of the canvas itself; humanity comes in a range of colours, after all. There is sometimes confusion as to whether it's possible to tattoo black skin, or whether colour can be added – but of course the mechanics are the same and it's entirely possible. The difference might lie in the way the ink is applied and the way colours work and blend within black skin; as the blank canvas is different, colour applied to it will behave differently, so the way artists work with colour pigments might vary between skin types. It just requires a little adjustment as the tattoo is created.

Mightier than the Sword

Before any of these considerations come into play, though, there has to be the initial design. For a lot of artists, the absolute, fundamental core of their tattooing – and the art form as a whole – lies in the ability to draw. Speak to tattoo artists, watch them when they are not tattooing, follow them home (maybe not that one) and you'll often see that, for them, downtime means drawing time.

Many artists will tell you that drawing is just something they have always done, from a young age. Irrespective of their career path or life up until they picked up a machine, the pen and the pencil have been their

greatest allies and usually remain so. It's the proving ground of their artistic ability, the place to try out new ideas, a comfort ... or just something they really get a kick out of. It's not their job; it's their passion.

That's why, in a great many cases, the first bit of advice an established pro will give to an aspiring artist is to make sure their drawing and draftsmanship are up to scratch. You might work with a stencil when you're tattooing, but if it rubs off and you can't draw well enough to fix it ... Well, there may be trouble ahead.

Straight onto the Skin

The other skill some artists develop is the knack of creating designs straight on to the skin. This is particularly handy if, as above, a stencil comes out badly or rubs away during the tattooing process.

But it's also useful if the client is well built — applying a stencil to a professional athlete standing at 6' 5" with arms the size of most people's legs, for example, is going to be time-consuming. Instead, the artist might grab a ballpoint pen and spool the design out right on to the skin, either copying an image or going from scratch — but again, the underlying skill is being sharp on the draw.

The Art of Flash

Flash has always been instrumental to the art of tattooing, allowing artists to create pieces quickly, on demand, for walk-in clients. A flash set that is bought in (there are flash artists who specialize in creating these sets) usually consists of at least two parts: the colour image that is displayed in the store for clients to choose and a separate line version of the image for artists to use as a stencil.

Right Anna Maltseva/Shutterstock Images LLC

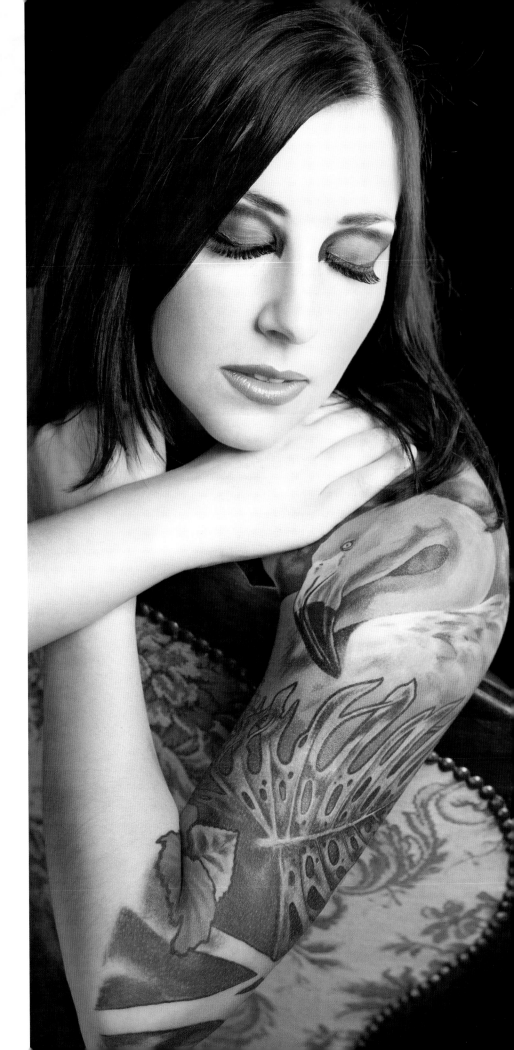

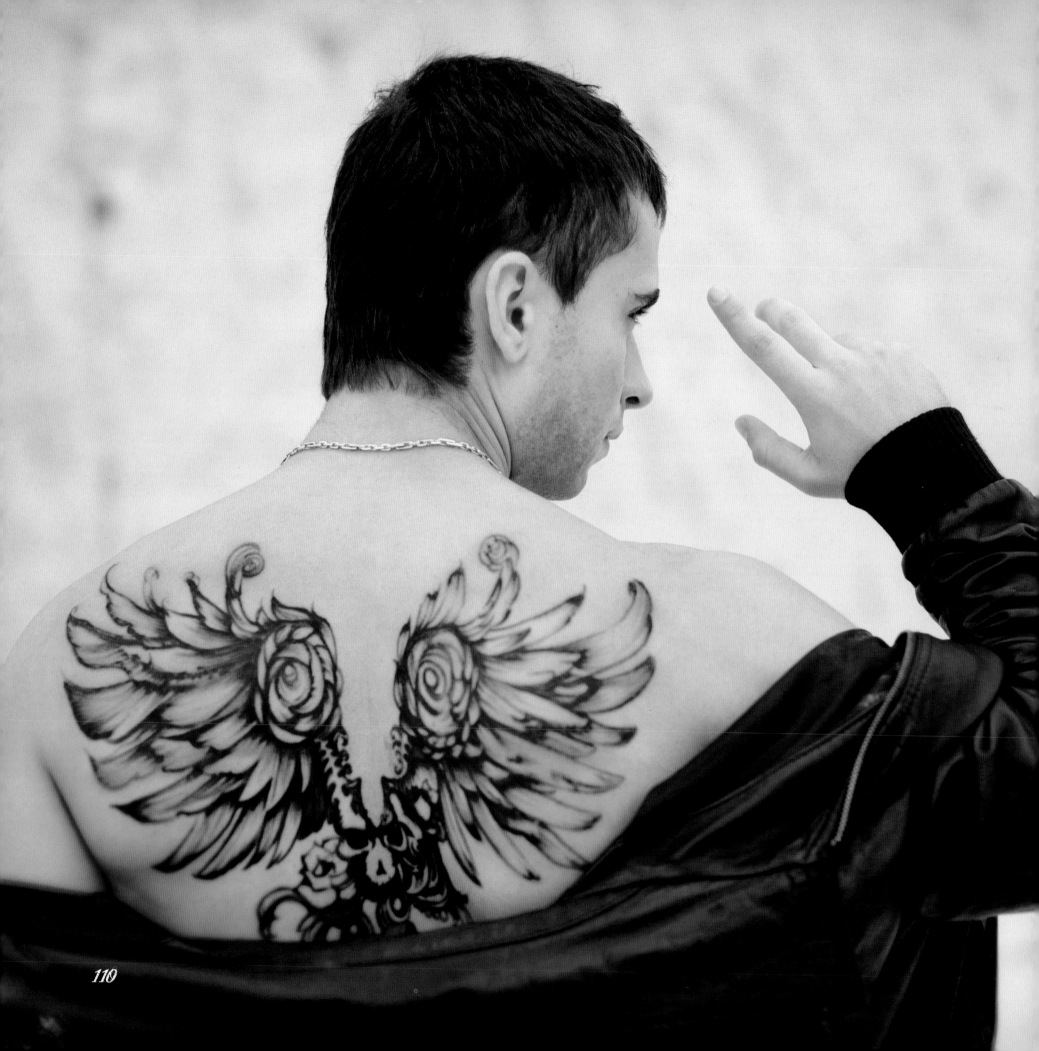

There is also flash that artists in a studio create themselves, following a similar pattern, and the pieces that they draw up for clients who request custom artwork (which is increasingly the standard practice).

DIY Decor

Beyond its practical value to the practitioner, individual pieces of tattoo flash and custom drawings also have an aesthetic appeal, and once they have been turned into a tattoo they might become a living part of the artist's studio (Ed Hardy for one claims to still have every piece of flash he ever created). Choice pieces are displayed around their station and become reminders of great work well done that contribute subtly to the emotional furniture of a shop like a hand-drawn photo album; each drawing has a potentially memorable story attached to it or it might go on to inspire further work. It's all part of the slowly accumulated artistic archaeology of a tattoo studio and one of the things that makes them such interesting, varied and personal spaces.

Skills to Pay the Bills

However, before an artist can begin the process of accretion that will gather together all of their past art, tools, personal mascots and other paraphernalia into a definable body of work, there is the long and winding road of picking up the skills to let them do it.

Modern tattooing is almost unique in that it can still reflect the employment and training practices of medieval guilds and craftsmen. That is, a young worker wanting to make their way in the industry needs to find an apprenticeship — and there is no official body, entrance exam, secret handshake or indeed any other process that will help them find it.

Some established artists tell lurid tales about their experiences making needles, cleaning tattoo tubes, sweeping floors and generally living the life of the underdog for years before even so much as being allowed to look directly at a tattoo machine. They may, or may not, be exaggerating. Others describe a more collaborative process where an artist recognized talent in their drawings and took them under their wing, mentoring them and getting them ready to start working in their shop.

There is no fixed route to getting either an apprenticeship or that first seat in a studio. All you can do is work hard, hang out in tattoo studios, watch and learn, and hope for some luck.

The Fortunate Few

At least, that's how it goes for some artists. The apprenticeship route is well established within tattoo custom but there is rarely a one-size-fits-all option (you certainly can't take a class at college) and it's far from the only way into the industry. Some artists are purely self-taught and claw their way into the business through sheer dogged determination. Others never plan to tattoo as a career and are steered into it through friends who like their art (back to the importance of drawing again) or sometimes even by artists who encourage them to take up the needle after seeing one of their pieces when they go to get it tattooed.

Friends Like These

As to the mechanics of tattooing and working out how to do it ... Well, it's surprising how many good and trusting friends and family seem to be required in the early stages. There is the moral support that they can provide but, even more importantly for the fledgling artist, they can provide their skin. It's remarkable how many artists talk about creating

Tattoo Art

their first pieces of work on trusting buddies – without those willing volunteers, some current practitioners might never have taken those first passes of the needle towards becoming professional tattoo artists. (Whether the first pieces are any good or not is another matter entirely.)

A different path in the 'physician heal thyself' mould is sometimes taken by those who experiment on themselves – at least the risk of breaking up a friendship thanks to a terrible tattoo is reduced, although creating a balanced piece is somewhat more difficult without significant contortions. Ultimately, scratching on to friends or yourself is no substitute for training under the supervision of an experienced registered artist with an expert grasp of the tattooing process.

To spare anyone's flesh from scarring, or worse, there are other inert objects that do their time in the service of honing the craft while an artist learns. Synthetic practice skin is available and pig skin can be a practical – albeit macabre – choice thanks to its similarities to human flesh (our porcine pals get sunburn just like we do). For those who prefer the vegetarian alternative, the humble grapefruit serves just as well – and even makes for a healthy breakfast afterwards.

Bye-bye Needle, Hello Paintbrush

When they are not creating tattoo art on clients (or citrus fruit), some artists find another creative outlet in painting. It might bear no relation to the work they create in their day job or

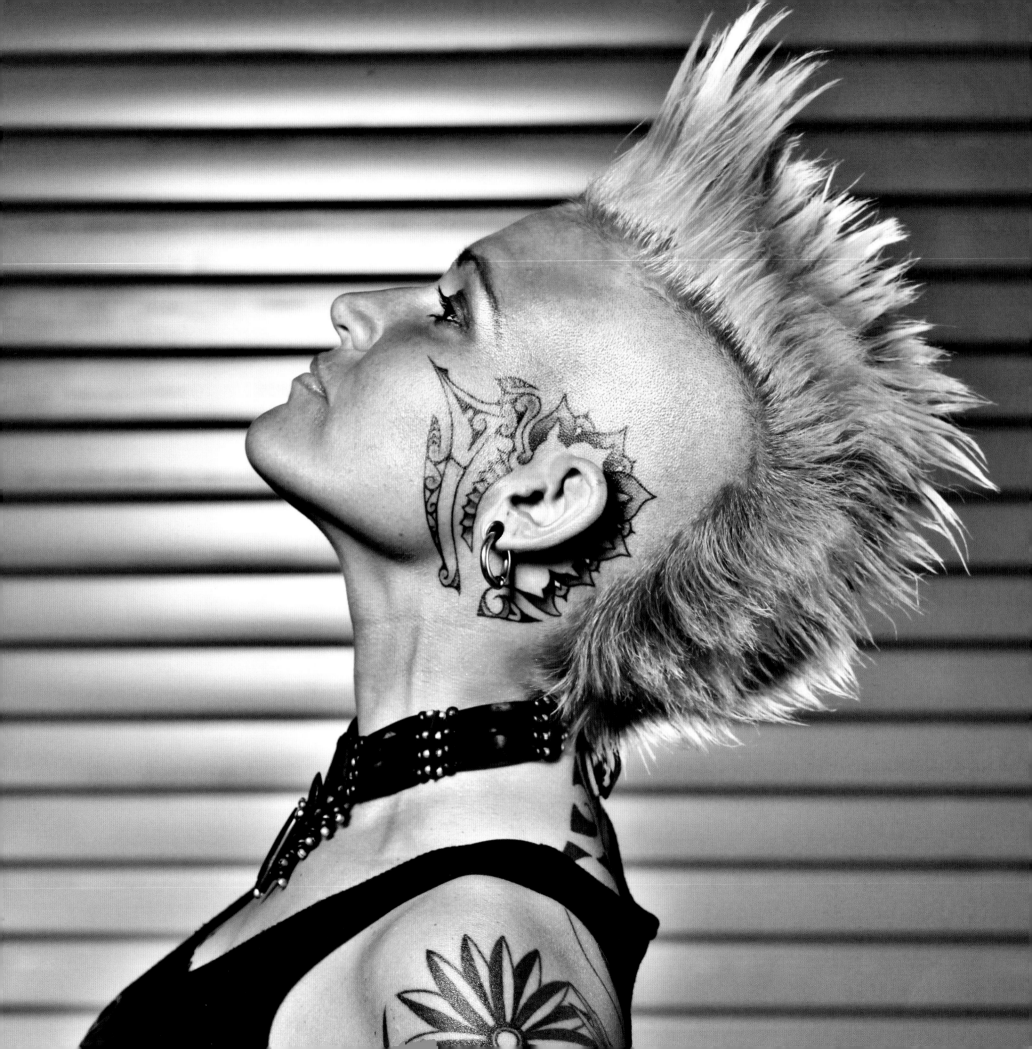

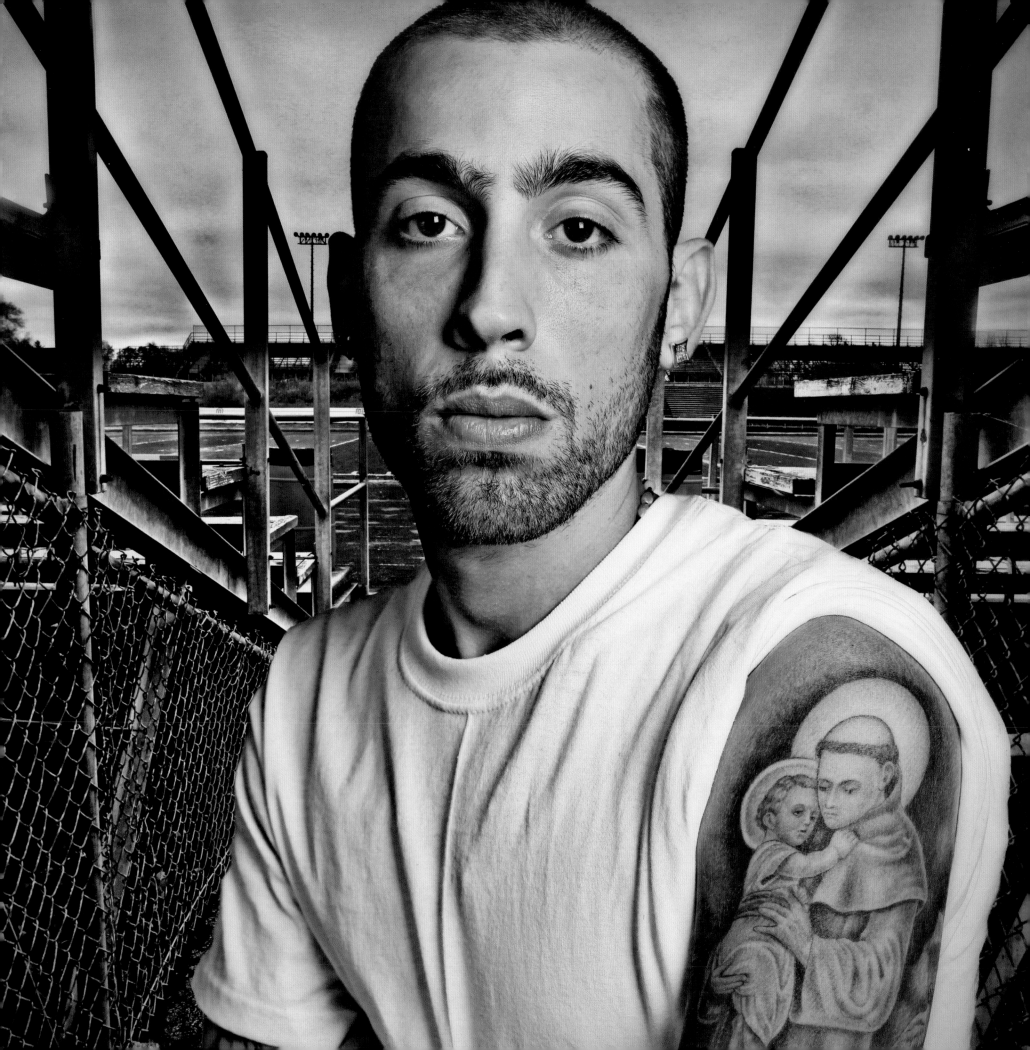

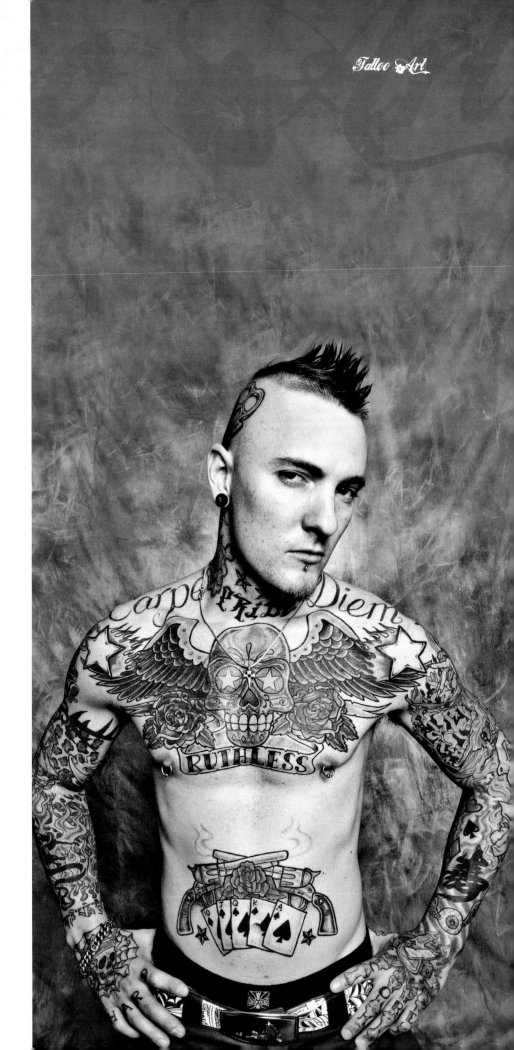

it could be an extension of their craft into a different medium, using painting as a way to explore new techniques and imagery to bring back into their tattooing. Or it might just be fun.

In interviews, many artists who work on art off the skin suggest that a good reason for doing it is that the art remains personal to them. It's a chance to create an image purely for themselves, as even the most open-minded client is still inevitably commissioning them for a piece. With painting, it's a purely indulgent act of creation and expression.

As with everything else in tattooing, the paintings and illustrations created by artists are now becoming more sought after and interest in them is rising. A few interesting names to investigate include Grime and Nick Chaboya (both create brooding, gothic oil vignettes), Guil Zekri (flowing surrealism), Shawn Barber (kinetic, moodily lit oil work), Matthew J. Hockaday (erotica with occasional mythic overtones) and Claire Reid (dark, dynamic expressionism).

Escher's Hands

There is a popular drawing by the Dutch artist M.C. Escher of two hands, each drawing the other in an infinite loop. It's a popular tattoo and a memorable visual metaphor for the idea of art creating art and the interconnectedness of creativity.

It's a concept that has always been important in the tattoo world. Gothic and Old English typefaces or the old sideshow script of Barnum-era circuses have informed plenty of tattoo text, for example, and conversely the appearance of some freehanded tattoo script has caught on in contemporary fashion. The origins of Japanese tattoos were woodblocks; now Japanese tattoo art itself is highly collectable.

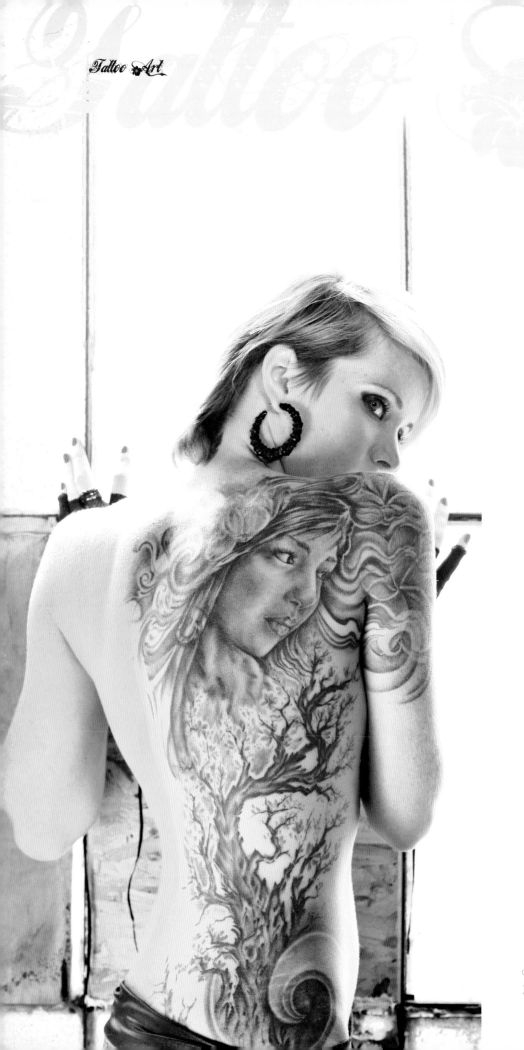

In short, graphic design and art have long inspired tattoos and, to return the favour, the influences of tattoo art can now be seen throughout popular culture in more places than dedicated tattoo magazines. For instance, album cover art provides many examples of tattoo-inspired graphic design, often in the Old School Americana style, on seminal works such as the Grateful Dead's *American Beauty* or bluesman Rory Gallagher's *Tattoo*. Payback has come via the horror art of many metal and hard rock bands over the years – Iron Maiden's mascot Eddie is the star of many metal fans' tattoos.

Two-way Street

People have found artistic inspiration for their tattoos in many places. Complete back pieces featuring Renaissance masters' takes on *The Last Supper* are more common than you might think, and artists themselves feature heavily as well – a grinning Dali head (green, with splendid moustache, of course) has become a tattoo trope in its own right.

More contemporary versions might include the fantasy art of Anne Stokes, which features characters from folklore, as well as legendary beasts, and has been turned into ink by fans all over the world. Likewise, even the mind-bending surrealist propaganda springing from the mind of Alex Gross and the sultry kohl-eyed suicide girls glowering from the paintings of Brian Viveros are popular touchstones.

Pop culture and fashion are full of references to tattoo art, and vice versa; temporary tattoos even walk down the catwalks of Milan. On the high street, T-shirts, bags and every imaginable kind of accessory have all been tapped by the commercial Midas touch of Ed Hardy's traditional tattoo imagery. Tattoos also feature regularly in high-profile advertising campaigns and some fashionistas take their brand fetish to the ultimate level by having the logo inked on. Lacoste crocodiles, Wrangler and Levi patches ... They are all out there on someone's skin.

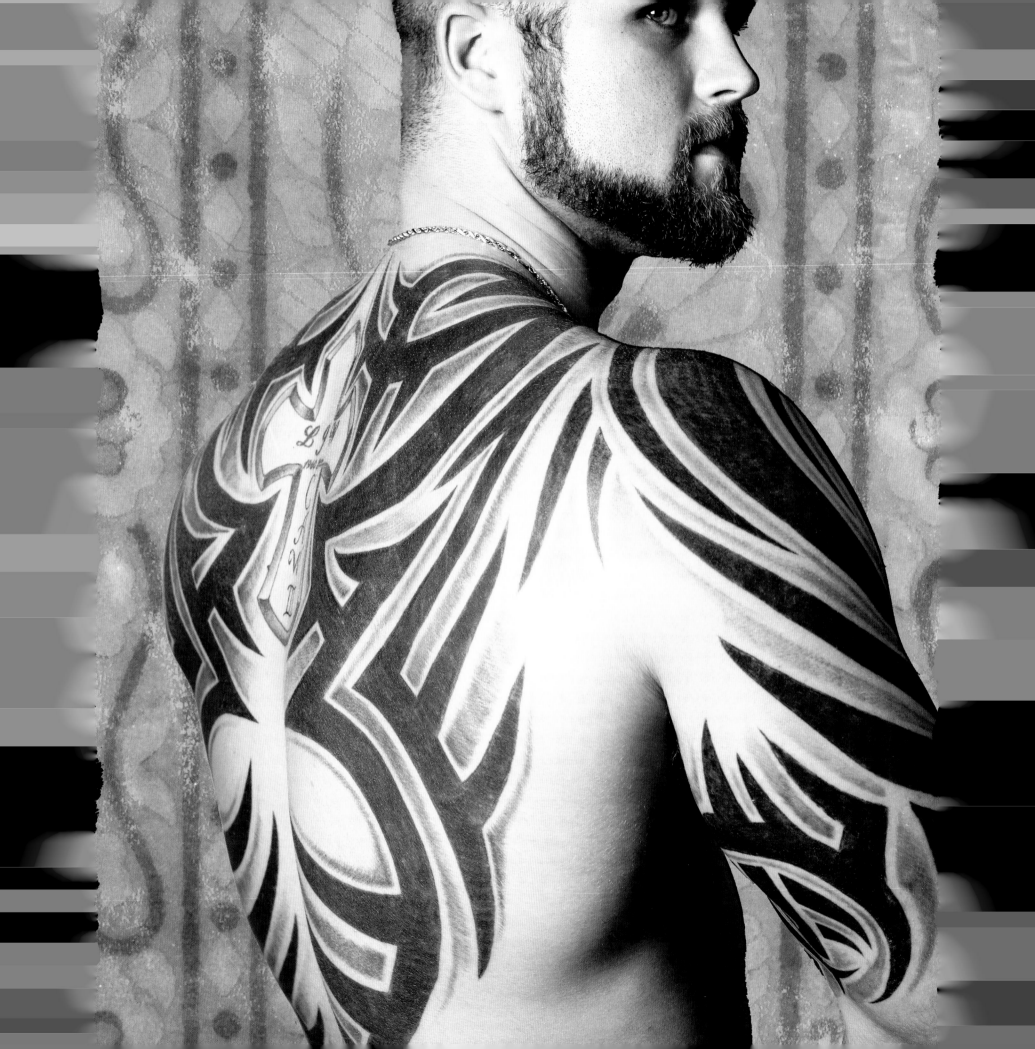

Street Level

Slightly further downriver from the mainstream feeding frenzy, there is the world of artists such as Ellen Greene – with her subversive glove art sports mischievously skewed versions of Old School images – and any number of street artists (Shepard Fairey and Banksy, of course, but many more anonymous artists whose work is simply spotted and photographed) who both nurture and take nourishment from the tattoo scene. The constantly circling consequences of the 'Escher's hands' effect mean that, right now, it's always possible to wear, carry and spot tattoo art without ever needing to be tattooed and to contribute to the cycle with your own body art.

The Artists

Tattooing is wildly subjective. Some people stick to a strict diet of black and grey – no frills, no colour – whereas for others, that would be a short cut to a monochrome migraine. You could be all about the Old School or only interested in trad Japanese.

That means there is no point in trying to isolate the 'best' tattoo artist or artists in the world today; it depends very much on the eye of the beholder. Plus, there is always someone new to discover, creating newer and bolder art. Instead, here is an introduction to just a few great artists working now – and an occasional nod to the past masters who inspired them – as a jumping-off point.

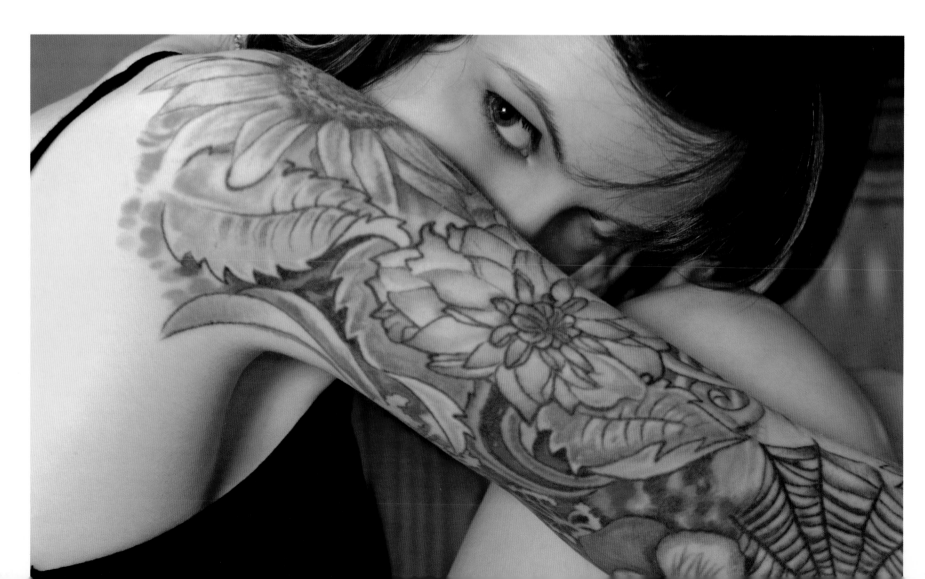

Old School

Past Master: Gib 'Tatts' Thomas

A traditional tattoo artist so Old School that he is generally credited with showing Norman 'Sailor Jerry' Collins the ropes when it came to machine tattooing in the 1920s, Thomas plied his trade in Chicago for much of his career. Prior to that, he is believed to have travelled extensively and his flash art is full of nautical influences: swallows and daggers that you might expect, along with Japanese elements. Perhaps even more arresting than his art are some of his advertisements, which proclaimed his ability to restore eye pigment colour using his tattoo equipment; it's not known whether anyone ever took him up on that one.

Present Practitioners

Marija Ripley: working out of the Sailor's Grave studio in Copenhagen, Marija specializes in pin-ups and – more specifically – mermaids. Her super-traditional art combines the allure of the sirens but also their terrible beauty, often featuring skulls and little reminders of death just beneath the surface.

Steve Byrne: based in Austin's Rock of Ages, Steve is an Englishman who specializes in thick-lined, traditional tattoos that don't conform to standard Americana conventions. He brings in European influences and occasional dashes of the macabre to give his work a truly unique feel.

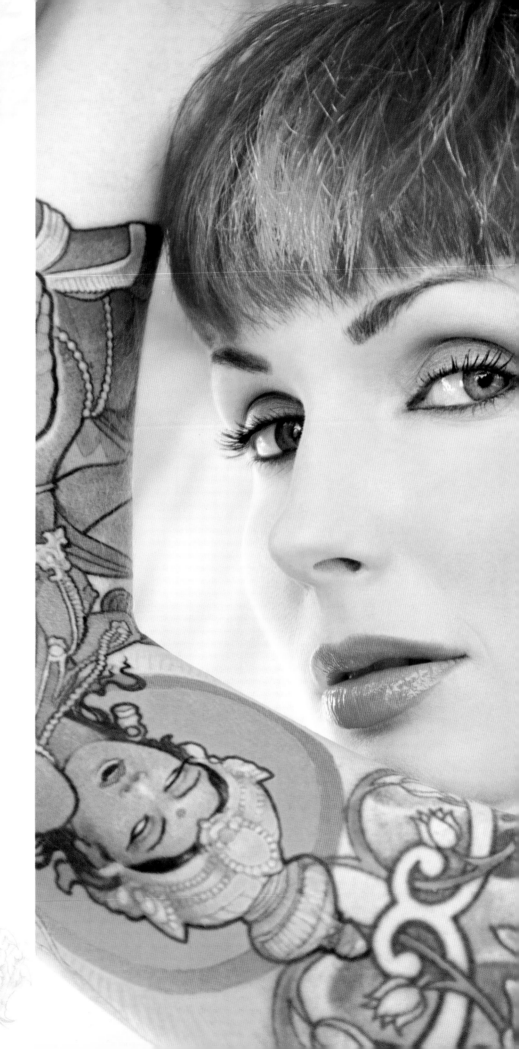

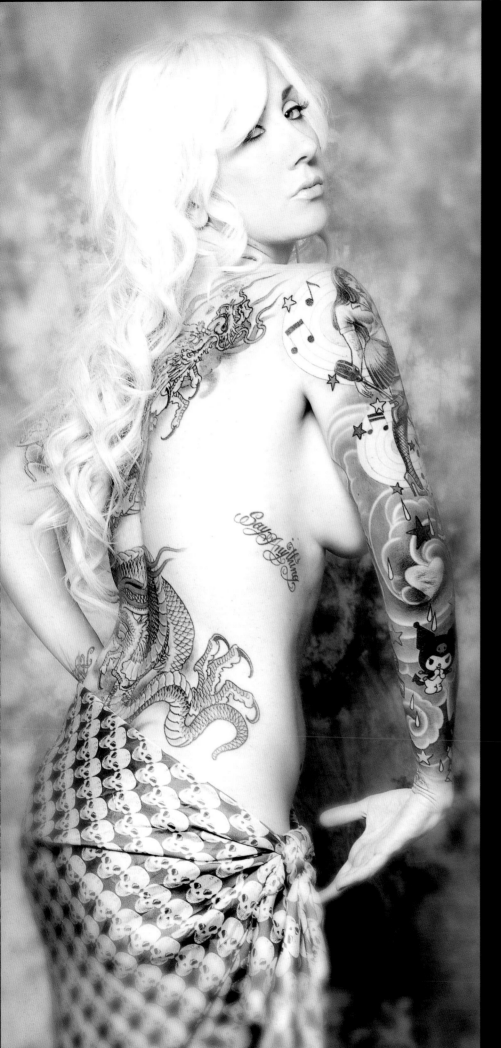

Miss Arianna: the Italian-born and based mistress of the traditional goes in for bold swathes of black shading and full-fat colours, with the clunky but clear construction of the truly Old School tattoo style. Her work features strong backgrounds, deep reds and images that get straight to the point.

Joey Ortega: with a style that embraces traditional Americana and blends it with some softer elements, Joey's clientele at Triple Crown Tattoo in Austin, Texas, is weighted towards the female side. His work is bold but with delicate shading, giving it a subtle, slightly ethereal look.

New School

It's called New School for a reason: the *enfant terrible* of tattooing is still so box-fresh that even the originators of the style are still developing their work. Here are a few artists making brightly coloured waves on the scene at the moment.

Joe Capobianco: larger than life and with a splendid quiff to boot, Joe is all about the ladies. Pin-up ladies, that is, created in his inimitable style from Hope Gallery Tattoo, Connecticut. Big-eyed beauties, his girls are so recognizable that they have their own sub-category: Capo Girls.

Gunnar: based at High Street Tattoo in Columbus, Ohio, Gunnar wears his Dali influences on his sleeve. Well, his clients wear it on theirs. A quirky cocktail of cute and creepy, his wide-eyed, toy-like images have the eerie charm of some kids' TV shows: endearing and unnerving at the same time.

Leah Moule: from her Spear Studio base in Birmingham, England, Leah crafts cupcakes and sweet treats with monstrous outlines and huge blasts of neon colour. There is a certain cheeriness to her tattooing, whatever the subject: the skulls and cherries alike are sure to bring a smile to anyone's face.

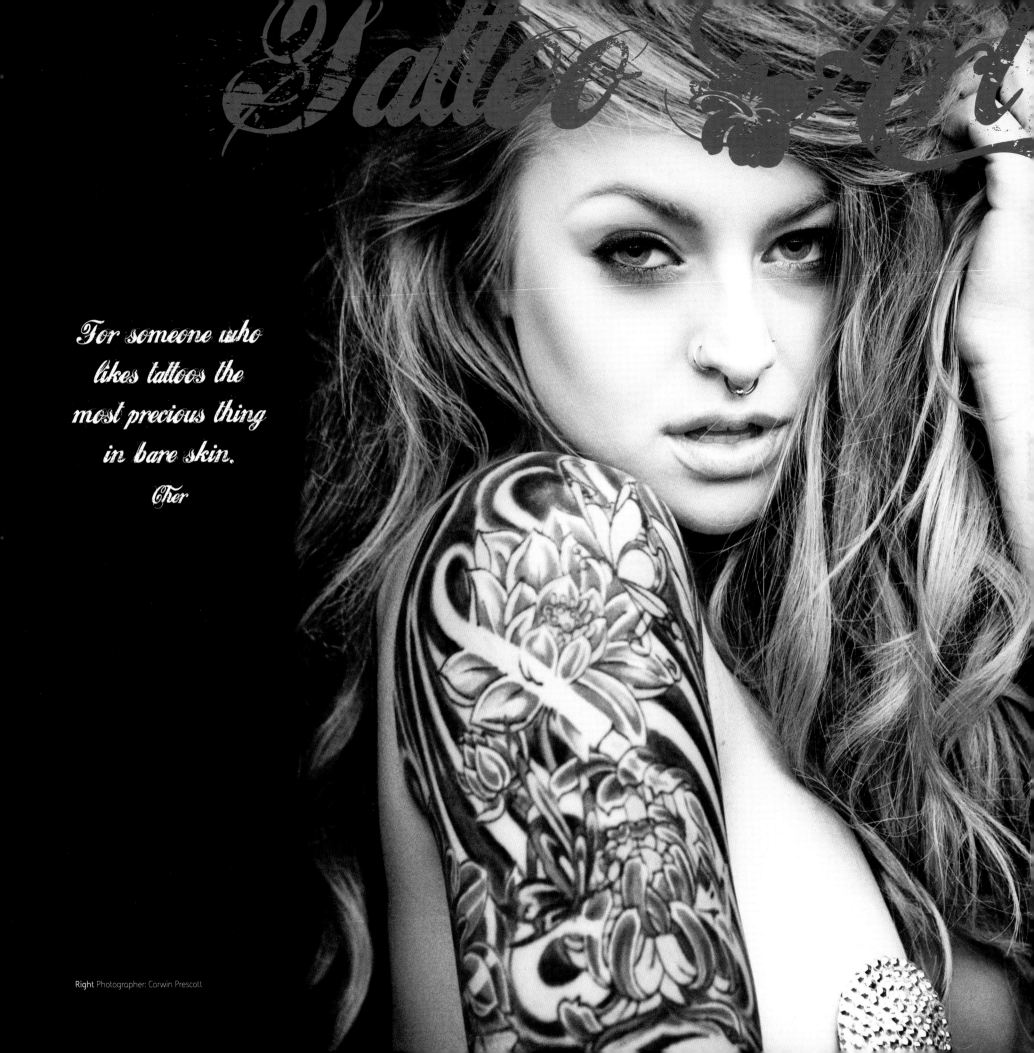

For someone who likes tattoos the most precious thing in bare skin.

Cher

Right Photographer: Corwin Prescott

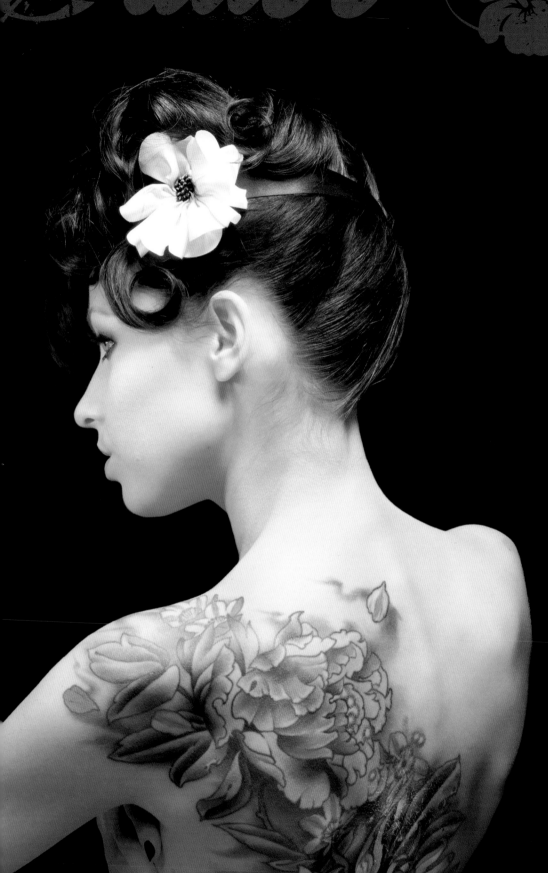

Dave Fox (*see* pages 26–27) : Philadelphia's Black Vulture Gallery is home to Dave, one of those artists who just has a hard time with paper and gets straight to work on skin. The result? Lunatic animal mashups (lions and tigers and bears, O my!), woozy skulls and a colour palette that positively vibrates off the skin.

Matt Difa: Matt cranks out his New School work from the Jolie Rouge studio in London. It's not his only style but when he does turn to it, there is a gentle sci-fi psychedelia to the end results: cartoony creations drifting in space against a backdrop of interstellar sweeties and some curious-looking pills.

Biomechanical

Past Master: H.R. Giger

The man with aliens on the brain isn't strictly a tattoo artist but his role in this part of the tattooing story is so vital that it's worth investigating him a little bit. In his own words (from his official website), his work is centred around a 'Biomechanical aesthetic, a dialectic between man and machine, representing a universe at once disturbing and sublime.' It's that vision that helped lead him towards an Academy Award for his work on the production design of the first *Alien* movie, and it's a vision that many artists in this school share. Educated in architecture and industrial design (at Zurich's School of Applied Art), his work fuses brute mechanics and fluid organic forms and has swarmed all over the world – there are several Giger bars and museum, dedicated to his work in Gruyères, Switzerland.

Present Practitioners
Guy Aitchison (*see* pages 38–39): the big daddy of biomech operates from Hyperspace studios in Illinois and tailors his work carefully to each client, even suggesting a more appropriate artist if

he feels he might not be suited to the job. Originally much more mechanized, his work has become increasingly natural looking, incorporating both floral and fractal elements.

Michele Wortman (*see* pages 132–133): also based at Hyperspace, Michele's art draws heavily on the natural world to produce cascades of blooms and free-flowing pastel colours without a hint of the darkness than can inhabit some corners of this style. Instead, her work veers more towards Giger's vision of the 'sublime'.

Nick Baxter: another maverick, Nick achieves astonishing degrees of depth and texture with his colour work. Independently, he occupies an area on the bio-organic edge, creating extraterrestrial flowers bursting from saturated green mulch or leaves collapsing into pixellated digital mayhem, along with the odd dinosaur and deep-rooted allegorical piece.

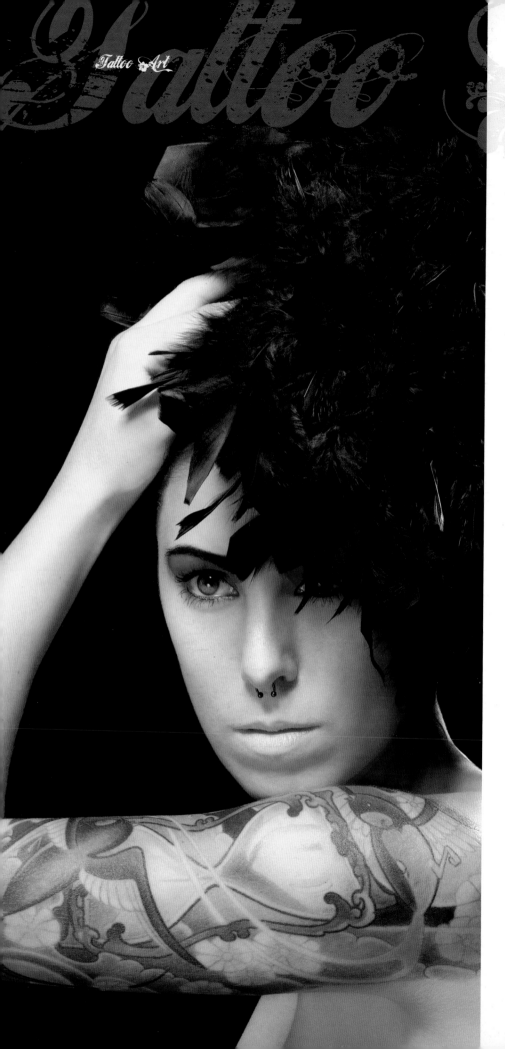

Tribal and Blackwork

It's tricky to pin down a past master from the entire bloodline of tattooing as an art form and, given that that's pretty much what tribal tattooing represents, it's probably futile to try. That said, it's encouraging to know that the work of artists such as Sua Sulu'ape Paulo II (who died in 1999) and his brother Su'a Sulu'ape Petelo – both master Samoan tattooists (*tufuga ta tatau*) from a highly regarded tattooing family – is still esteemed throughout the world and spotlights the ongoing relevance of traditional tattooing methods and meanings to modern society.

Present Practitioners

Alex Binnie: anyone wanting an extraordinary take on tribal should encounter Alex's art, born at his Into You studio in London. Bold and brave, with elements of different tribal forms and Japanese aesthetics melted in as well, his pieces win global acclaim for good reason.

Xed Le Head: not afraid to let his tribal work wander into the spiritual or mystic realm, Xed Le Head's enigmatic reputation usually precedes him. Whether or not that affects the appreciation of his tattoos is another thing, but from London's Divine Canvas he creates intricate and sometimes baffling work full of detail and contrast that can have a hypnotic quality.

Pat Fish (*see* pages 170–171): she may work out of Santa Barbara Tattoo in California but Pat's bloodline is resolutely Celtic and goes back to Pictish warriors, which may account for the popularity of her Celtic tribal work and the way it resonates with collectors. Often inspired by the remains of tribal art, her pieces carry plenty of weaved detail and something of the quality of illuminated medieval manuscripts.

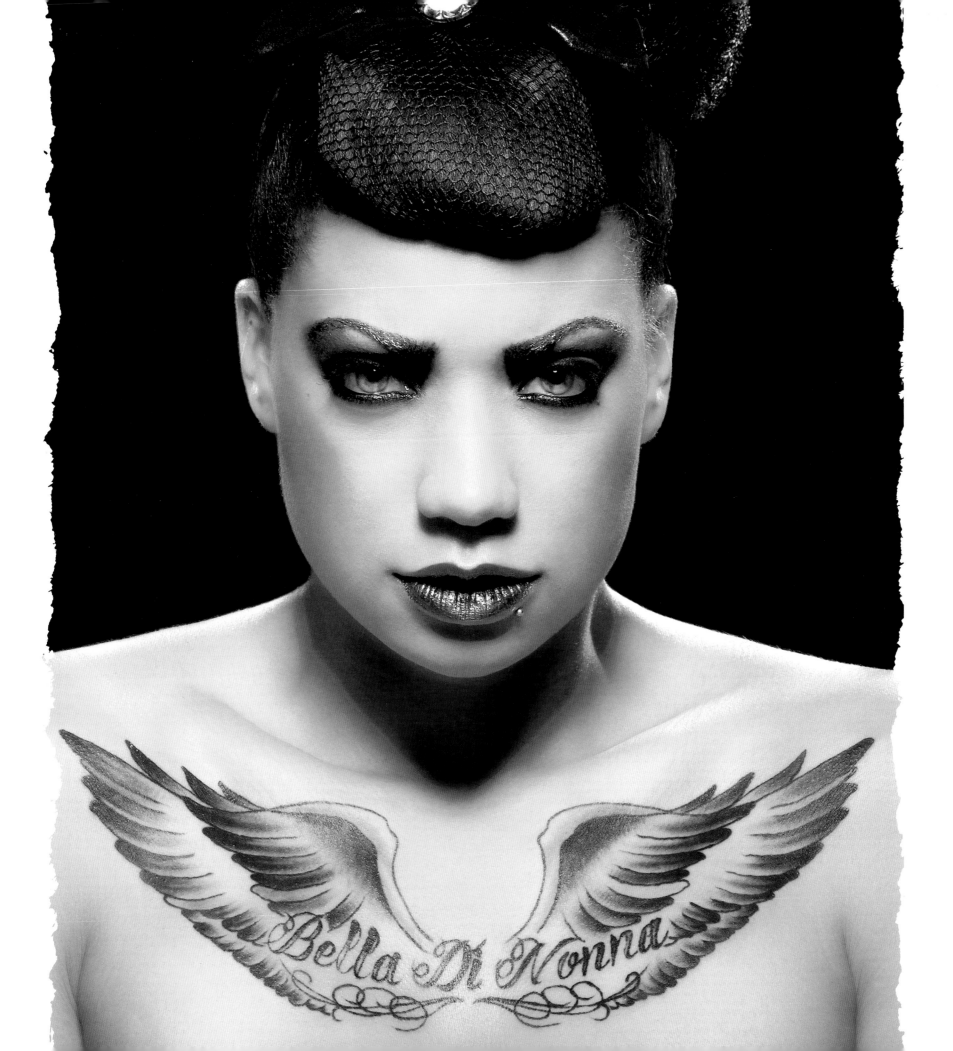

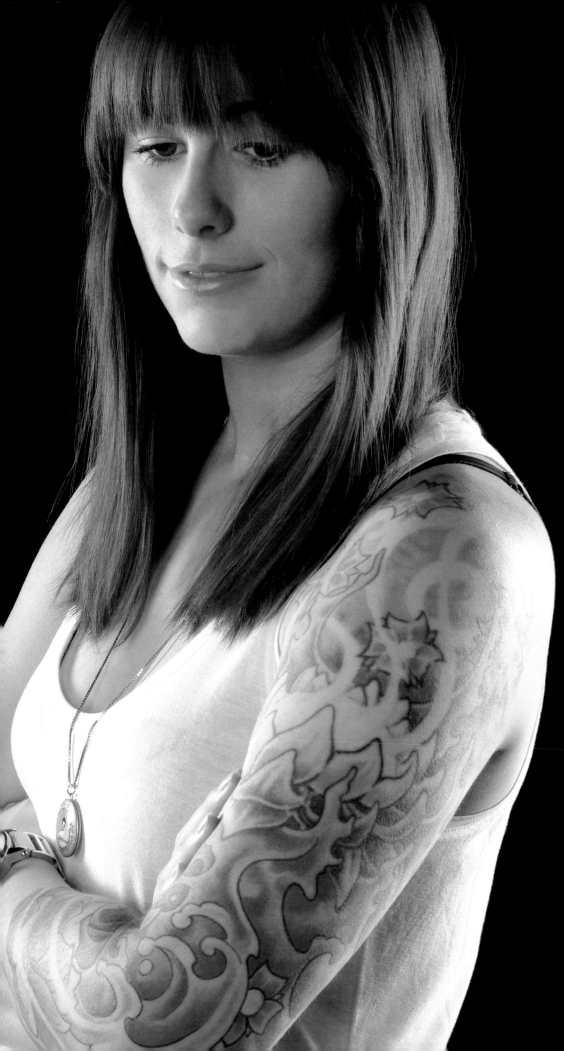

Jondix (*see* pages 80–81): more spiritual and Buddhist blackwork than 'tribal' (the Buddha would probably have encouraged not getting too hung up on styles and schools anyway), Jondix brings Tibetan flavours to his tattooing and infuses it with a meditative quality derived from his passion for Himalayan religion. Dotwork, demons and dharma combine to remind us that all things – including tattoos – must pass.

Black and Grey

For some past masters of this style, 'black and grey' could refer to the colour of their regulation prison clothes as much as their art. This is a style born very much out of privation and the jailhouse and created on the fly with makeshift tools by unknown hands. But in terms of bringing black and grey work into the professional arena, credit generally goes to Jack Rudy and 'Good Time' Charlie Cartwright. Inking with single needles in a fine-line style from the store Cartwright opened in East LA in 1975, Rudy helped pioneer the school's aesthetic by working on pieces that took full advantage of variations in natural skin tones to create smooth blending and layered detail.

Present Practitioners

Paul Booth: as close to royalty as the world of tattooing gets, Paul's work (on skin and on canvas alike) is revered throughout the industry. He tattoos from his Last Rites studio in NYC and his gloomy horror art is a study in immaculate composition, working in perfect harmony with the skin while at the same time depicting images suffused with violence and malevolent power.

photocredits Photographer: Salvitri Bastiani • Make up and hair: Audray Adam

Mario Barth: the Austrian's entrepreneurial zeal has seen him launch several tattoo studios and bar operations, including his 'King Ink' setup in Vegas. He works across a number of disciplines but his black and grey work (often portrait pieces) has a neat line in high-contrast images with an almost charcoal sketch look to them.

Liorcifer: another New York artist (based at Tribulation Tattoo), the mighty Liorcifer brings some aspects of both traditional and Japanese tattooing to his black and grey work, along with a severe dose of creepiness. Expect to see many devils, flaming beasts and apocalyptic horsemen riding out of the shadows amongst his dark fantasy black and grey work.

It's only his outside; a man can be honest in any sort of skin

Herman Melville

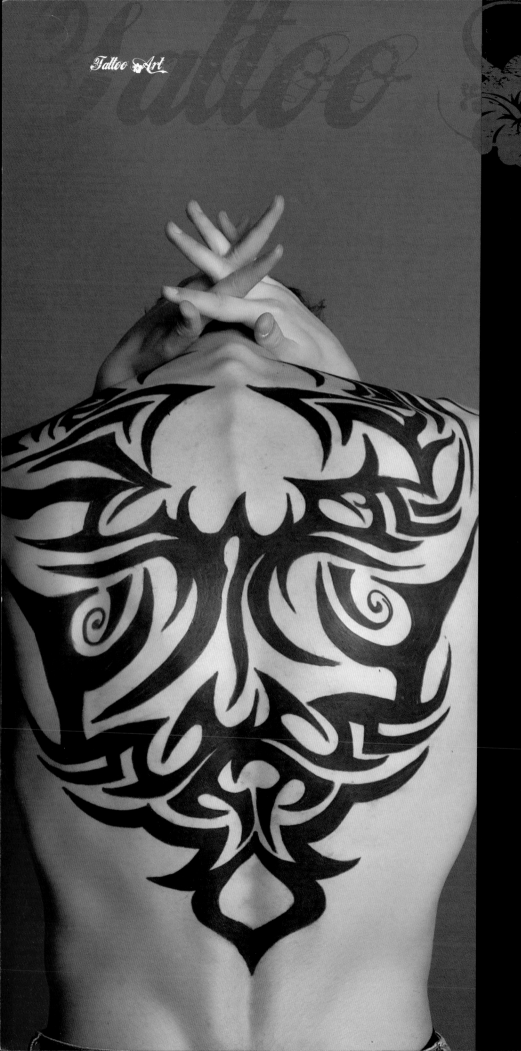

Art

Japanese

In some ways the Japanese artist Horihide has influenced many more styles than just the traditional Japanese form, which he created using *tebori* needles and mastered only after a gruelling apprenticeship lasting several years (and seemingly lifted from a kung fu movie, complete with tales of physical punishment and ruthless discipline, according to some accounts). He corresponded and collaborated with Sailor Jerry for a long time and was one of the principal reasons for the latter beginning to incorporate aspects of Japanese tattooing into his work. Horihide's tattoos show perfect understanding of the complex rules surrounding *horimono* and his books of tattoo work and illustrations are regarded as key texts for artists working in the field.

Present Practitioners

Horiyoshi III: a name that circles the world, Horiyoshi III (born Yoshito Nakano) is the undisputed heavyweight champion of traditional Japanese tattooing. Although he no longer takes on new work (focusing instead on finishing existing pieces and bodysuits), his art is iconic, drawing on fables and folklore to engrave the skin with luminously beautiful images.

Mike Rubendall: another industry heavyweight (and keen kick-boxer), Rubendall's Kings Avenue stores in Long Island and Manhattan are pilgrimage points for tattoo collectors. His blazing take on traditional Japanese art includes distinctive fire and water work and a brooding intensity to the mythical creatures that prowl through it.

Filip Leu: inked by Horiyoshi III himself, Filip's passion is for full bodysuits and he dedicates his time to creating them from the auspicious private space of his mountain studio in Switzerland. Alive

with the sinuous, muscular energy of rampaging dragons and sword-wielding warriors, his work seems ready to leap off the skin and into the world at large.

Fine Art

Ed Hardy has had such a big impact on the world of tattooing that he could have appeared in any of these categories, but he is included here because of his innovative approach to colour and to mixing different styles into something slightly more abstract. With a background in printmaking, Hardy trained with Sailor Jerry and shared many of the same influences; he even spent some time in Japan learning from Horihide before returning to the US to launch his own studio. Hardy's ability to balance tattooing's commercial possibilities and fine art potential has seen him turn his name into a brand with global clout (they don't call him The Godfather for nothing), but it's all based on the quality of his art.

Present Practitioners

Jeff Gogue: with a totally unique style and tireless devotion to the art of tattooing, Jeff is the complete professional. Self-taught at first, he did everything he could to improve his skills, including taking painting lessons and crisscrossing America to pick up tips and tricks at conventions. Now a committed teacher himself, his work blends breathtaking colour staining with subtle line work and rich, nuanced shading; and he just keeps getting better.

Ivana (*see* pages 60–61): sporting a signature Jeff Gogue chest piece, the dynamic Slovakian artist creates tattoos that occupy a thrumming world of acid-bright colour and embrace abstract themes, as well as left-field takes on floral pieces or traditional skulls rendered in eccentric brushwork.

Buena Vista Tattoo Club: slinging together components from graphic design, typography and slapdash brush strokes, the BVTC tag team of Simone and Volko create pieces in a style they refer to as 'realistic trash polka'. It's an apt description; their tattoos show glimpses of the photo-real buried under layers of Gothic bric-a-brac, lurching eventfully over the skin to their own peculiar music.

Realism and Portraits

The real leaps forward in photo-like tattooing have actually only taken place since the 1990s and there are many artists who have contributed to its development. Filip Leu gets credit, along with Mike Demasi and Nikko Hurtado, all of whom tried to take the tonal variations achieved by black and grey masters and to apply them to colour work, gradually edging their tattoos ever closer to reality.

Present Practitioners

Mike DeVries: specializing in portraits, Mike has bolstered his inking skills with some formal art training but it's the latent talent that does the hard work. His pieces feature sharp, metallic highlights, tactile skin tones and super-furry animals – always striving to add just a little more life than even the camera captures.

David Corden: coming into tattooing after many years as an engineer, David had always drawn portraits, and it shows. His work is finely detailed and precise down to the last element, capturing every wrinkle of skin or gleaming catchlight in his subjects' eyes.

Joshua Carlton: looming out of the skin as if rendered in 3-D, Joshua's work could make anyone wonder whether it's possible to go any further with tattooing (although it probably is). Striking depth and detail, plus augmented reality via little painterly flourishes, show why he is so highly regarded in the realism school – and in the tattoo world at large.

Lettering

In order to glimpse the origins of some tattoo lettering styles, you only need to look at the work of sign painters in the US: there clearly is some shared heritage between the two. In fact, some artists (including Jeff Gogue) are known to have dabbled as sign painters and letterers when not tattooing; the attention to detail, spacing and proportion required is obviously vital to both disciplines, as is a steady hand – and hopefully the ability to get the spelling right first time.

Present Practitioners

Nick Colella: a disciple of Jack Rudy and now working out of the Chicago Tattooing & Body Piercing Co., Nick acknowledges the importance of sign work and also custom car paint jobs to lettering. His script is at once elegant and edgy, and is often done without the aid of a stencil – just to add to his technical accomplishments.

Loic Lavenu: Loic's novel approach to tattooing involves layering and blending several graphic sources together to complete a single image. His text work might include several different styles and fonts sitting in a jittery stack, adding depth but also underlining the meaning of the phrases he illustrates.

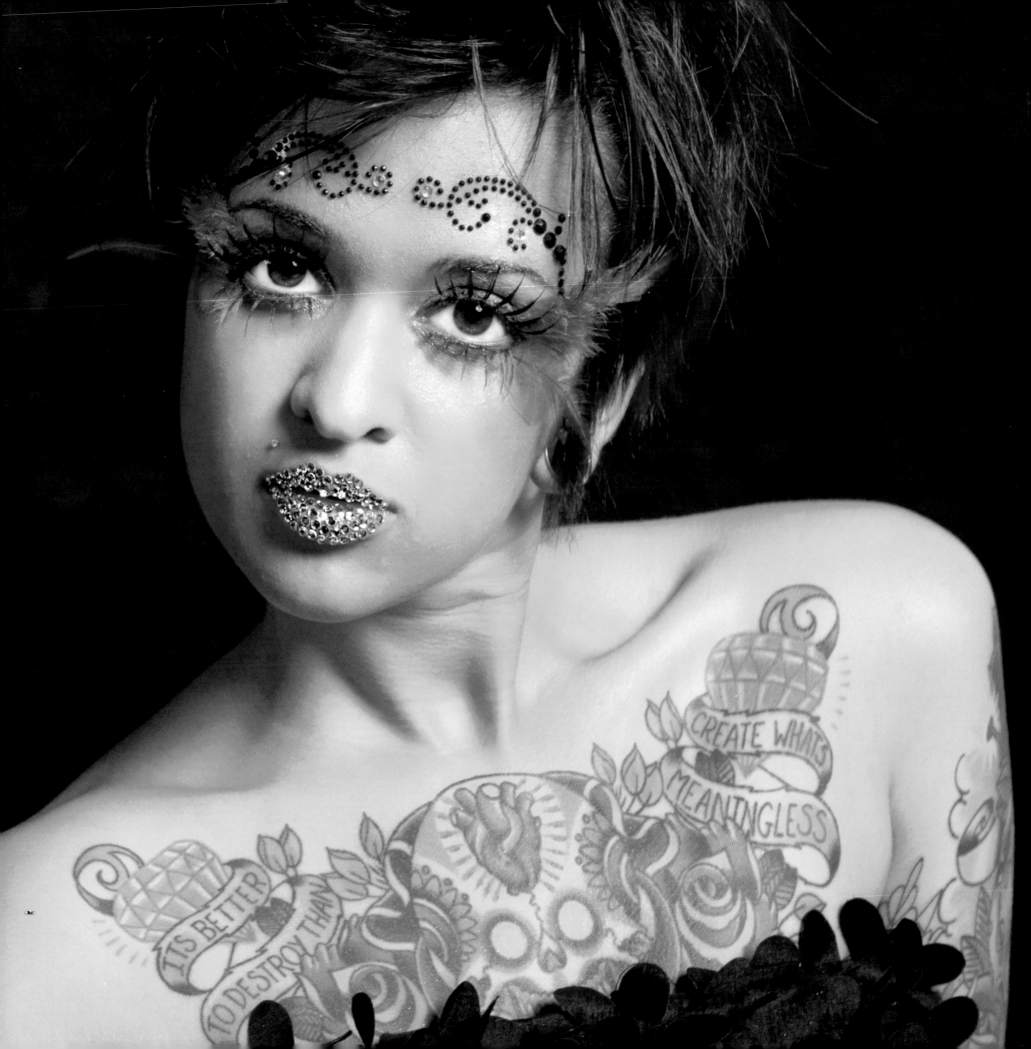

Michele Wortman

Tattoo Artist

Michele Wortman began her career as a tattoo collector. Already an accomplished painter, she intuitively imagined approaching tattooing as an art medium where any idea could be explored. However, her early collecting experiences were mixed; after being told that tattoos had to be done a certain way, she got several large tattoos which, upon later reflection, did not express the kind of energy that she felt matched her personality. She believes that part of the issue came from searching outside herself for cultural symbols that embodied her philosophies, rather than looking within and finding something more personal. A much deeper problem, though, had to do with the actual look of the work, which she felt was too rigid, dark and heavy. She wanted to embody a tattoo aesthetic that felt right to her.

Following this experience, around 1998, Michele began a quest to redefine what is possible with a tattoo, particularly when it comes to women's needs. Tattooing began largely as a men's pursuit, a fact that still affects the overall look of tattoos to this day. Now that many more women are entering the field, this is changing, and Michele is excited to be a part of this change. With a strong emphasis on flow, balance, luminosity and creating an overall feminine look, her work has been received with great enthusiasm by women from around the world. She is best known for her limited use of black and for her 'Body Sets', an approach to balancing tattoo work on the female form.

for more information visit her website www.hyperspacestudios.com.

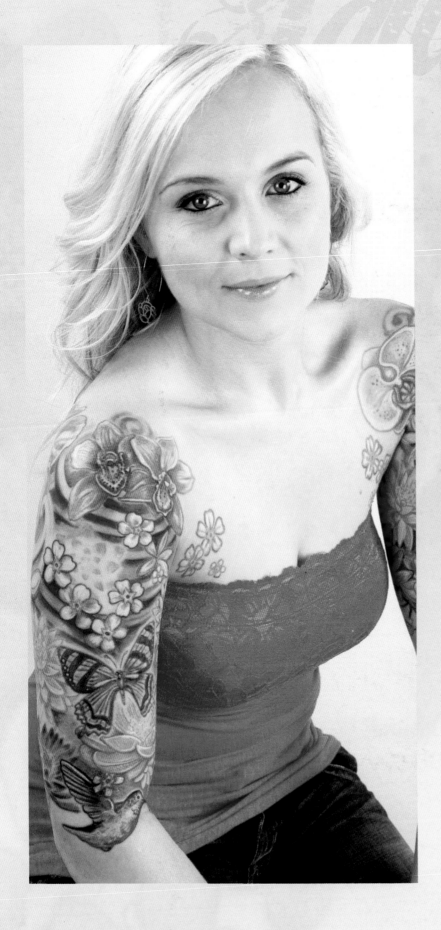

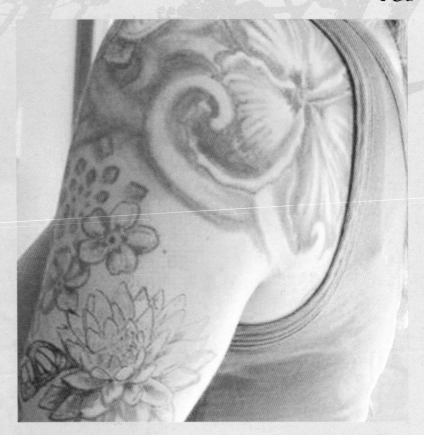

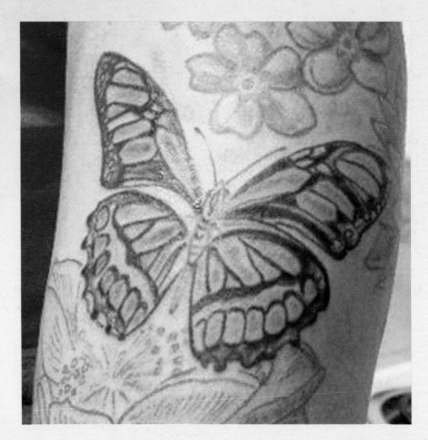

Under the Needle

If you have been inspired by the art on these pages and are thinking about getting your first tattoo, this section is for you. Getting inked can be a spur-of-the-moment decision with no planning involved and the results might be fine, but it's wise to take a more considered approach. You'll end up with a much better tattoo.

With that in mind, here are some tips and pointers, plus a look at what to expect from both an artist and a studio. And a little hymn of praise to the wonder that is the lollipop, friend of all tattooed folks.

First Things First

Tattooing is probably enjoying more popularity now than at any point during its long history. The perma-dazzle of TV shows, websites, glossy magazines and, yes, books like this all contribute to raising its profile higher and higher.

This has many benefits: great artists get the exposure they deserve and it's easier to get in touch with them, discuss ideas and create wonderful tattoos. But the potential downside is that tattooing could be relegated to a disposable fashion fad, with the single most important fact about the art form (and that's what it is) being overlooked: it's something that permanently alters your appearance. Which means it's something that deserves some time and some thought – especially in the case of the first tattoo.

Good Things Come

Over the centuries, getting the first tattoo has always involved waiting: waiting to take part in a Polynesian tattoo initiation ceremony or waiting for shore leave to get a tattoo from the port artist – and even waiting for it to become legal again in the US.

photocredits Photographer: Justice Howard/www.justicehoward.com

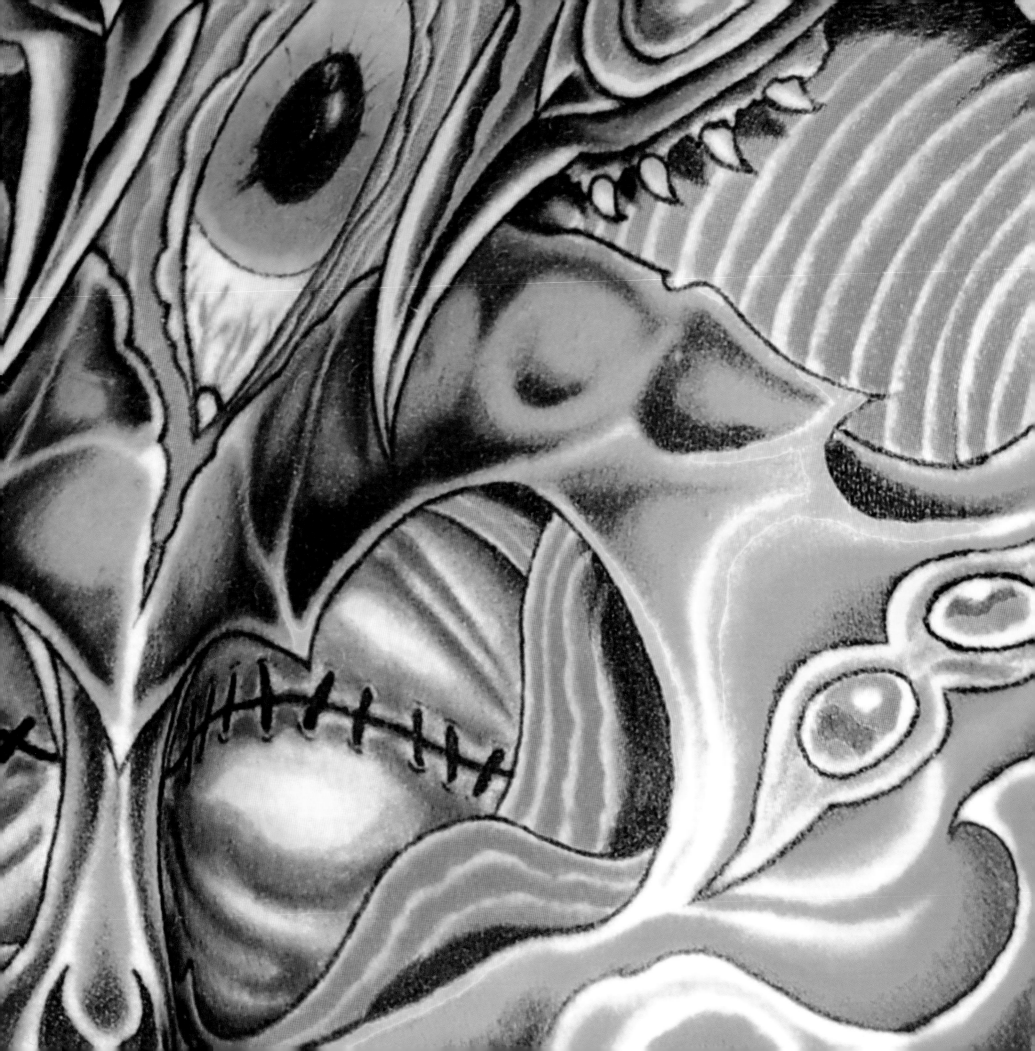

Waiting is important. A tattoo can be chosen as a piece of art or as something with a specific meaning – or perhaps both. It doesn't have to be serious, but with the quality of work available these days, it should be as good as it can be. So while in most cities you could go out and get one now, why not wait? Wait to find the very best artist to give you the very best version of that tattoo.

That's not to say you have to go for a custom piece: flash can be just as great. But again, why not take the time (even a few hours) to decide if that piece is definitely the one for you? Go away and come back again. Enjoy your deliberations.

Whether you go for flash or custom ink, don't let the restless pace of the world dictate the speed of your decisions when it comes to tattoos. Wait. Chances are, as you look at your incredible ink over the years to come, you'll be glad you did.

Good Tattoos Aren't Cheap; Cheap Tattoos Aren't Good

It's an old tattoo rule of thumb, but it's a good one and it's worth bearing in mind right from the start. Like lots of things in life (apart from maybe hamburgers, which can be delicious at any price), cost really does dictate quality with tattoos. A good one is expensive. It's not about the time the tattoo takes or how big it is, although that might come into it a little bit; you are paying for the time an artist has spent learning and the breadth of their experience.

So cost shouldn't really be the boss when it comes to deciding to get a tattoo. Don't compromise on quality because of your budget; save up and get exactly the piece that you want, from the artist you really

admire. It may take longer, but imagine the satisfaction when that piece is in place, however large or small it might be.

Plus, in the grand scheme of things, tattoos sit well within the 'cost per wear' ratio we have all used to justify that new dress or those slightly-more-expensive-than-usual running shoes. After all, you'll wear it every day for the rest of your life. Whether it costs a few hundred or a few thousand pounds/dollars, that is better value than any suit or little black number you'll ever own (provided you eat your greens and get regular exercise).

Starting Your Search

The journey towards your first piece of body art can begin in lots of different places, but two big factors to decide are the subject and the style. For argument's sake, let's begin with the subject matter.

Your tattoo might be inspired by a life event and arrive ready-formed in your mind, and all you need to do is find the artist to make it a reality. Great: that was easy. However, you might have experienced something you'd like to commemorate with a tattoo and are now reaching around for the best way to express it visually. This is the time to do some research.

There are lots of tattoo books and magazines full of the lore and symbolism of body art, so they are obviously useful places to start. Some tattoo styles – such as Americana – come with lots of meaningful designs built in so they might provide the exact image you want or suggest a starting point for your own design. Equally, your faith might quickly dictate the kind of tattoo you want or a memorial tattoo might immediately point you down the portrait route.

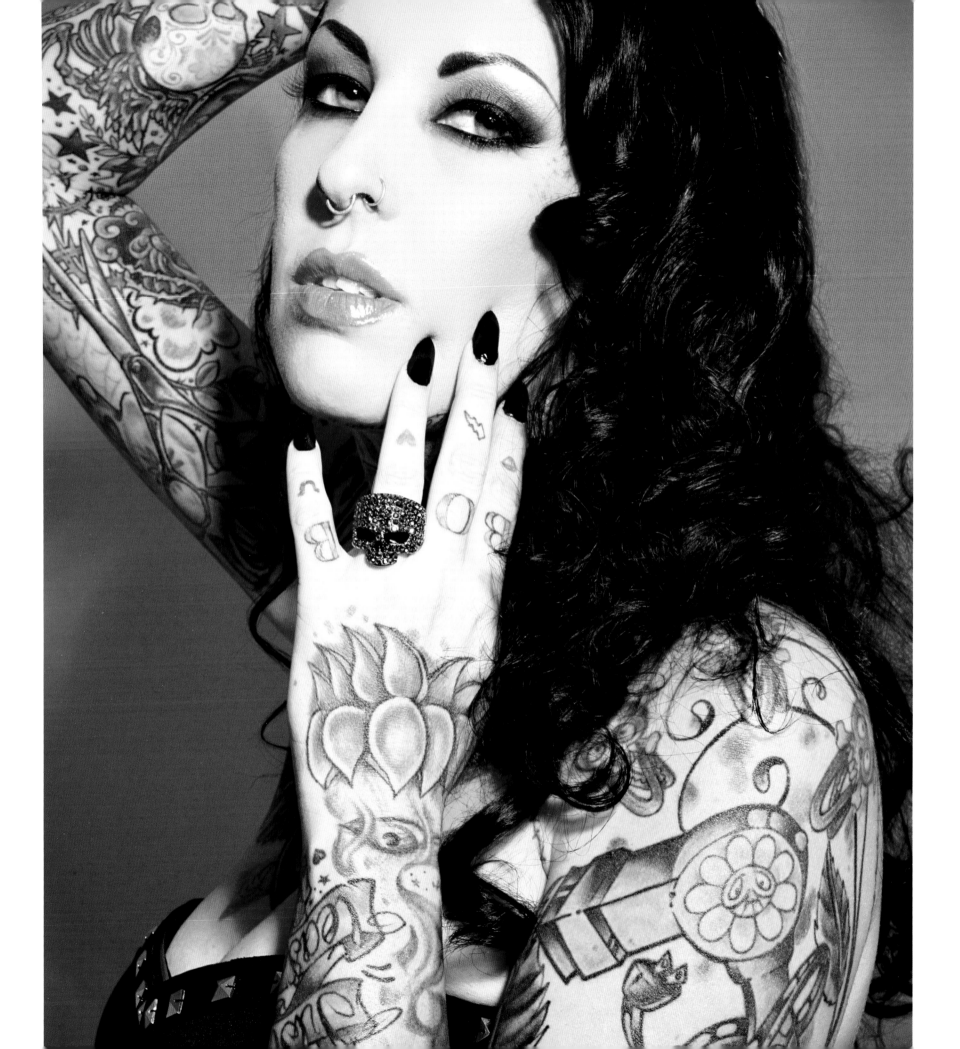

A little free association can also help when you have a subject in mind but no specific image. If you are memorializing a person, what makes you think of them? If it's an event, is there something that reminds you of it? It doesn't have to be an obvious connection; it just needs to mean something to you.

Drawing Inspiration

It's also helpful to remember that you don't need to go to the artist with a completed drawing. It's fine to have a general idea of what you want, plus some visual references, which you can take to them for discussion.

Visual references can be anything from photos, to illustrations, to existing tattoos. Be aware, though: no custom artist wants to slavishly copy somebody else's tattoo. It's hardly creative and it's disrespectful to both the original artist and the collector who commissioned it. Using other tattoos as a jumping-off point is fine, of course – inspiration takes many forms – but let your artist take the image and run with it; they are not a photocopier.

Body Art

And what if your tattoo isn't intended to mean anything and you want it to exist purely as something beautiful on your skin? Well, once again, you have some choices. You could find an artist who will relish the chance to work on a client who simply says, 'Here's my skin: go!' However, this is a very bold move for your first tattoo and you need to make sure they don't only create psycho cow massacre party scenes if you're a vegetarian.

Another option is to be indulgent. Think about the things you find beautiful and let your mind wander. Visit galleries. Take weird photos

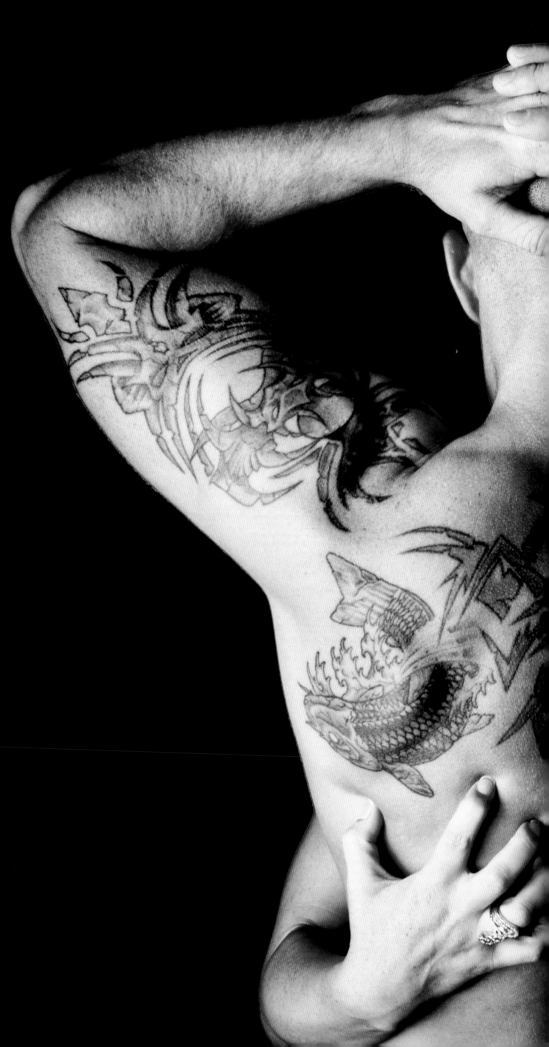

on the street. Doodle. Write lists or keep a scrapbook (or visual blog) full of curiosities that catch your eye. Be honest too – the more of yourself you can put into the subject you choose, the more unique your final tattoo will be.

Also, don't worry about how to turn your abstract concept into a tattoo – your artist is the expert in that area, so talk to them about it. If you have an interesting project and you are happy to collaborate with the artist, they'll be more excited about your piece and you are sure to end up getting an even better tattoo as a result.

Style Counsel

Another way to approach your first (or indeed your next) tattoo is to let style lead the way, which might in turn suggest designs with personal significance to you or a theme for your abstract body art. Looking through the designs in this book and in dedicated tattoo magazines will soon help you to identify the tattoo schools that really appeal to you, as well as the colour palettes you like. Turned on by tribal? All about the Old School? The more photos of existing tattoos you see, the more you'll discover what you like and dislike.

As well as catering to specific tastes, each style has some distinct advantages:

 - Traditional or Old School art was designed to be tattooed, so it always works well. It's a versatile style that creates bold, simple pieces that look clean on the skin and hold their shape and colour.

 - New School tattoos have even bolder lines and super-bright colours that create a real impact. They can also have a cheeky sense of humour or a slightly more feminine feel than other styles.

- Biomechanical can be great for abstract or allegorical pieces and adapts well to the shape of the body – for those who want art that looks like it belongs there.

- Tribal shares the same body-hugging traits as biomech, plus it can offer very specific meanings or simply be about creating a bold design with flowing lines.

- Black and grey is subtle and can be packed with detail, and it works across any number of styles, from traditional pieces to portraits. It's particularly good for horror tattoos too.

- Traditional Japanese art comes with its own rich heritage and a catalogue of meanings that can apply to everyone; it is perfect for those seeking big, ongoing pieces that can link together.

- Fine art tattoos let collectors experiment and also allow artists to really open up the throttle on their imaginations. It's a diverse style, so it's often more about the work of a specific artist.

- Realistic and portrait tattooing lends itself well to either memorial tattoos or to those created for the love of the art – be aware that not every artist can work in this style, though, so find a master!

- Lettering will definitely get the message across but it's worth taking the time to find an expert in visual wordsmithery who can make it look great and get the technical aspects spot-on.

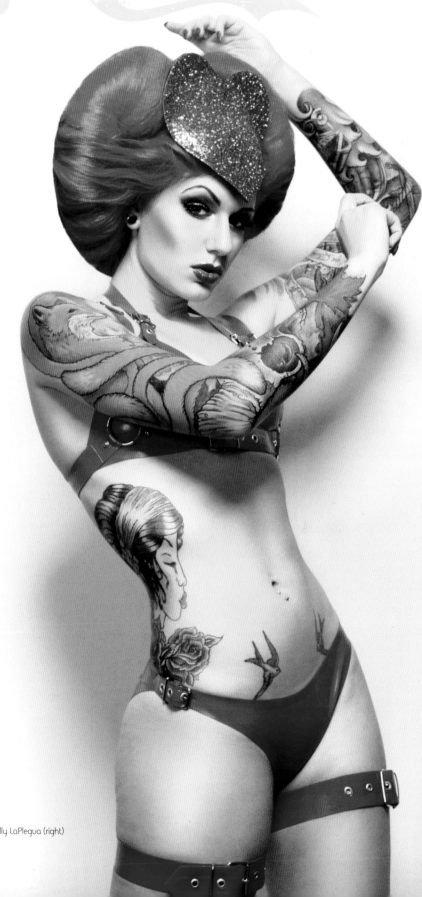

 photocredits Photographer: Jane Queen/www.dangerouslydolly.com • Models: Cervena Fox (left) & Kelly LaPlegua (right)

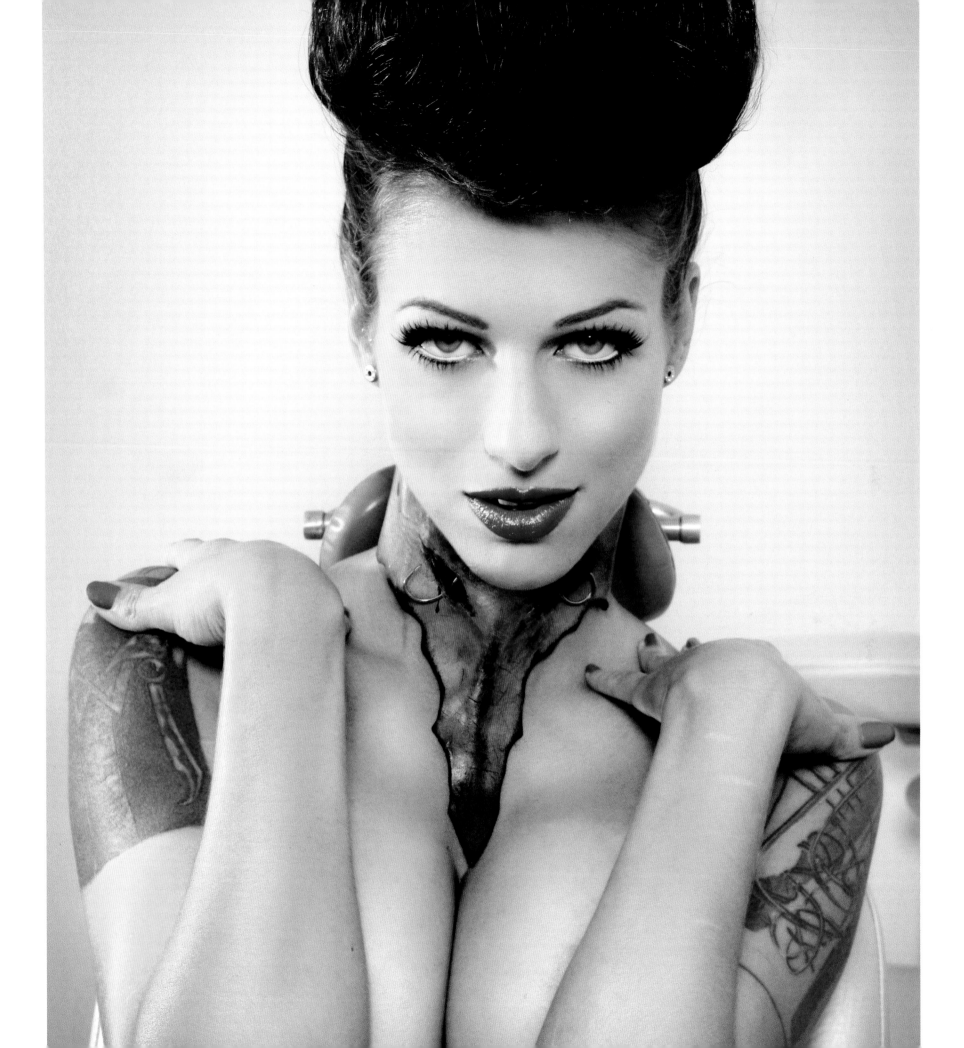

NOON
Tattoo Artist

Frenchman NOON started tattooing when he was a boy — by hand to begin with — and has never stopped. He bought his first tattoo machine in 1996 and began to teach himself most of what he knows today.

He has worked with Lionel Fahy (Out of Step Tattoo) and Yann Black (Your Meat is Mine), and the three of them have created their own style, heavily influenced by 'art brut' ('outsider art'), which is ever-evolving in NOON's tattoos.

NOON describes his style as mostly based on the line, and he likes to portray what the client wants as simply as possible so the design is light and easy to wear. He likes to write love stories — his French 'romantic' side — and he likes to use abstract lines and patterns. His work is also inspired by the tattoo culture of French prison life, which features bold and basic forms that hold up and keep their form for years.

NOON is also a painter, and as a fan of the 'art brut' movement spends time collecting art and tattoos in this style. He spends most of his time tattooing between New York City (Tattoo Culture), London (Mo Copoletta's family business) and Berlin (AKA Gallery). He travels a lot, so you might also see him in Australia and Norway, but when he is not travelling he works in the countryside to the east of Paris, booking private appointments in his home.

NOON's work has been featured in tattoo magazines and art press all over the world, and in 2010 he was inducted into Bob Baxter's 'Hall of Fame' of the 101 most influential people in the tattoo world.

for more information visit his website ww.boucherie-traditionnelle.com

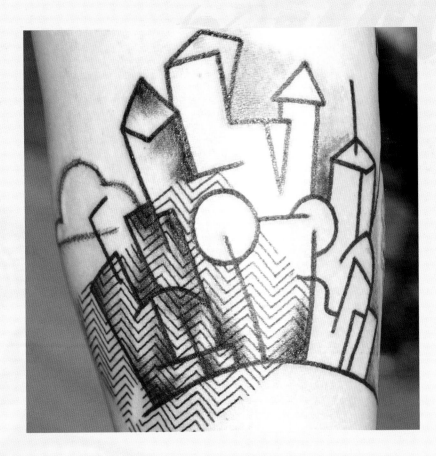

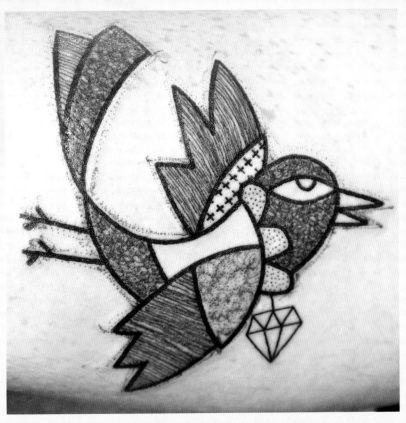

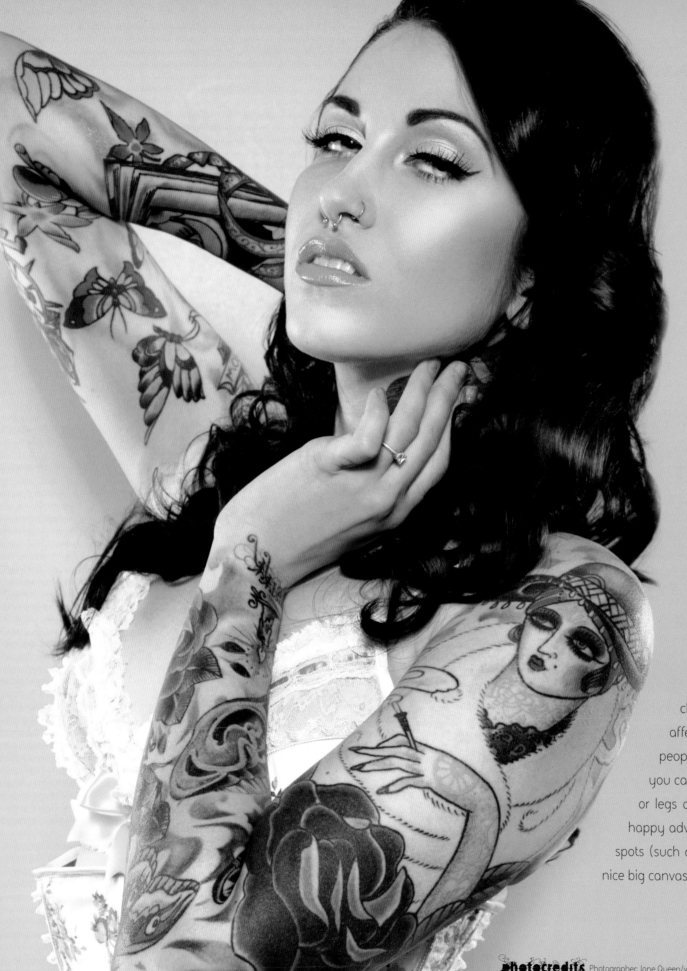

Hitting the Spot

Another vital thing to consider when planning your tattoo is placement. Where do you want it to go? Your tattoo's home on your body will determine how big it can be, for example – some designs simply won't fit in some places and come out well.

Artists generally urge clients to get the biggest version of the tattoo that they can – 'go big or go home' is the jock-like refrain. It's not all machismo: bigger tattoos generally look better and wear well over time. However, you shouldn't get something huge that you'll regret, so give it a little thought and discuss placement with your chosen artist to get some professional advice.

It's also important to consider how visible your tattoo will be. While those with ink are far from social pariahs, there is still a little way to go towards sweeping away those last little clinging prejudices. Visible tattoos can, and do, affect your employment prospects and the way people look at you, so it's worth getting something you can conceal for your first piece. Tops of the arms or legs and the back are popular sites and have the happy advantage of being not quite as painful as other spots (such as hands, neck and ribs), as well as providing nice big canvases for your design.

photocredits Photographer: Jane Queen/www.dangerouslydolly.com • Models: Krysti Pryde (left) & Laydi Marie (right)

Give It Some Time

Once you've got a concept for your tattoo – and it may take minutes, months or years – a good piece of advice from many tattoo artists is to forget about it for a month or two. Let the initial giddiness subside and go back to the design later: if you still love it, it's time to get your ink.

This tactic has a few advantages. It helps you dodge any regrets, of course, but stepping back will also help you see any flaws in your thinking, iron out bits that don't work (does the portrait of your hamster *really* need antlers and clown make-up?) and generally feel confident about your idea. If you are bored by it after a few weeks, then it's definitely not something you should have permanently added to your body.

Finding Your Artist

Once you are clear on the subject and style, you need to find someone who can actually put it on your skin. This doesn't have to involve an epic pilgrimage: there is absolutely nothing to suggest that the artist in your nearest studio won't do a perfect job. And it depends on what your nearest studio is, of course: you might live in the same neighbourhood as Jeff Gogue, in which case you probably don't need to go anywhere else.

It's all relative too – if you are after a simple little flash design, a high street shop will probably do nicely. You don't need Jeff Gogue to do a neat little star behind your ear; that would be like hiring Michelangelo to paint the ceiling. Oh, hang on …

The neighbourhood is a good place to start, anyway. Visit some tattoo shops and have a look at their designs but, more importantly, look at examples of finished work in the kind of style you are after. This is the

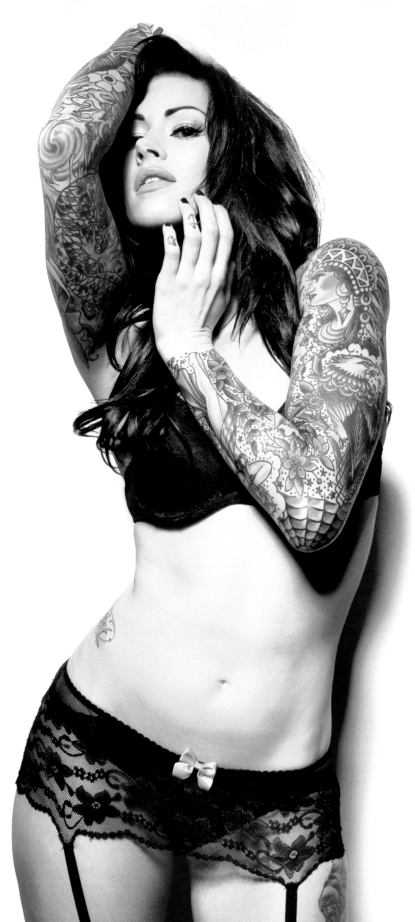

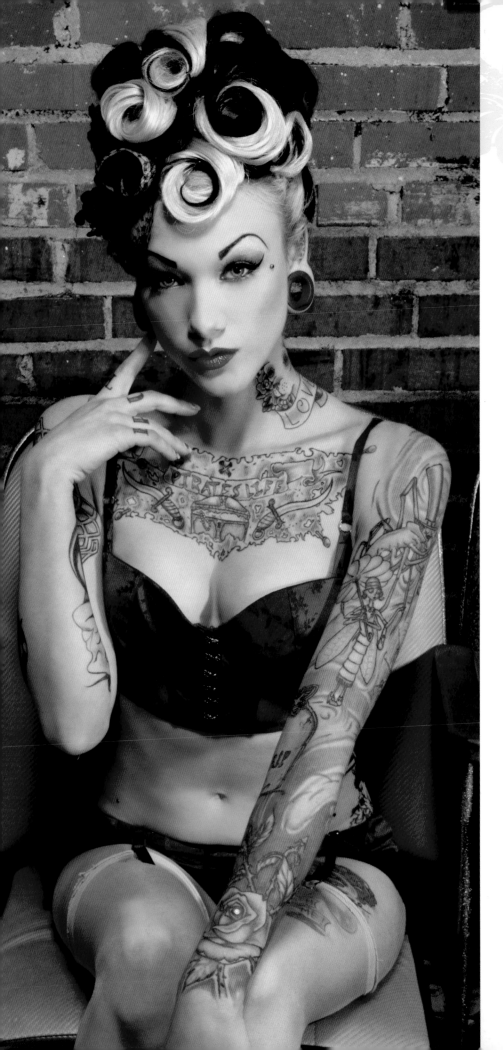

only way of assessing quality, as a drawing will tell you about an artist's draftsmanship but not their tattooing. Then compare it to other examples from the wider world – if it still holds up, you may have found your mark. If you have any doubts, walk away.

Casting the Net Wider

Can't find exactly what you want nearby? No problem. Don't settle for a compromise if you are not totally sure, because after a while you'll only see the flaws in your ink – and you can never convince yourself to like a bad tattoo.

Start looking for artists who do the kind of work you are after. Magazines such as *Inked*, *Skin Deep* and *Total Tattoo* run regular profiles on established names and rising stars, along with galleries of artwork; keep your eyes open and you'll find what you are looking for. Then there might be a road trip in your future (never a bad thing) or you could wait until an artist comes to a convention.

Meet and Greet

It's often a good idea to meet an artist before getting tattooed by them, if you get the chance. A consultation for a custom piece will help to firm up the design. It has another purpose, though: you are going to be spending at least a couple of hours with this person (in the case of a medium-sized tattoo) and they are going to be jabbing you with needles. You want to make sure that you don't hate the living sight of them – that is not going to make your time in the chair enjoyable, and bad memories of the process might spoil your enjoyment of the finished tattoo.

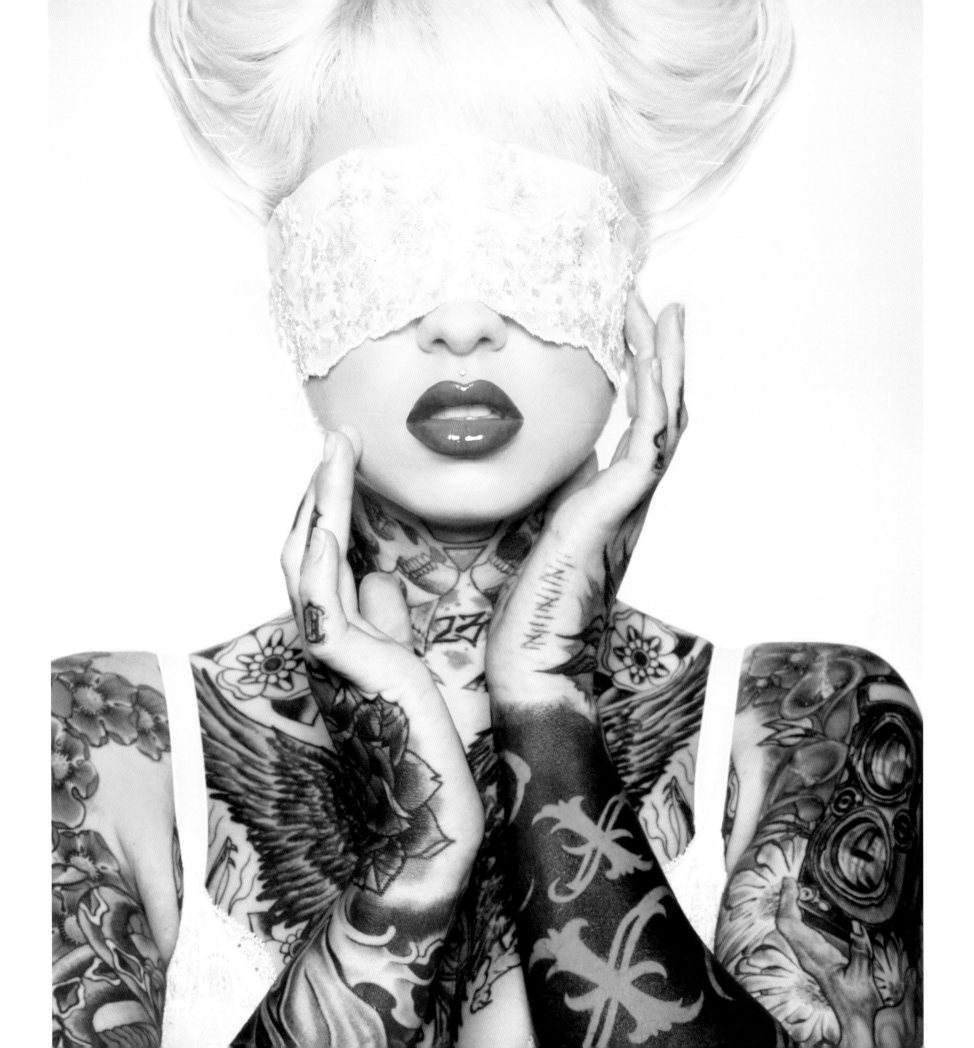

Sampling Studios

The same is true of the studios where most (but not all) artists work. Tattoo parlours are unique places, each with their own distinctive personalities. You could compare them to hairdressers (where some tattooists used to operate in the early days) or even car repair garages. Some will be noisy and a little scuffed, full of tough guys, gals and braggadocio, and requiring a thick skin and an easy sense of humour; others will be sleek and quiet like top-end salons or high performance tuning shops. Either can give you a superb tattoo and a memorable experience.

By the same token, either can be exactly the wrong place for you. If you can check out a studio before your tattoo, do so — even if all you can do is look at their website or scan tattoo forums to see what their reputation is like. Trust your instincts and the way you are treated if you do visit — no one needs to put up with rude staff or unsanitary conditions, or simply a studio that doesn't quite fit with them.

Don't go overboard, though. Sometimes a little banter is refreshing and it's fun to hang out in an Old School shop where art (and hygiene) is the only thing taken seriously; it's all part of the unique process of getting a tattoo.

Hooking It up

Once you have locked down your piece and your artist, it's time to take care of some logistics. The exact process varies but, if you are planning a custom piece, the usual procedure is to book a consultation and appointment with your artist first, and then pay a deposit to secure your spot.

At the consultation you'll discuss some ideas, work out what you are going to get and the artist will prepare a drawing for you to look at – usually a few weeks ahead of the actual day of your tattoo. This will give you the chance to make any little changes and ensure you are completely happy.

This process doesn't have to happen face to face. It's just as easy to work remotely with a willing artist, depending on the complexity of the piece, and you'll arrive on the day of the appointment to check out your drawing. For smaller pieces you might simply walk in on the agreed date with all your references and they'll draw for you there and then. It just depends on what you are getting, and the studio will let you know exactly what is going to happen when you call to make your appointment.

One final point: top artists have long waiting lists! A little patience may be required....

Be Prepared

The day of your appointment will arrive eventually, though. If it's your first tattoo it's natural to feel nervous; even those with multiple tattoos still get a little buzz before getting inked. The adrenaline rush is one of the many reasons why tattooing can become mildly addictive.

One thing you can never prepare for is how a tattoo feels. Not because it's insanely painful, but because nothing else really approaches the sensation – it's a sensory assault of sound, heat, pressure and some pain. But you can prepare yourself for everything surrounding it.

First of all, don't have a drink to steady your nerves (or at least, don't have multiple drinks). Alcohol thins the blood, so you might bleed more (some painkillers have the same effect, so don't take any, just in case) and, more importantly, no artist wants a drunk slumped in their chair. Getting tattoos you don't remember is funny in the movies but not so much in real life. Well, not always. So make sure you are sober.

While you shouldn't drink, one thing you definitely should do is eat. Get some slow-release fuel – carbs, such as pasta or wholegrain products – on board a few hours beforehand to keep your energy tank topped up. A tattoo means a sustained period of being under attack for your immune system, so it works hard and needs sustenance.

Sweeties and Scruffbags

You can also refuel during your tattoo. Lots of studios have a supply of lollipops in the corner, which helps for several reasons. First of all, they are nice. They also help to keep your blood sugar levels up if you start to flag. And finally, there is nothing like watching a burly biker dude sucking on a pink lolly to take your mind off the pain of your own tattoo.

Lastly, think about your wardrobe. You can dress to impress once your tattoo has healed, but on the day keep it casual. You want loose clothing that won't rub on the freshly minted ink work, which can be a little tender at first.

Surveying the Studio

It doesn't matter if you haven't been able to visit your studio before the day of the appointment. There are a few things to double-check before you proceed with the tattoo, though. Depending on where your studio is (the laws differ in the UK and US, for example), you should see a certificate showing that the studio/artist is registered or licensed and that it meets all the relevant health and safety requirements. You should also see equipment for sterilizing everything (including an autoclave: a chunky box that heats grips, tubes and anything that comes into contact with blood in order to sterilize it) and lots of disposable gloves, and you should be able to smell disinfectant. However funky, a tattoo studio should still be spotless.

You should be given a release form to sign, reminding you of the risks of tattooing and that it is a permanent form of body modification. There should be clingfilm over all the working surfaces and you should always – always, always, always – see brand-new needles taken out of sealed packs in front of you. If you don't, it's OK to request to see that happen – any responsible artist will be happy to oblige.

Be Sterile, Be Safe

If any of those elements are absent or the studio seems reluctant to provide paperwork, just walk out. Don't feel pressured to go through with a tattoo if you are not absolutely sure it's a safe, sterile environment; the risks are simply not worth it.

But what are the risks? In a typical studio, they are negligible. You are usually in a cleaner environment than the average doctor's surgery. However, if the place isn't clean, then there are health risks posed by cross-contamination and, of course, blood-borne infections: namely, hepatitis and HIV. These are not things to trifle with. Make sure you are safe. (Lecture over.)

photocredit Photographer: Aura McKay • Model: Tatia Vega • Tattoo Artist: Dave Green of Sacred Heart

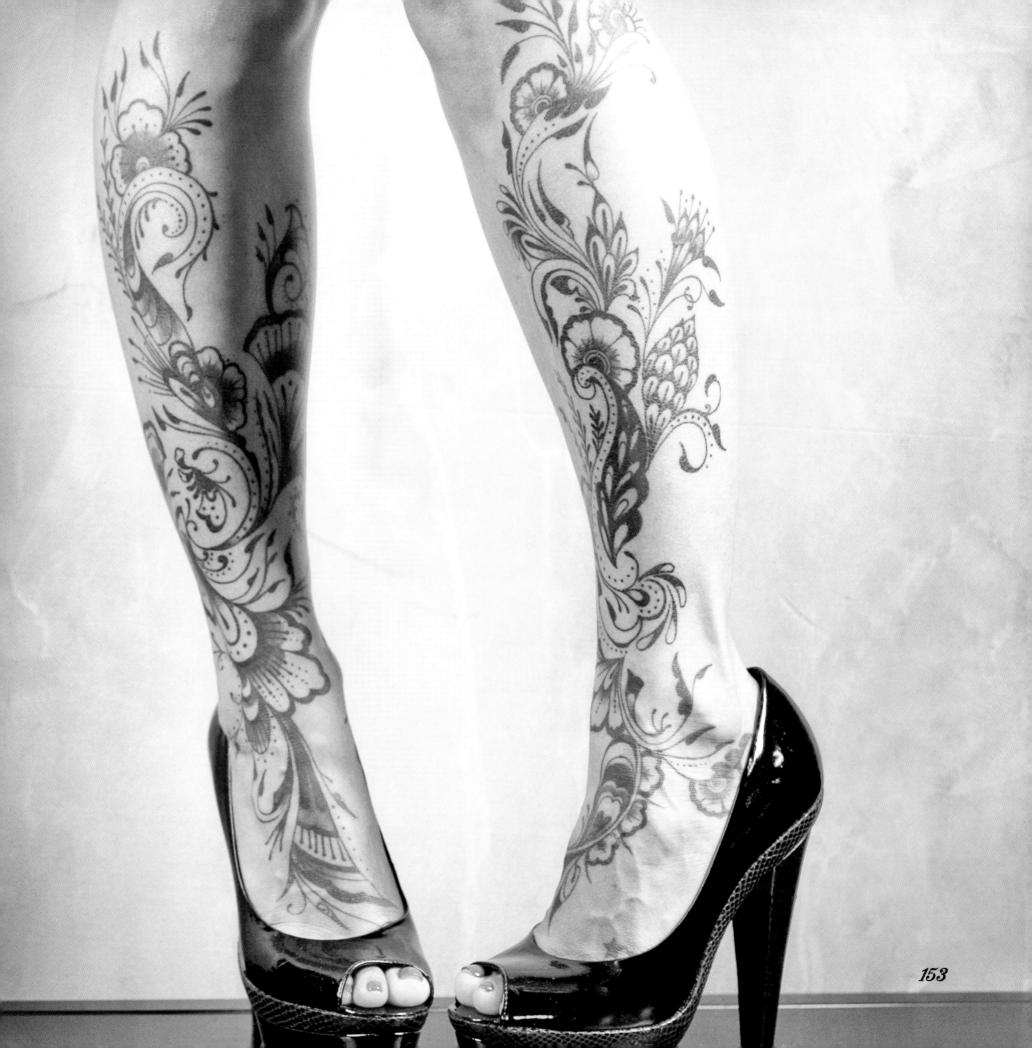

153

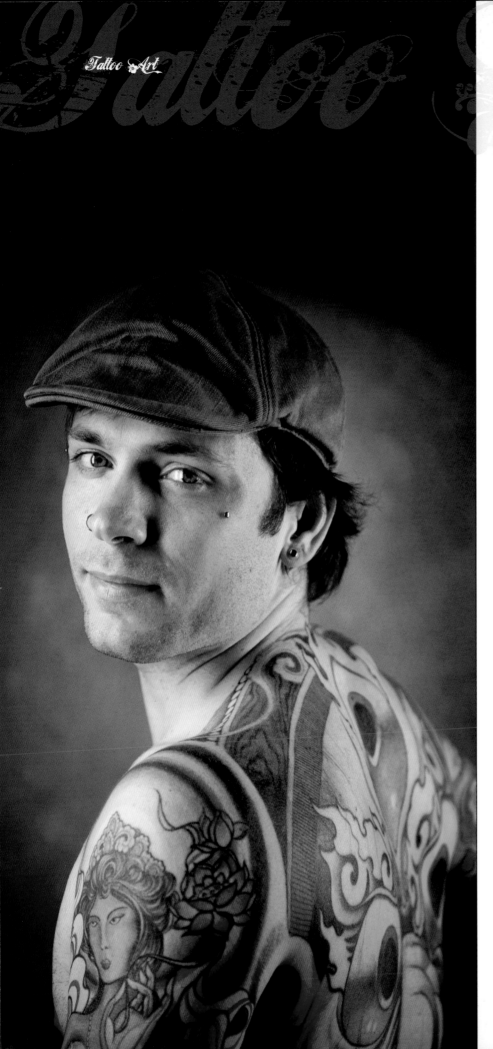

Smooth Operators

Once you have given the studio the once-over and signed on the dotted line, it's time to get ready. Your artist will check the drawing with you one last time and make up a stencil, and then they will gather the tools of their trade around them: inkpots, machines, gloves and a razor.

Razor? That's for you. They'll shave the area to be tattooed so that it's a nice blank slate, and they will also disinfect it with spray or an alcohol rub. Getting razor burn is almost more painful than the tattoo, but it will wake you up. Then the artist will place the stencil on your skin.

Bring the Pain!

Almost time! You will be given a chance to check the placement of your stencil – chances are you'll be too preoccupied to say anything other than 'great', but do check it. You'll never be able to move the tattoo, but shifting the stencil is a lot easier.

Ready? The artist will smear petroleum jelly on you (nothing kinky; it just helps their hand slide across your skin) and start the machine. Regardless of what else is going on in the studio, the buzz of the machine about to give you your first tattoo will be the loudest thing you have ever heard. Don't worry, though; it soon disappears into the background.

The artist will usually begin with a small line to ease you in. Try to relax – the tenser you are, the more it startles you and the more it hurts.

(Let's pause for a moment here. The question of whether or not a tattoo hurts is easy to answer: yes. It's needles dragging through your skin; of

photocredits Photographer: Aura McKay • Model: Rad Kelham

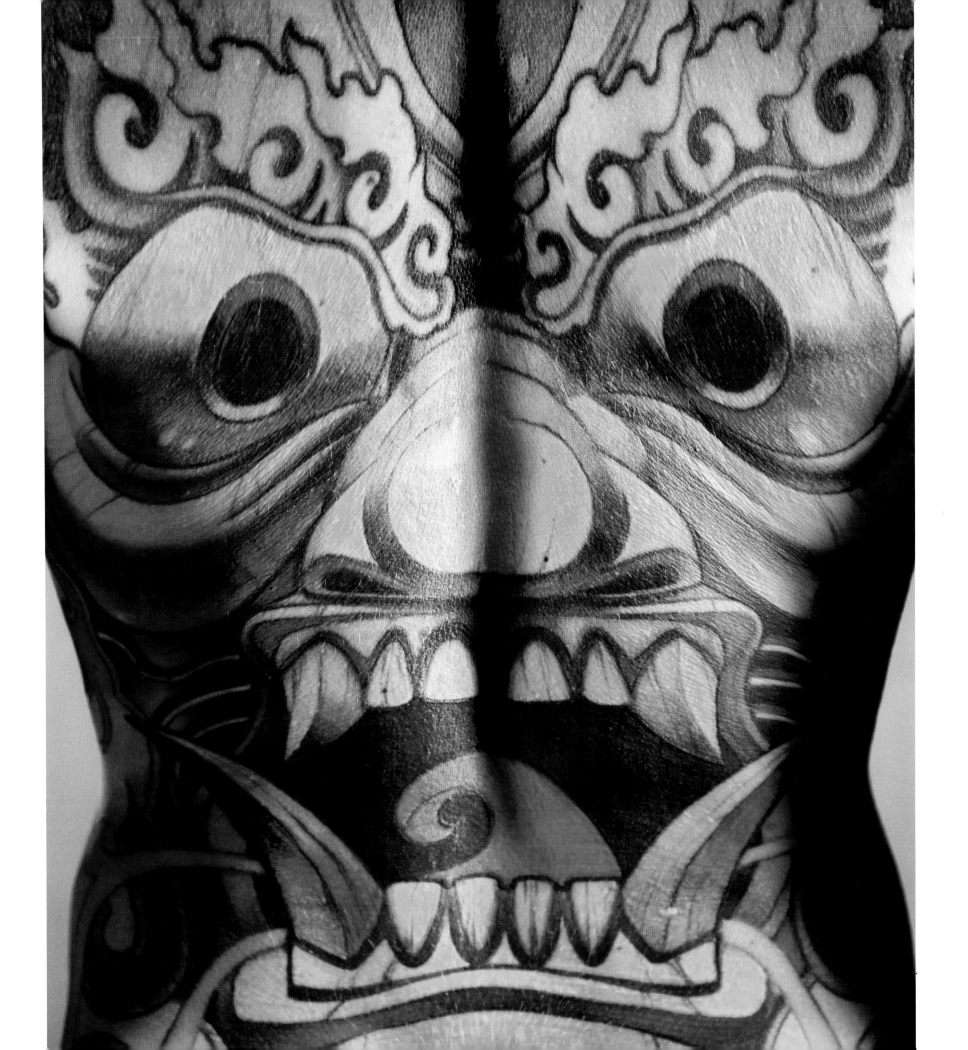

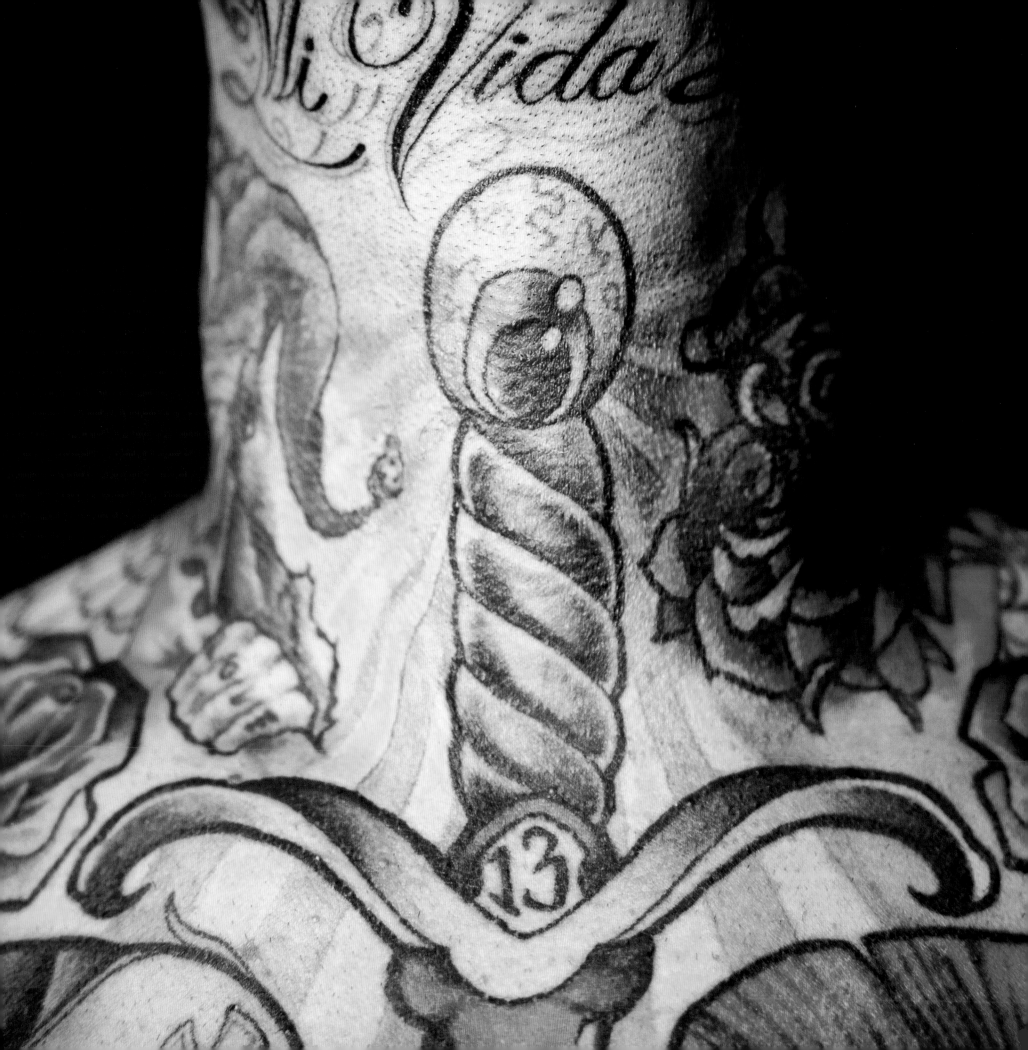

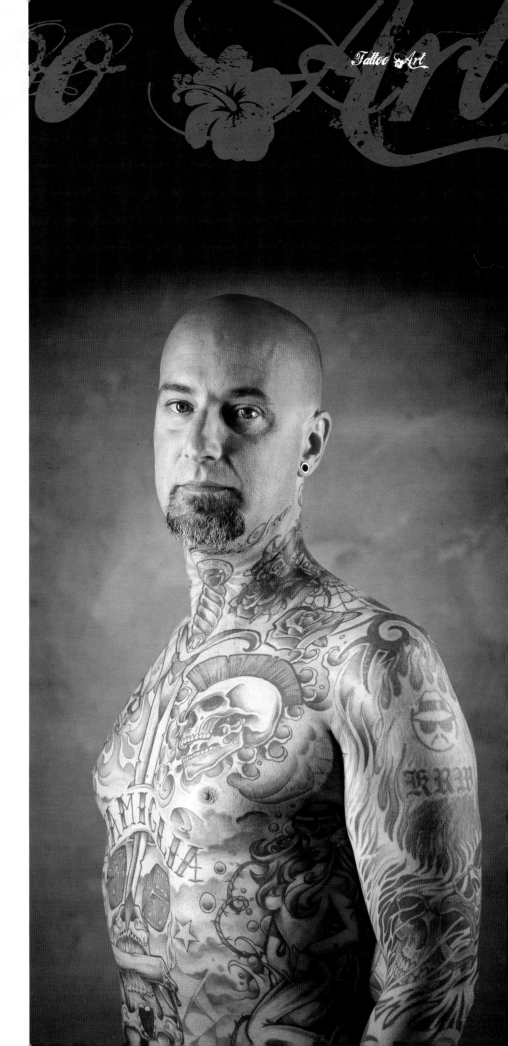

course it hurts. How much, though, is unpredictable. It depends on the artist, the person, the placement and the weather (probably). Some pain is inevitable, but if we are honest, that has always been a part of the rite-of-passage appeal of tattooing. It's a good pain and, when the tattoo is done, it's almost impossible to recall it anyway.)

Taking a Break

All machine tattoos are created in the same order: outline first and then shading. It's generally agreed that the outlining process is the more painful part because more ink is going in and the artist has to work slowly to get nice, even lines.

TV shows would have us believe that a tattoo is created during a lively fifteen-minute conversation. It's understandable — the real process would make amazingly dull viewing, as you could be in the chair for hours for a big piece. During that time, of course, you'll chat with the artist, but sometimes they'll just want to concentrate (and you might want to grit your teeth).

While you are being tattooed, it goes without saying that you'll need to keep as still as possible — even for the bits where it stings a little more. If things get really painful, though, ask for a break, especially if you are feeling light-headed or sick. Better to stop for a few minutes and feel fleetingly embarrassed (although you really don't need to) than pass out and feel mortified. There is cultural shame attached to flinching during your tattoo for Maori warriors and Samoan initiates; if you are not one of them, then you can sit as stoically as you can but ask for a break if you need it. Enjoy the privilege.

Tattooing at Conventions

Conventions are very popular at the moment and can be a great way of investigating new artists or getting a tattoo. If you are after a tattoo from someone who normally works overseas, a nearby convention is the perfect opportunity.

The same standards of hygiene and preparation should apply at a well-run convention, and you should expect the artist to take all the same precautions. Your preparation should be similar too – it's important to contact the artist first to book a slot if they are offering them. Then all you need to do is consider how you feel about hundreds (or thousands) of people watching you getting tattooed ...

Deeper than the Needle

Getting inked in front of an audience is nothing new. Tattooing has often been a public affair in different parts of the world and has always had its share of rituals and symbolic meanings; in fact, the act of getting tattooed has been just as significant as the tattoo itself. It's the part of the art form that has largely been lost in translation when it comes to Western tattooing, though – a convention crowd is a little different to chanting monks or a singing Samoan community.

That doesn't mean that getting tattoos has to be a spiritual experience. Sometimes it's just a tattoo. But there is equally no harm in letting the creation of a piece of body art become a cathartic moment or in acknowledging its place in a chain of cultural practices stretching back over millennia.

Even without a ritual or spiritual intention, inviting another person to breach our skin, effectively wounding and weakening us, and allowing them to alter us by putting something of themselves – their art, their skill – into our bodies is an astonishing act of trust. It's a unique co-mingling of ideas, cultures and abilities – sealed with the spilling of blood – that is surely incredibly primal on some level and a profoundly human activity. We share eating, fighting, reproducing, killing and more with every living thing on our planet, but nothing else on Earth gets tattooed; it's just us.

Be at Peace

Again, that might not resonate with you, but consider this: getting tattooed might be one of the few times we can make landfall in the liquid modern world. For the duration of the tattoo you are allowed, and expected, to do nothing but sit still. You don't need to work or text or speak. You can just concentrate on the exact present moment with each movement of the needle. That could be a meditative experience, if you like; or it could just be a brief moment of restful solidity. For a little while, regardless of what you were doing before or will do after, you are simply allowed to stop.

Aftercare and Healing

Once the tattoo artist's work ends and your tattoo is in place, your next task begins. In order to really enjoy your ink for years to come, you need to heal it properly.

The artist will generally clean up the fresh tattoo and wrap it (often in clingfilm). Artists and collectors have their own ideas and habits

photocredit Photographer: Aura McKay • Model: Leah Yung

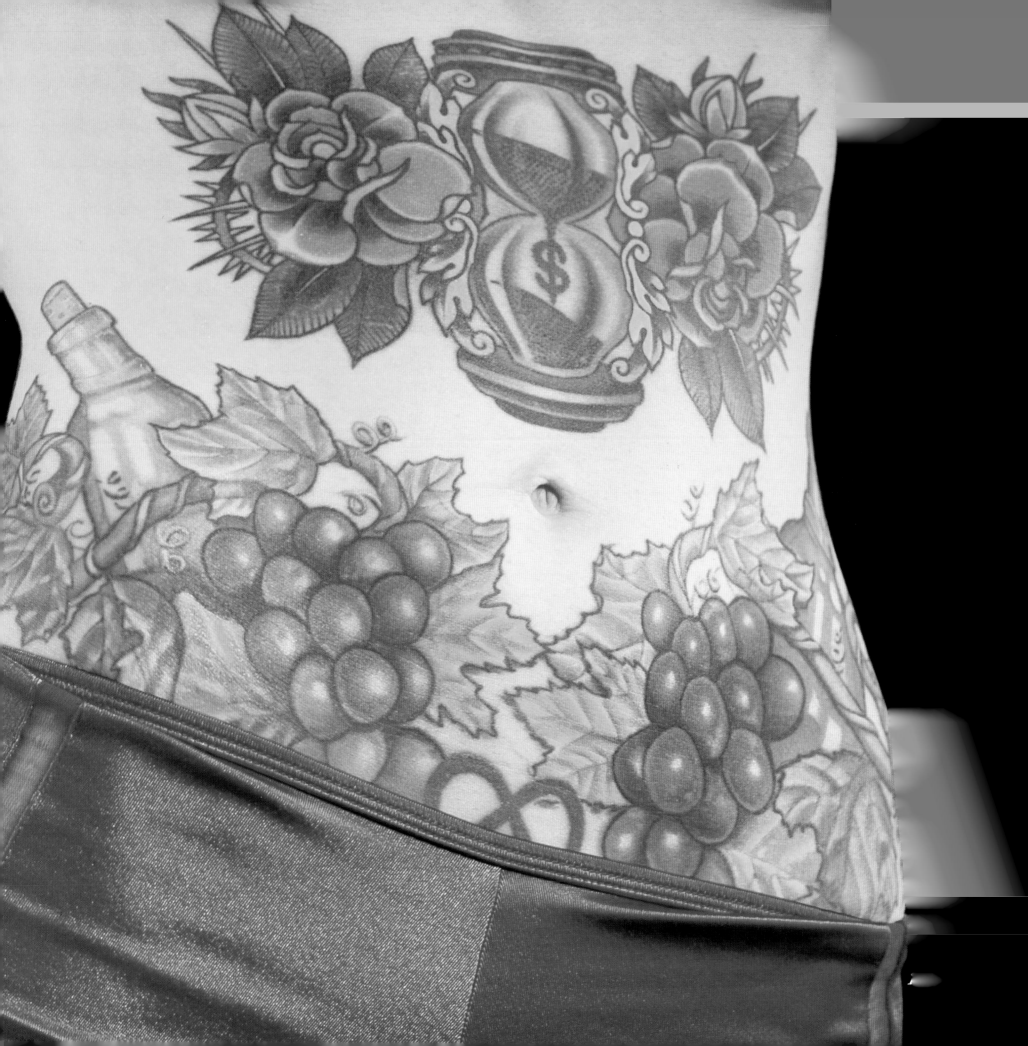

for the next part: some leave it alone and let it heal naturally, whereas others leave it a day and then wash and wrap it a few times a day, adding a light moisturizer (nappy rash creams can be very effective). There are lots of ways to do it; talk to your artist and take their advice.

One rule, though, is absolutely ironclad: DO NOT PICK THE SCAB. However much you want to (and you will want to), the scab is part of the healing process and beneath it the ink is settling into the skin. If you pull up the scabbing tissue, you'll pull ink out of the tattoo with it, as while it's healing the piece is semi-permanent; you can't get rid of it, but you can damage it. Pick the scab and the tattoo will look patchy when it heals, and all that work will have been in vain. So leave it alone!

Lasers and Cover-ups

If you have taken time to pick the right tattoo and had a great artist work on it, you'll hopefully have no regrets. Even old tattoos, whose meaning has changed, faded or even been lost, can be emotional signposts back into our past, showing us how far we have come.

However, if you really don't like what you see – and we all make mistakes and change throughout life – there are a couple of last-ditch options. Laser surgery is one, and the technology is improving. It works but it's expensive, time-consuming and painful (you are effectively

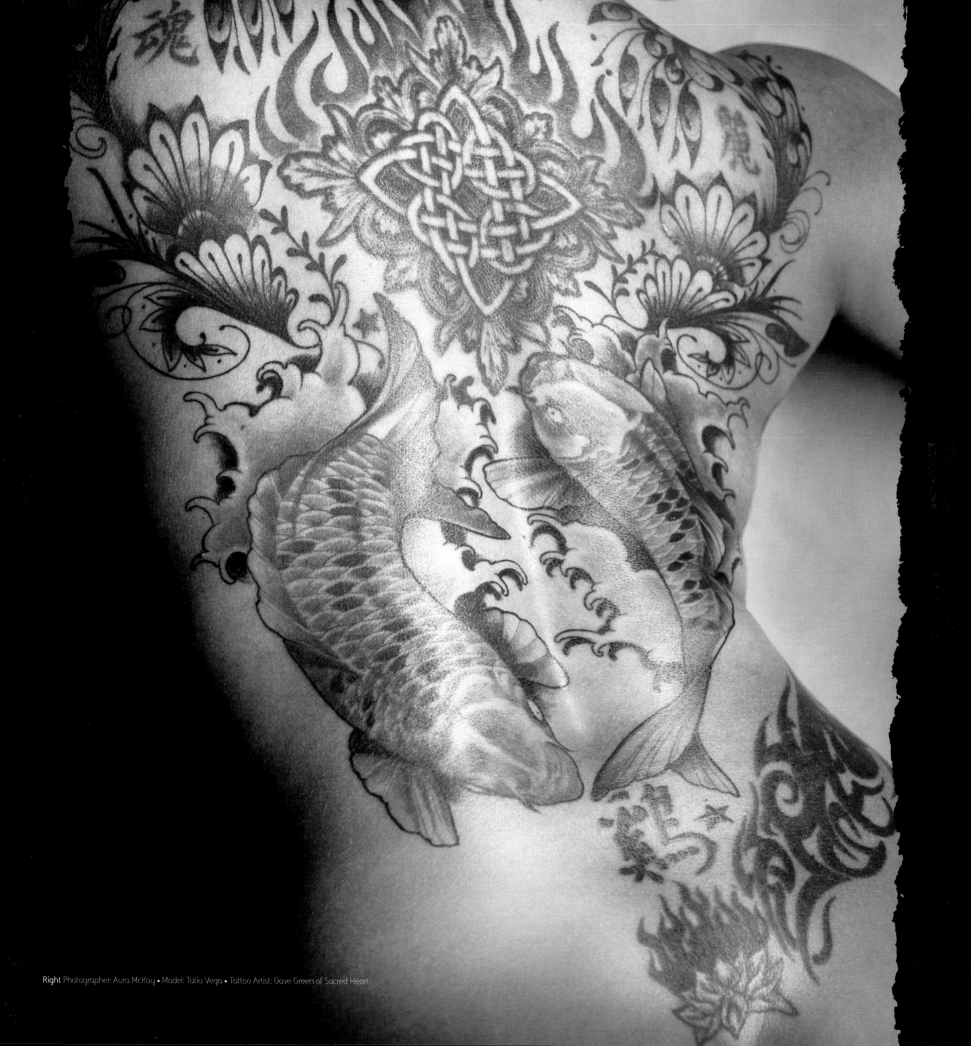

Right Photographer: Aura McKay • Model: Tatia Vega • Tattoo Artist: Dave Green of Sacred Heart

burning the tattoo off – and layers of skin with it); getting the right tattoo in the first place is definitely a better option. The existence of the laser doesn't automatically turn the body into an Etch A Sketch, so it shouldn't be viewed as an alternative to careful planning.

Less damaging to the body is getting old work covered up. This is something of an art in itself, as the new design will have to be bolder and darker to overwrite the old one – and bigger as well. Artists are usually very helpful when it comes to imaginative ways to disguise an old tattoo – flowers and blackwork are favourites – so consult the experts.

Living with Your Art

Hopefully, you'll never need to consider either option and all that is left for you to do is appreciate your art for the remainder of your stay. It's a misconception that tattoos are eternal artworks – they are

as ephemeral and short-lived as we are. If you get tattooed as soon as you legally can, your art might last 70–80 years. The *Mona Lisa*, on the other hand, is over 500 years old and counting.

A 50-year-old tattoo definitely won't look as good as the *Mona Lisa*, either. That's the other reason why body art is impermanent: it ages along with us. That's surely part of its charm, though. Over time, collectors cease to see their art as separate to themselves; it just becomes part of their anatomy, changing just as imperceptibly.

In time, you can have a tattoo touched up and recoloured to give it a boost, and there are a few things you can do to keep it fresh along the way. Moisturize, take care of the skin and keep tattoos out of the sun – nothing will do them more damage than our solar companion. If you are letting them out for some air, cover them in factor 50 and they'll stay pretty for longer.

But some change is inevitable; that's life. And life – with all its diversity, colour, wonder and incomprehensible strangeness – is what tattoos have tried to reflect for thousands of years. That's the real beauty of tattoo art: it's all about life.

Enjoy your ink.

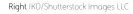

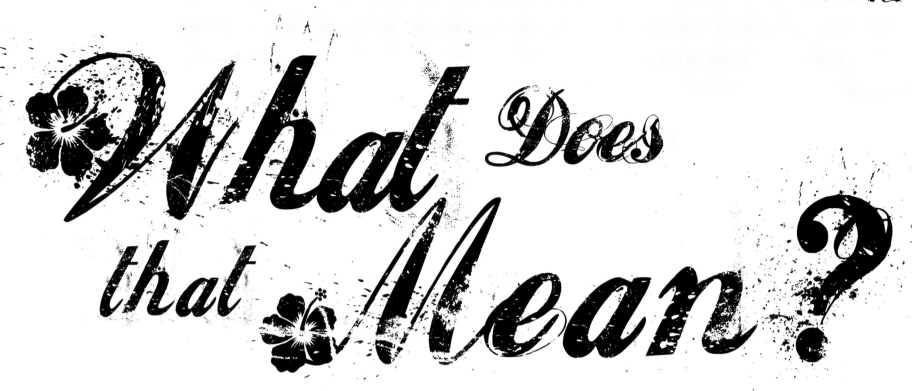

What Does that Mean?

At some point, anyone who has a tattoo will be asked about its meaning; people are inherently curious about the stories that inspire ink. Of course, a tattoo doesn't have to mean anything at all and can simply exist for its own sake, as a piece of art.

However, throughout their time on Earth, tattoos have accrued a vast amount of symbolic meaning so, for those who want their body art to speak volumes, there are sure to be a number of tattoo styles, images or symbols available to get the message across. No tattoo meaning is fixed and they can represent whatever the wearer chooses, but here are some starting points and established conventions.

Prison Tattoos

Historically, tattoos have been employed at various points by different cultures to designate criminal status, but it was inevitable that those falling foul of the law would ultimately reclaim the art form for themselves and put their own stamp on it.

While prison tattoo iconography might not feature in many people's plans for their artwork, it's nonetheless a fascinating topic to study, and some academics have done just that. In the nineteenth century, French academic Dr Alexandre Lacassagne carried out a detailed investigation into the tattoos adorning former convicts. He collected tracings of more than 2,000 original tattoos and classified them according to subject and position; many of the markings he observed are still in common use today.

Recurring images and motifs described in Lacassagne's *Les tatouages: étude anthropologique et médico-légale* (Paris, 1881) include standard-issue fare such as names, dates and even arrows, but there are some symbols unique to France. Chest and back pieces bearing uplifting slogans such as 'liberty or death', 'born under an unlucky star' and 'vengeance' crop up, as does the regular use of three dots placed

between thumb and forefinger on the left hand, in a triangle. The symbol stands for *mort aux flics* – 'death to the cops'.

Dots of Danger

Dots on convict tattoos could (and can) mean other things too. Five spots arranged in dice formation signified a man between four walls, i.e. a prisoner, in France, whereas for Hispanic communities in the US prison system they might also represent the Holy Trinity or stand for *ma vida loca*: my crazy life.

Only a little larger than a dot, but carrying even weightier meanings, the teardrop tattoo is prevalent throughout the US prison network (and appears on the faces of hip-hop artists such as Lil Wayne). A provocative symbol, it can refer to time served, the number of people a person has killed or solidarity with a loved one in prison; it can even act as a memorial to fallen friends and gang members.

From Russia with Pain

Russian prison tattoos are probably the most notorious and most heavy with symbolism, and they could feature images signifying everything from anti-government sentiments to gang membership and status within the prison community.

A few common symbols included a church, where the number of spires denoted time served, a spider's web, pointing to being ensnared within the prison system (and also marking off the years of incarceration), a rose on the chest, proclaiming membership to the Russian mafia, and even the Madonna and Child to signify a lifelong

thief. The tattoos could be status symbols but were also forcibly bestowed on prisoners by gangs as punishment for their crimes, for disloyalty or even for failing to pay debts.

O, Death

Wearing the wrong kind of tattoo in a Russian penal setting could dramatically affect a prisoner's life expectancy, but that is certainly not the only link that tattoos have with death. Some tattoos amongst Native American tribes were believed to provide admission to the afterlife: a warrior's soul would be sent back to the world to wander as a ghost if their ink credentials were found to be lacking when they entered the spirit lands. Tattooed images from other cultures would signify a life taken (such as those on the hands of the Dayak people of Borneo), while others (Thai tattoos in particular) were intended to ward off evil spirits.

Don't Fear the Reaper

The idea of death preoccupies modern society – and therefore the contemporary tattoo collector – just as much as it did ancient tribes. Organized religion, philosophy, literature and art all provide arenas in which we can wrestle with our mortality, and from them a character has emerged, who transfers well to the tattoo world: Death, in person.

In our rage against the dying of the light, it's logical that we have personified death, as that gives us an enemy or concept that we can actually see and attempt to rationalize. Death wears many costumes, such as a rider on a pale horse in the Bible (Revelation 6:8) or a character in the *Everyman* morality play from fifteenth-/sixteenth-century Europe. He even appears, white-faced and black-

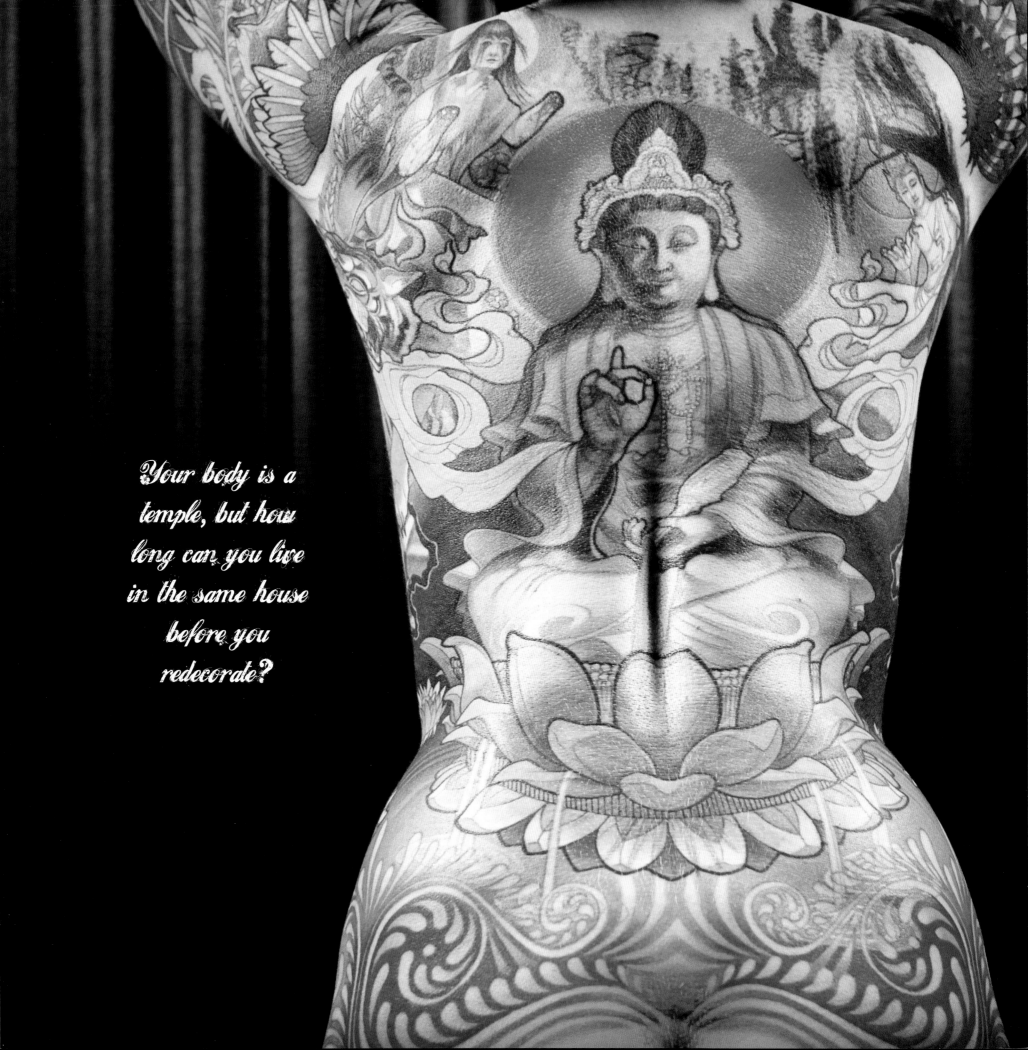

Your body is a temple, but how long can you live in the same house before you redecorate?

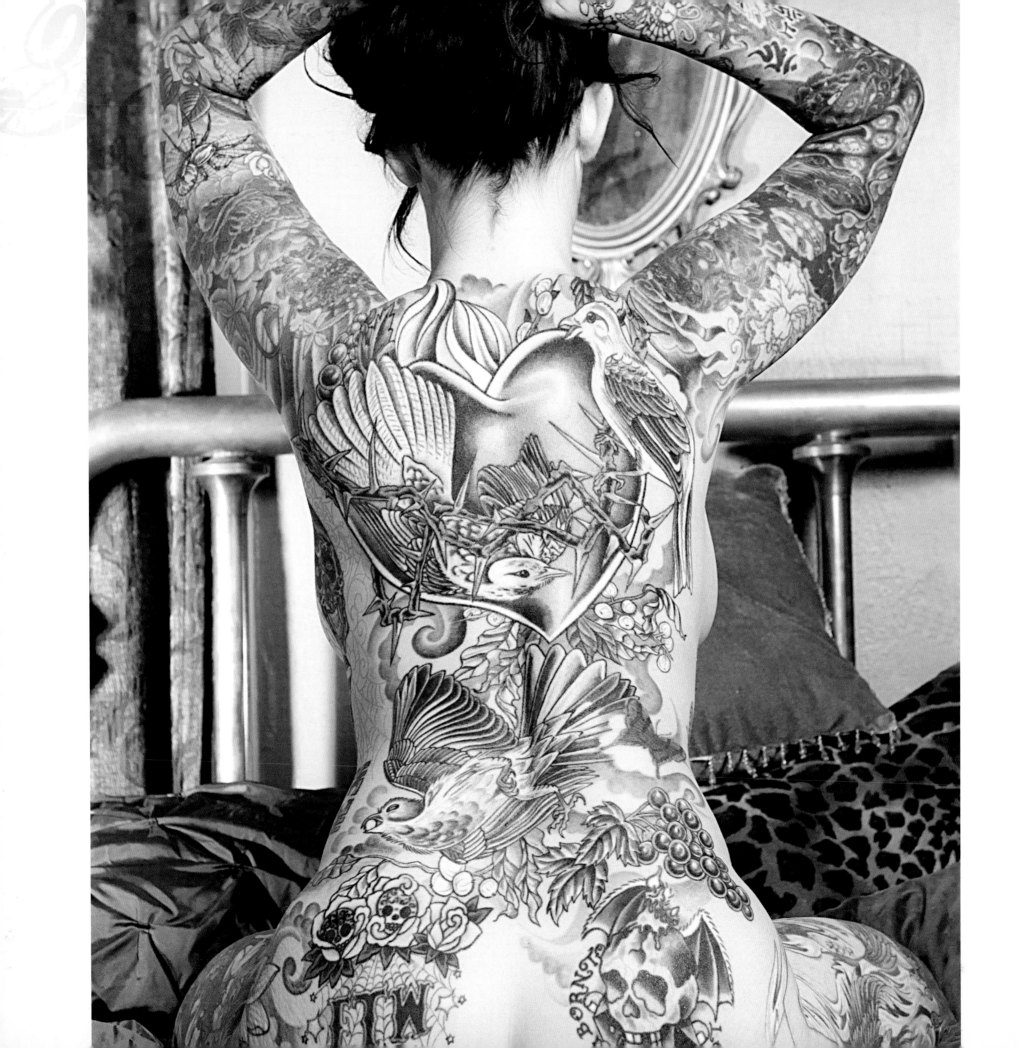

robed, to play chess on the stormy beach in Ingmar Bergman's *The Seventh Seal* (or Battleship in *Bill & Ted's Bogus Journey*, if you prefer).

Death can appear in tattoo art in any of these guises, but perhaps his most common representation is the form of the Grim Reaper — hooded and armed with a scythe to harvest souls. Death's appearance in ink might have a religious motivation or serve as a reminder — as it does in *Everyman* — to live well now, because death (and perhaps judgement) is waiting.

Sweet Skulls

Beneath the Reaper's hood is usually a skull — itself a potent image of death and a hugely popular tattoo design. Like the Reaper, a skull can remind wearer and viewer alike that death smiles at all of us, and it can be a dignified, democratic symbol of the single unifying truth facing humanity: regardless of race, colour or creed, we bear the same skulls underneath, and we will all die.

However, skulls can be a little more fun than that too. Rendered in traditional Americana-style designs with their origins in biker gangs, a skull might show a fearless attitude in the face of death; add a snake coiling through the eyes and it becomes a symbol of immortality, either of the soul or of an individual's beliefs and ideals.

Skull tattoos can equally be instruments of terror and intimidation or indulge the wearer's taste for the Gothic, but another extremely popular incarnation goes in the opposite direction. Tattoo versions of colourful Mexican Day of the Dead sugar skulls (*calaveras*) share the same intention as their confectionery *compadres*: celebrate the lives of the deceased, encourage their spirits to inspire us in life, advertise that life goes on and even bring luck.

Remember, Remember

Skulls and bones serve admirably as reminders that death (or a pirate) is near, but tattoos commemorating the lives of others don't have to be limited to mortal remains. Of course, scrolls with dates, portraits and tombstones are unmistakable signs of a life's passing, but those wanting to note a death via their skin might choose any number of more subtle references to our bony friend.

The natural world has traditionally provided plenty of inspiration. The ancient Egyptians used the scarab beetle to represent both death and rebirth (scarab totems are often found buried with mummies), and many cultures feature the phoenix — an immortal bird that dies in flames and rises from its own ashes to live again. On the ground, black cats and jaguars (in Andean culture, especially, for the latter) are heralds of death, either of the soul or of a time in a person's life.

Those wanting something more visceral might plump for maggots: a nod towards the eventual corruption of the flesh. For a less wriggling image, twin dice showing ones ('snake eyes') or the ace of spades are popular deathly signifiers. Finally, ivy might be one of the more abstract and serene options; its ability to grow and thrive even on dead trees points to the tenacity of life and the capacity for either the immortal soul, or our memories of the departed, to endure.

Pat Fish

Tattoo Artist

Pat Fish decided to learn how to tattoo almost 30 years ago. She wanted an occupation where she could pursue art full time, and have direct contact with the person she was making the art for. Pat went to Cliff Raven to get her first tattoo, and afterwards showed him her art school portfolio. In a remarkable stroke of good fortune, Cliff agreed to teach Pat his art.

From the beginning, Pat has focused on bringing the knotwork of ancient Irish Celtic illuminated manuscripts and the carved Pictish stones of Scotland to life on skin. She does other types of tattoos, but these intricate patterns fascinate her the most, and she takes pride in being able to work in the ancient style to create custom designs. To take a knot that may have been carved on a gravestone many centuries ago and transform it to fit a client's body is a challenge she greatly enjoys.

Her assistant Colin Fraser performs a vital step in the process by taking Pat's line drawings of knots and morphing them in Photoshop to conform to the relevant body part of the client. They work as a team, switching from analogue to digital. What begins with something that Pat draws on graph paper with a light box then moves to a Mac, where it can be stretched and transformed, thereby accelerating the project with digital magic. The photos in this book show a custom creation of one continuous piece of interlaced knots, giving the impression of body armour.

Pat is proud to be able to offer this style of tattoo work to the people who come to her to become art at her studio in Santa Barbara, southern California.

for more information visit her website www.luckyfish.com

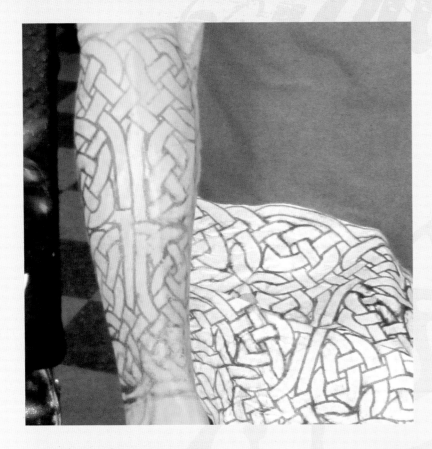

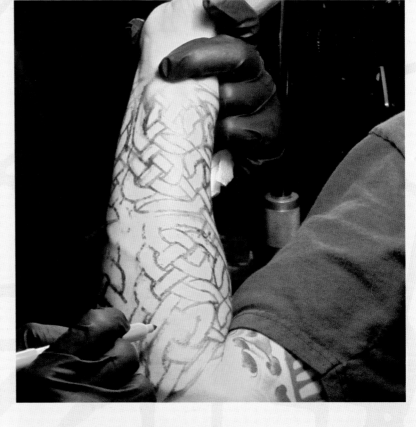

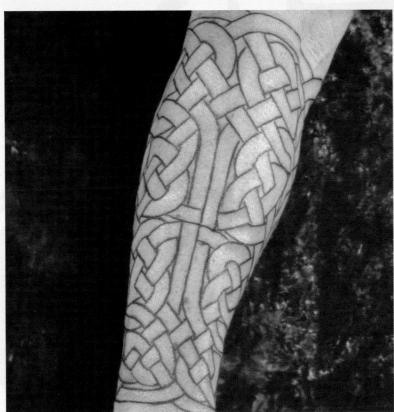

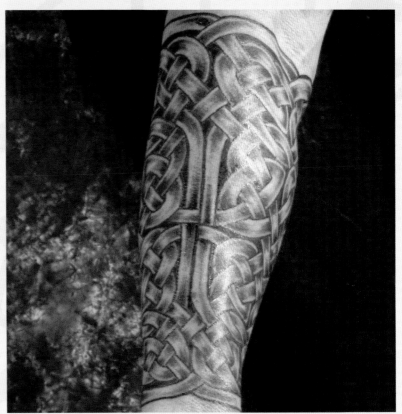

or view his patterns for sale online at www.luckyfishart.com

How Does Your Garden Grow?

Ivy and vines in general have other symbolic functions beyond death, and some of them are a lot more light-hearted. The ancient Romans believed that ivy soothed hangovers brought on by wine, so a different function of those winding leaves might be to keep a collector's head clear the morning after (there is no guarantee that this works, alas).

Plants – and more specifically, flowers – have a big role in tattooing. Some of it is purely functional, as a dark bunch of leaves is great for covering up old tattoos, but there are plenty of other things that those pretty petals can say.

The Name of the Rose

Roses are the bedrock of traditional tattooing; it's hard to look through a sheet of vintage flash without seeing them, and they are just as prevalent today. This is partly because they make great tattoos and the early Old School artists had a limited colour palette that suited red and green roses beautifully; but the blooms have also been tremendously significant throughout history, and tattoos can reflect this.

The obvious meaning is love, which can take many forms. Romantic and erotic love – again, a prime motivation for many tattoos – is simply and strikingly embodied in the image of the red rose thanks to numerous associations with romantic poetry or even the idea of red as representing passion; add the thorns and the image shows love's capacity for causing both pleasure and pain. Further down the erotic route, a rose of Jericho artfully conceals the folds of a vagina within its petals, fusing love, sex and beauty into one image. However, a rose can also point to love of any kind, with no sexual undertones.

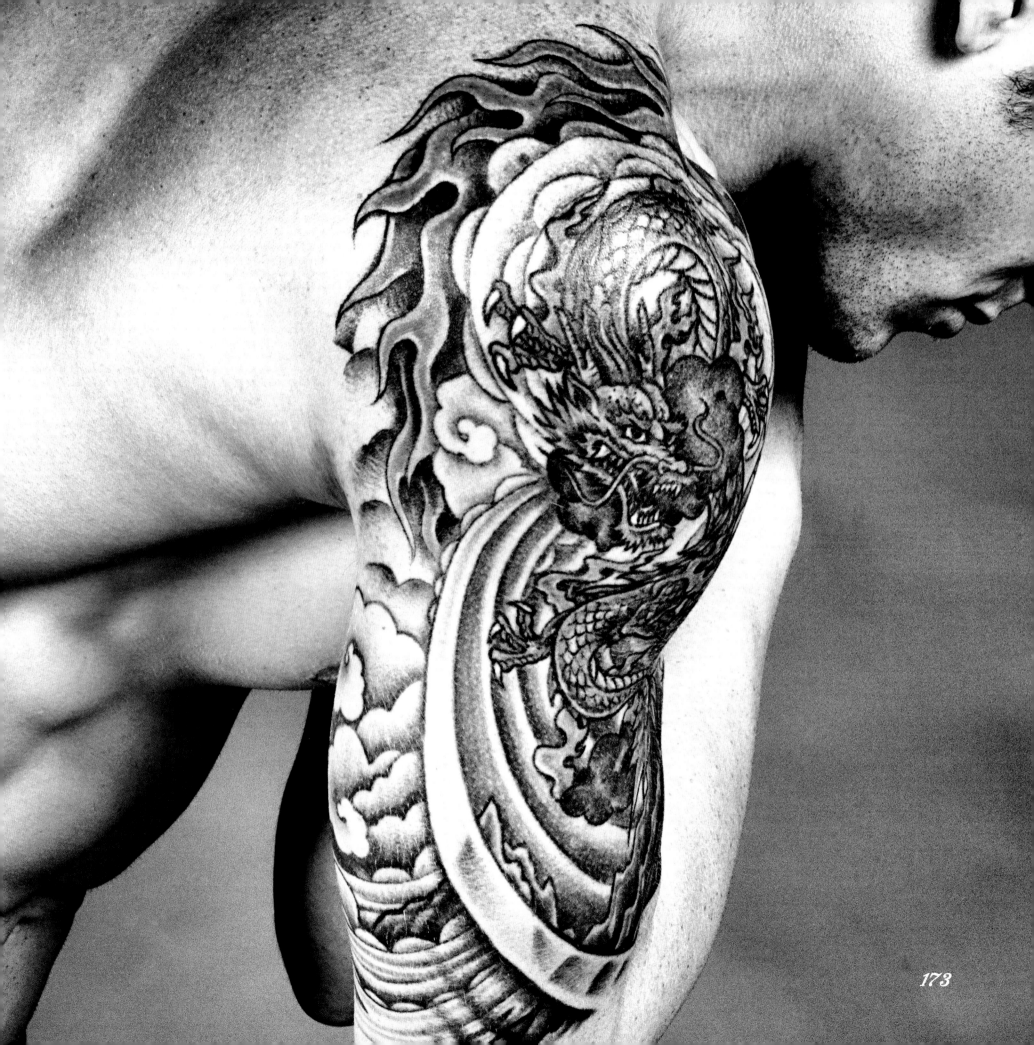

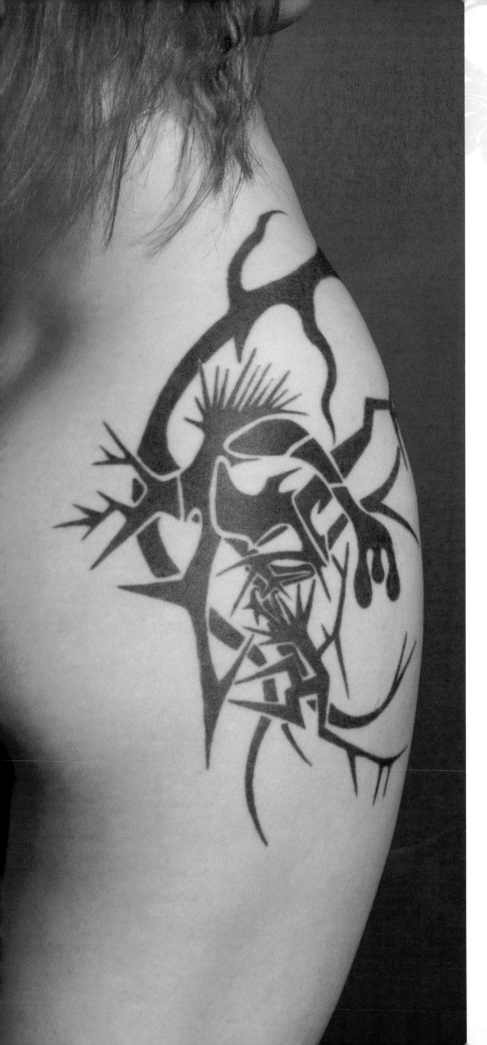

Red roses have also taken on special importance in the Christian faith and might represent the blood of Christ (and thus His love and sacrifice for mankind), while the thorns can refer to the mocking crown placed on His head during His crucifixion.

Lotus Eaters

As the rose is sacred to Christianity, so the lotus is divine in both Hinduism and Buddhism and adherents of either faith might choose a lotus tattoo for that reason. A water-borne flower, the lotus is revered by Hindus for whom water is itself sacred; for Buddhists, it represents purity and perfection and embodies clear-sighted Buddha nature. It's also described in some interpretations of the heart mantra '*Om mani padme hum*' as referring to wisdom – the mantra is a popular Sanskrit tattoo in its own right.

In tattoo culture at large, the lotus has also become something of a catch-all symbol of a general spirituality, perhaps building on its existing importance in Eastern religions. The flower is a popular image in dotwork tattoos but can appear in designs of any kind, adding beauty but also an immediate spiritual tone to a piece.

From the divine to the decadent, the lotus has also featured in episodes from classical literature – most notably, Homer's *Odyssey* and Tennyson's *The Lotos-Eaters* – where consuming the flower led to moral and spiritual lassitude. Lotus eaters forget all responsibility and effectively turn their backs on living meaningful lives; a lotus tattoo could serve as a warning against indolence or to acknowledge a potentially destructive longing for an indulgent existence.

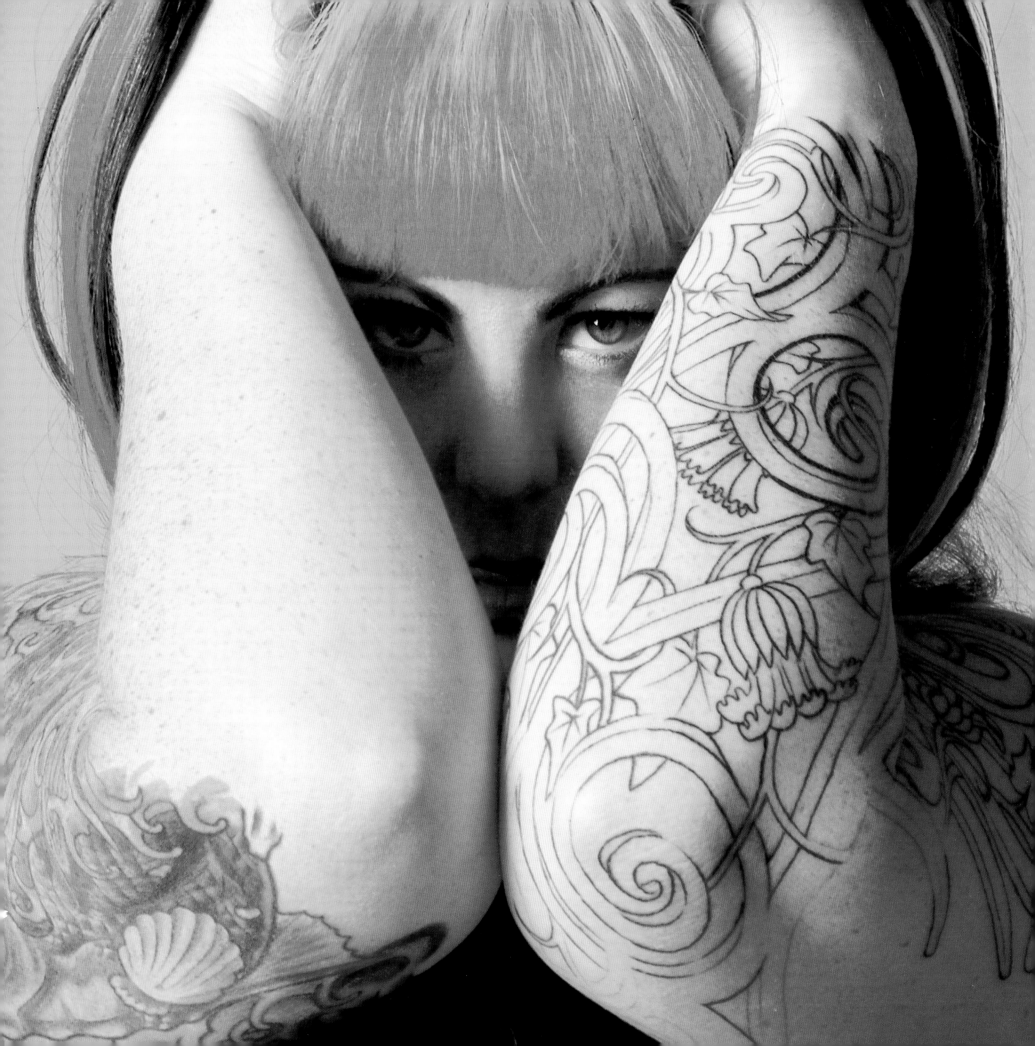

Sweet Cherry

Indulgence is fruitily expressed in some representations of the cherry in tattoo art. While it's perfectly possible for cherries to appear because they are sweet and delicious, both 'sweet' and 'delicious' can be given a lascivious symbolic twist. Cherries can signify virginal innocence or an ironic lack of it, appearing as playfully flirtatious or plump with ripe sexuality, and can be tattooed with differing amounts of dripping juice, accordingly. Tasty.

From the sexy to the sublime, cherry blossom fulfils an entirely different role in art and tattoo designs. The beautiful pink and white blooms appear only fleetingly and herald spring, which makes them delicate symbols of renewal or rebirth.

At the same time, their blink-and-miss-it arrival and departure can represent the brief flowering of the human soul – here and gone in an instant. To that end, they are a regular feature of traditional Japanese tattooing, where they are known as *sakura* and epitomize the samurai ideal: proudly beautiful and ready to accept death and fall in a heartbeat. Tattoos of cherry blossom also contain Buddhist notions of impermanence: all life is change and nothing remains – not even the cherry blossom (or even the tattoo) – so life should be lived awake in the present moment, unburdened by past or future.

All at Sea

The oceans are another symbol of restless impermanence, ceaselessly changing as the tides ebb and flow. Waves and water feature prominently as elements in Japanese tattooing and nautical themes are essential to the classic tradition of Old School tattoos.

Sailor tattoos plug right into the creation of modern tattooing in the West. Seafaring men with strange markings – heady souvenirs of the strange lands they had visited – kick-started the tattooing movement and the tidal wave hasn't abated since. Over time, sailors created an entire mythology around their tattoos, as could be expected from men whose lives depended on the unpredictable moods of a savage mistress such as the sea. A few talismans were definitely going to help.

Shipping Out

Ships are important images in tattooing and, for sailors, a rigged ship in full sail would traditionally mean that the wearer had safely made the journey around Cape Horn. In the early days of Americana, sailors would swear that Sailor Jerry's ship tattoos were nautically accurate in terms of their rigging.

In a slightly different version of the image, a ship could also appear to be sinking. Referred to as 'Sailor's Grave', the image at once recalled the perils inherent to a life at the mercy of the waves and acted as a good luck charm to guard against the risks of shipwreck. It could also commemorate a real-life sinking.

Up in the rigging of those ships, life was all about holding on – whatever the wind and waves threw at you. Sailors would cling for grim death to ropes, which is why many had the words 'Hold Fast' inked on their knuckles: to remind both themselves and their shipmates not to let go.

These days, those words can take on a wider significance, for landlubbers as well as sailors, when applied to the storms of life, reminding us to hold on regardless. Likewise, ship tattoos are no longer the sole preserve of mariners; instead, they might honour a seafaring friend or symbolize travel, escape and wanderlust.

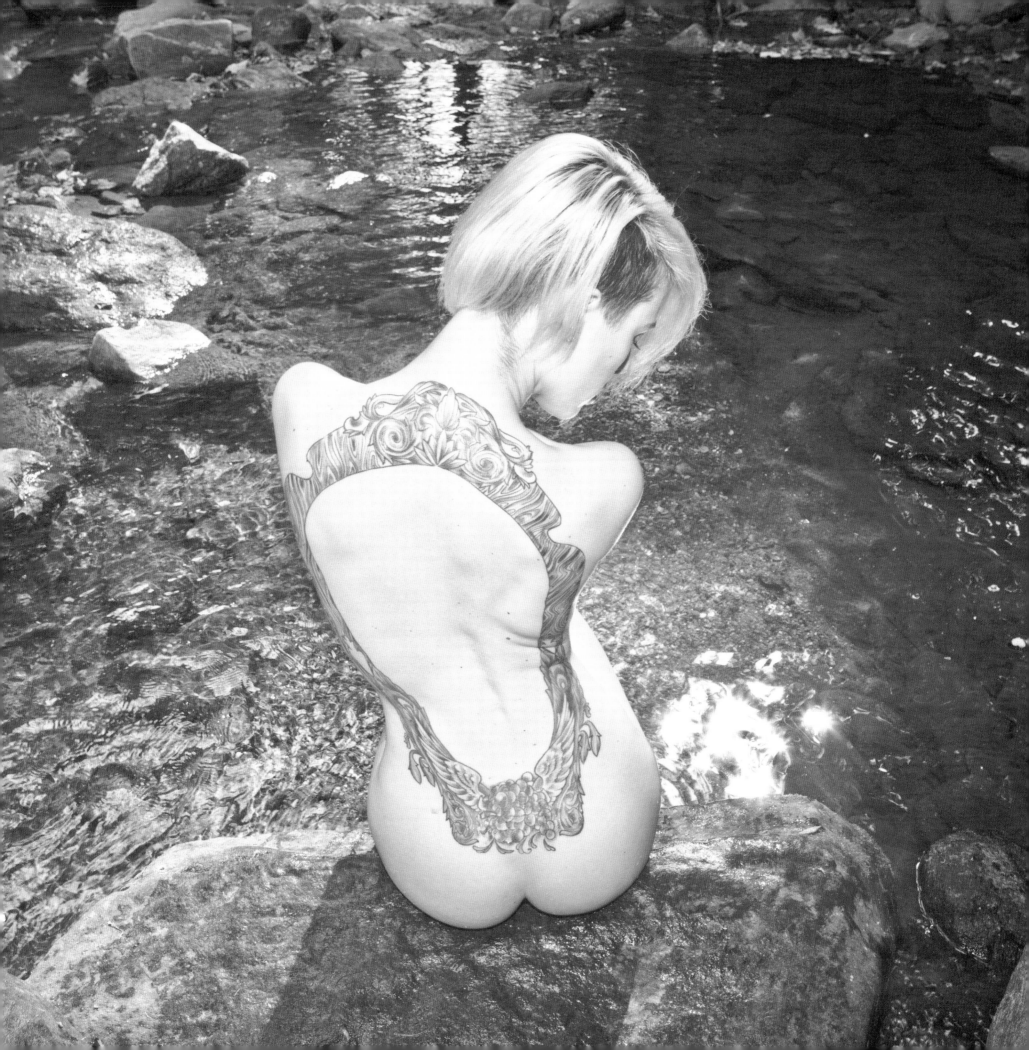

Hold Steady

Another favourite amongst mariners – cartoon or otherwise – is the anchor. Sailors have worn them as tattoos for centuries, and in some cases they symbolize a young sailor's first crossing of the Atlantic. They have a more general appeal, though, as an anchor is vital to the safety of any ship – or any soul. An anchor holds a ship steady against the tides and undertows, keeping it secure; an anchor tattoo might fulfil the same function for a collector, helping them to remain firm no matter what currents may tug at them or what temptations may cross their path.

Speaking of temptations, mermaids are right up there when it comes to watery peril and make for popular tattoos in a range of styles – they are not limited to traditional representations. In classical mythology, sailors were lured on to the rocks by the songs of the sirens (or mermaids); only Odysseus resisted their songs and he only managed that by being lashed to the mast of his ship. Given that this would be inconvenient for most people, a mermaid tattoo is a more practical warning against temptation – although it could also be a lure, depending on the wearer (and how much they like sailors).

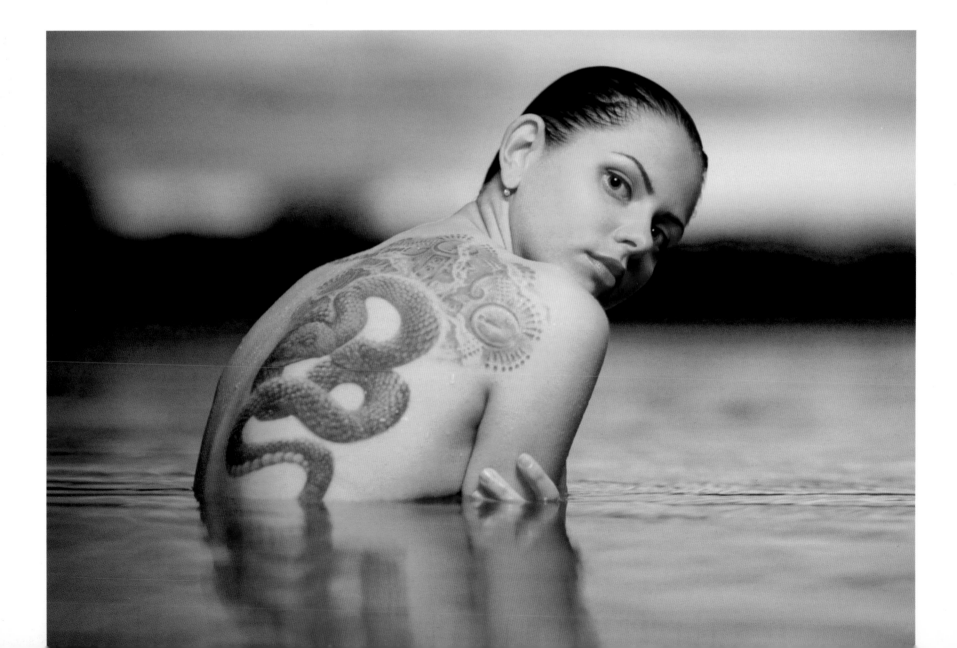

Swallowed Up

According to one school of thought, the original concept of mermaid sightings came from sailors who, driven almost blind by sexual frustration, spotted basking manatees or seals on far-off rocks; to their lust-crazed eyes, even a blubbery sea beast counted as a hot prospect. However apocryphal these stories are, there is little doubt that sailors would have been delighted to spot a different creature: the swallow.

Swallow tattoos are intimately linked with the history of traditional tattoos. They stand for love and fidelity (a jilted lover might sport a swallow with a sword through it, with obvious meanings, although the same image can also commemorate a friend lost at sea), but to sailors they represented imminent landfall — swallows don't fly far out to sea — and therefore became good luck tokens. It's a function they still have for any tattoo collector. Their other traditional meaning, however, is usually overlooked: they denoted that a sailor had travelled 5,000 nautical miles (two swallows meant double that).

Other critters play a role in nautical tattooing. Sharks act as totems against, well, sharks, whereas turtles show that a wearer has crossed the equator. Stranger inclusions are the pig and the rooster, traditionally placed one on either foot. Neither can swim and their aversion to water means they will help an overboard sailor make it swiftly to shore or, by extension, help anyone who feels like the tide is rising around them.

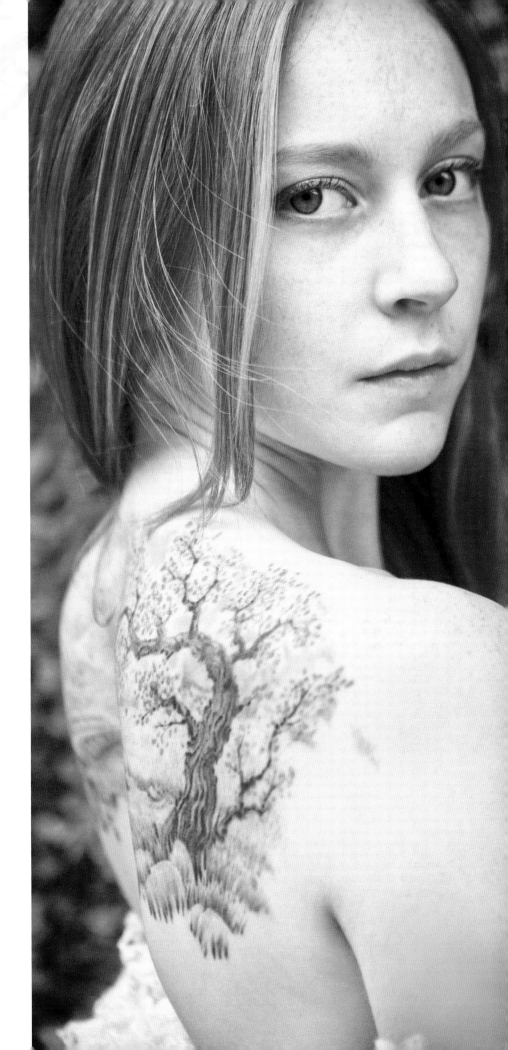

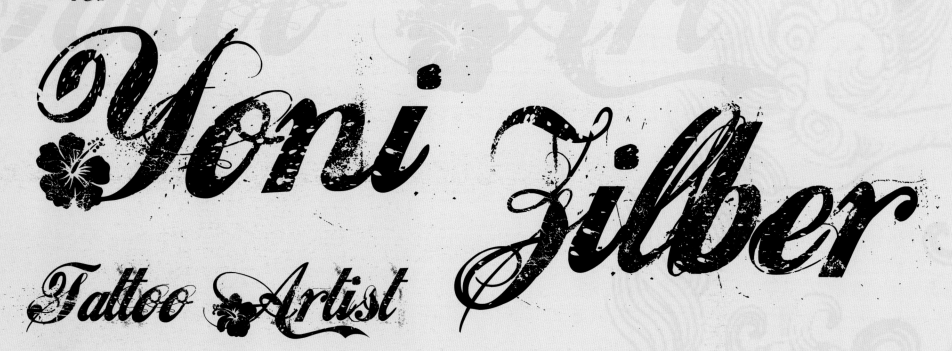

Yoni Zilber
Tattoo Artist

Born in Israel, Yoni Zilber has been tattooing since 1998. He bought his first tattoo magazine at the age of 12, and spent much of his time drawing and copying many of the images he saw on skin and on record album covers. He got his first tattoo at the age of 14 and from that time he knew he wanted to be a tattoo artist.

In Israel, it was not easy to find a teacher, so instead Yoni got more tattoos from the same artist, and after a lot of persuasion he was finally allowed to trace the studio's designs. He then practised with needles and designs for two more years before he did his first tattoo – and he has never looked back.

Yoni has worked and continues to specialize in a number of different artistic styles, including Thai, Art Nouveau and ornamentals. In recent years, he has developed a deep admiration for Tibetan art, and believes sensitive line expression, rich compositions and simplicity lend themselves beautifully to the body. To succeed in this complex, ancient style, Yoni studied tirelessly but found he could only progress so far. However, in 2007, he was lucky enough to meet and become an apprentice to Pema Rinzin, an accomplished Tibetan Tangka painter and contemporary artist, whose work adorns walls in the Dalai Lama's temple in India, as well as the Rubin Museum in New York.

When working, Yoni likes to draw the main image in advance and stencil it, and the background is done freehand. He is particular about the parts of the body he tattoos, favouring those areas that age well. He is also sensitive about tattooing sacred images too close to the ground, as this is disrespectful in some cultures.

for more information visit his website www.yoniztattoo.com

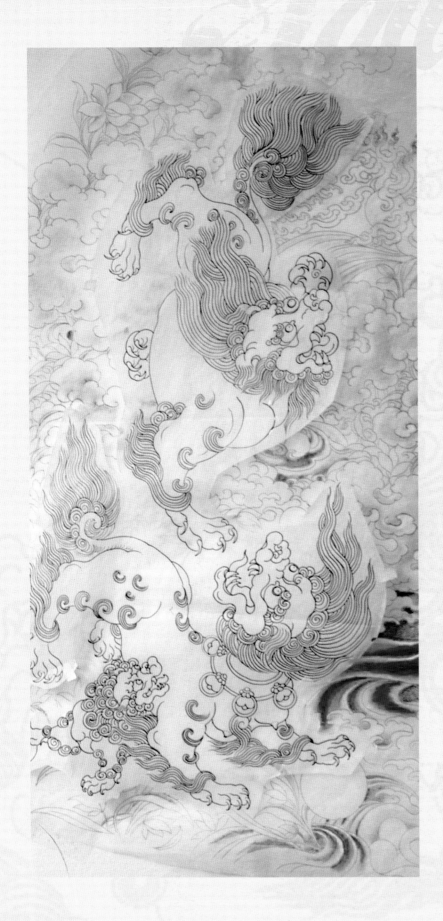

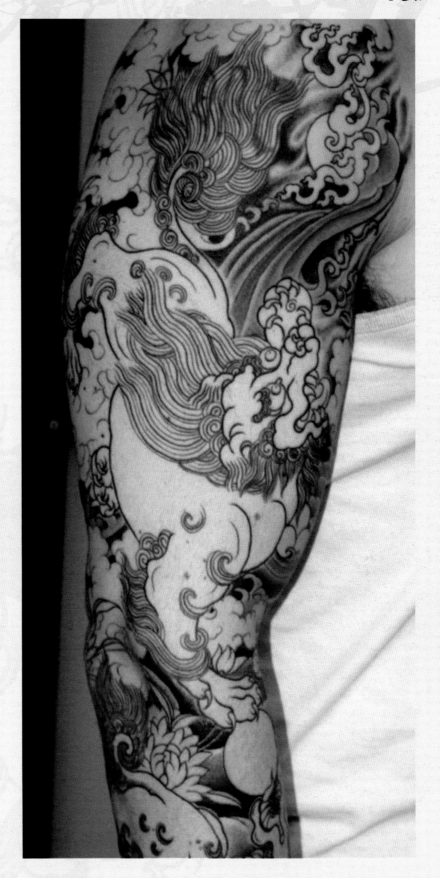

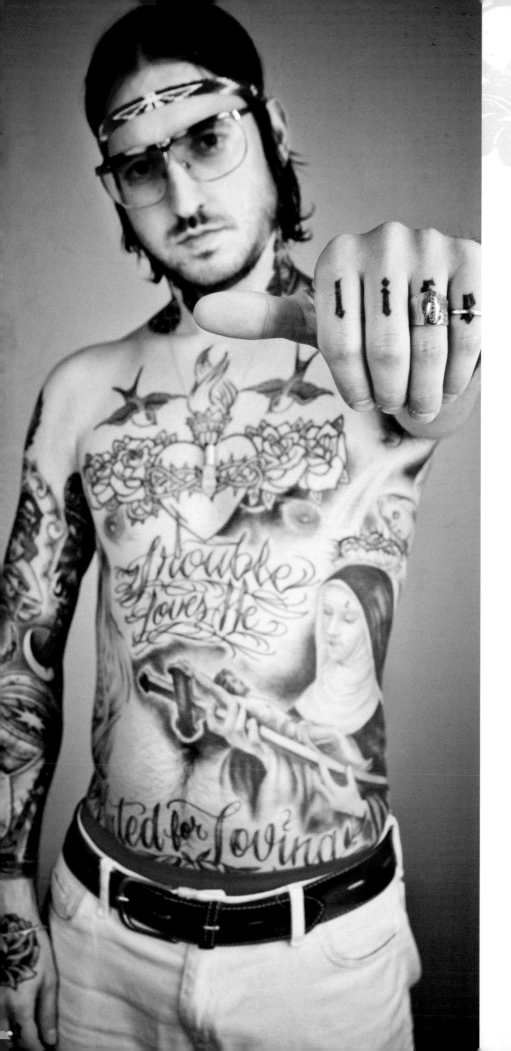

Into the East

The visual world of Japanese tattooing contains a veritable mythical bestiary full of creatures rather more exotic than the barnyard stalwarts of nautical tattoos. It's a style rich with symbolism that attracts many collectors due to the elegance of both the art and the allegorical messages it conveys.

Strangely, the story of tattooing falls rather silent in China. However, many Chinese fables and traditions made their way to Japan and eventually found expression in the country's culture, including its body art. While the concept of the samurai is uniquely Japanese, other elements, such as dragons, are shared by both nations and influences from China and Japan alike can be seen in modern Japanese tattoos.

Enter the Dragon

The dragon as it appears in Japanese tattoos is a wholly different beast to the fire-breathing monster of European folklore. Rather than a creature of flame and fury, it is spirit of water and rain, so dragon tattoos are often surrounded by both swirling clouds and waves. They don't have wings and appear instead as a serpent-like presence of great power.

Dragons can have many complex meanings. In tattoos, they might act as protecting spirits which safeguard the wearer or bring them luck. They are also considered to be wise, noble and compassionate, as their association with both Japanese and Chinese emperors gives them a royal status, perhaps even suggesting leadership. A dragon is seen as embodying our higher, better natures and is the most powerful and auspicious mythical creature, so it naturally has an elevated rank in the tattoo pantheon.

Sharing similar qualities of strength and power, samurai warriors in tattoos can signify fearlessness in the face of adversity and also an unquestioning sense of loyalty. In the heyday of the samurai, a warrior would dedicate his life to the service of his master and die for him without hesitation; the age of sword swinging may have passed, but samurai tattoos still reflect these qualities of service and selfless devotion.

Crouching Tiger, Hidden Dog

From the noble to the savage, tigers possess a terrible beauty and strength — poet William Blake wrote of their 'fearful symmetry', which seems appropriate when thinking about the big cats in art. They know absolutely no fear and fight with swiping ferocity; their brutal charisma makes tigers a popular tattoo choice for martial artists and anyone who wants to evoke (or even invoke) courage and a fighting spirit through their tattoos.

Tigers, with their predatory nature and capacity for violence, also symbolize the darker side of human nature in Japanese tattooing: a potentially destructive force stalking unseen through the unlit jungles of our hearts and minds. They often appear doing battle with dragons, thus representing a metaphor for the constant struggle between our higher and lower selves. If the dragon is above the tiger, the better nature is winning, and vice versa; perhaps the most honest placement is showing them evenly matched.

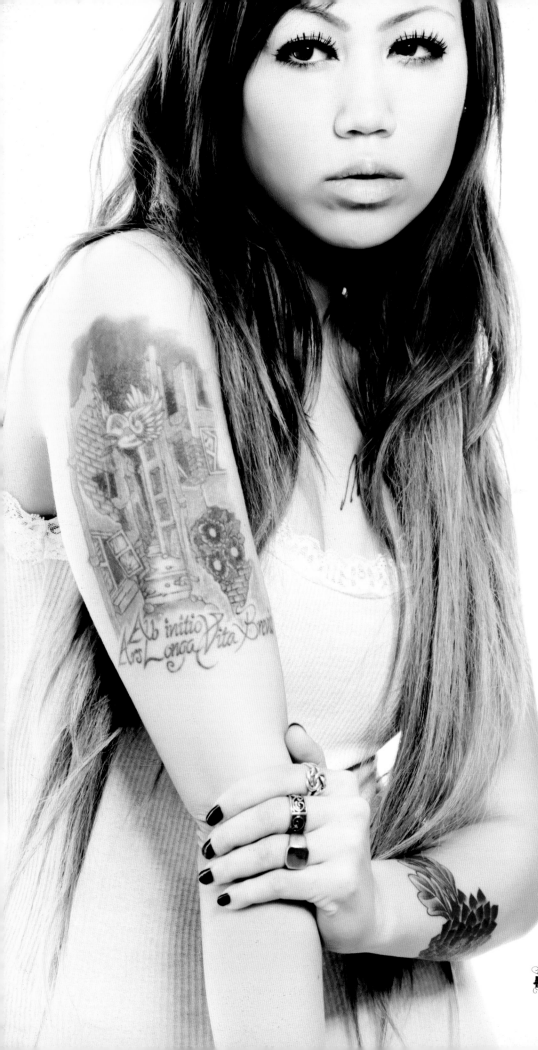

More positive and less prone to skull-crunching are Foo Dogs, traditionally depicted as a pair. They are actually not dogs at all; they represent how lions looked in the minds of ancient artists who heard the beasts described but never saw them. Also known as Lions of Buddha, they are his spiritual companions and act as guardian spirits outside homes and temples; stationed on the skin, they serve exactly the same purpose. Nice doggie. Sorry, lion.

Go Fish

Depicted more accurately than lions, the uphill battle of the koi carp as it fights river rapids to make it upstream has made this elaborately patterned fish an ancient symbol of perseverance against all odds. It can reportedly live for hundreds of years, which further added to its potency as a symbol of endurance in the Japanese tattoo canon.

Koi were traditionally the earliest tattoos a young man would receive – *yakuza* or not – when beginning his journey through both adult life and tattooing. Just as the fish leaps and struggles to overcome obstacles, so will the person bearing its image on their skin, which again makes a koi tattoo the perfect choice for anyone either facing trouble ahead or wishing to be prepared when problems occur.

The potential rewards for toiling upriver can be great. In Chinese legend, the koi that made it to the Dragon Gate on the Yellow River and jumped through would be transformed into a dragon – the most magical of all beings. In the evolution of a person's tattoo, they might finally attain a dragon back piece to symbolize the end of their journey. That might not be the end goal for every collector, but the koi is a symbol sufficiently suffused with courage, strength of character and sheer determination to make it a satisfying and inspiring choice for a traditional Japanese tattoo.

Keep the Faith

Moving away from the Japanese style and symbolism linked specifically to koi, the fish remains a recurring image that has carried other meanings over the years, which still appear in tattoo art. It's a common symbol for Christianity, for example, modelled on the secret fish sign that early Christians would use to advertise meetings while avoiding persecution. (*Ichthus*, the Greek word for fish, became an acronym which read 'Jesus Christ, Son of God, Saviour' when translated.)

Tattoos are often used to demonstrate faith of all kinds. Some images have obvious meanings but others have acquired many layers of significance over time.

Cross Purposes

The cross, for example, is an extremely popular tattoo and carries with it clear references to the Christian faith, whether or not Christ Himself features in the design. They can be embellished: three lines at the top is the symbol for the Pope, whereas three at the bottom represent the Holy Trinity. But the cross has never been an exclusively Christian image and can be used in tattoos for other purposes.

The Latin cross – with a longer vertical arm – is most commonly linked to Christianity. A Greek cross, however, with arms of equal length, can be shorthand for the four points of the compass, the four elements (Earth, Wind, Fire, Water), the human form and more abstract ideas, such as harmony and balance, because the lines intersect in the centre and the image is perfectly symmetrical.

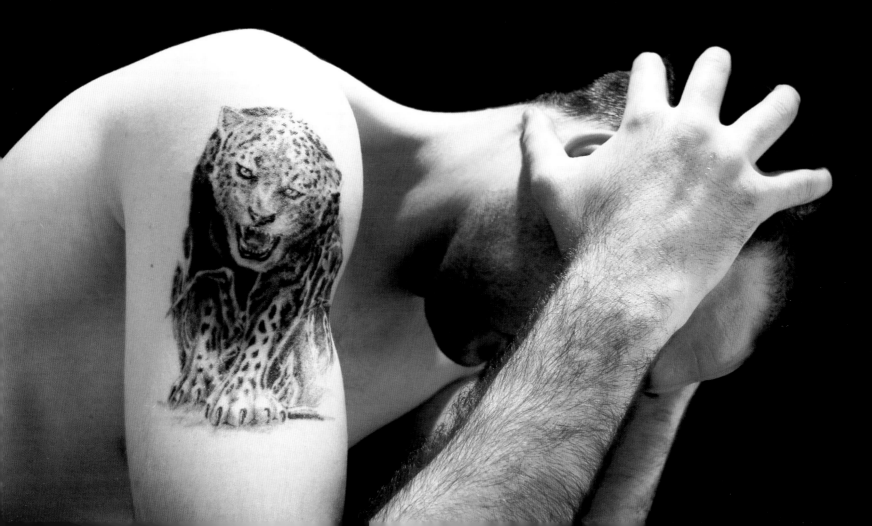

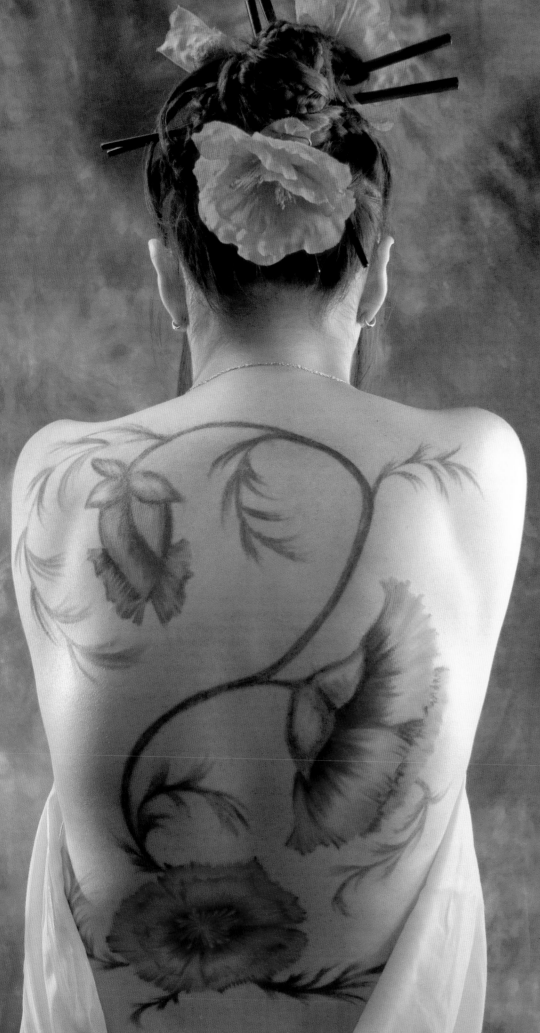

Mixing other geometrical shapes with a cross design can also change its meaning. Adding a loop to the top of a Latin-style cross creates an image identical to the Egyptian *ankh* symbol, which represents the sunrise and therefore rebirth (and new beginnings); on the other hand, encircling the never-ending knotwork of a Celtic cross might point to the union of Heaven and Earth, eternity and the good old circle of life.

The Good, the Bad and the Ugly

Presenting slightly more of a challenge to a tattoo artist are images inspired by the angels, devils and demons of world religions. They can advertise belief or have specific functions, and they also appeal to secular collectors for both their appearance and attributes. Angels, for example, have a range of roles (avenging, protecting and communicating) in Islam, Hinduism and Christianity but also exist as a general idea that transcends specific ideologies. Tattoos of guardian angels might protect the wearer, whereas cherubs might be cute messengers of love, and both can refer to a specific faith or no faith at all.

Devils are similarly ambiguous. Tattoos might depict the fallen angel Lucifer, or Satan, as a reminder of sin or embodiment of evil, but they exist in Old School tattoos as more playfully subversive figures. Devil girls ironically reference pin-ups and can be wickedly sexy, while the cherub-like chubby devil 'Hot Stuff' might suggest a sense of humour and a taste for bad — but not evil — behaviour.

Further down the road to hell, fantasy demons spawned in shadow and flame give artists plenty to work with. Likewise, Indian epic the *Ramayana* describes Rakshasas: shapeshifting creatures with a penchant for gory slaughter. Alternatively, there is the fierce stare of Japanese *oni*: malevolent spirits in folklore worn as protective tattoos to frighten away evil.

Ye Gods!

Deities and saints aren't averse to appearing in ink along with devils and angels (with the exception of Islam, which prohibits representations of the Prophet but may tolerate other forms of tattoo). Rather than the Christian God Himself, though (although He does appear, as does Jesus), Mary – or the Madonna – is probably the most widespread religious tattoo and offers guidance and compassion to the inked devotee. A common design is Our Lady of Guadaloupe: a mainstay of traditional art with Latin American roots. Rather more prosaically, Mary was also tattooed on the backs of some sailors, in case they were sentenced to the lash: they hoped (probably in vain) that no one would flog the image of the Madonna. The risk of flogging has generally abated for collectors (unless they are into that sort of thing), but the idea of Mother Mary as a protecting companion remains.

Hindu gods can also make fine companions for the faithful: elephant-headed Ganesh is genial and compassionate, while monkey god Hanuman battles malign spirits and is the deity of acrobats and wrestlers. On the other hand, goddess Kali – blue-skinned and terrible and often adorned with skulls – is an incarnation of Durga: the demon slayer. She's your girl in a fight.

Slightly more peaceable is the Buddha, who appears either as a head or as a seated figure in a meditative pose. He is the symbol of enlightenment, the Buddhist path and a perfect being who has attained nirvana – something we can all aspire to.

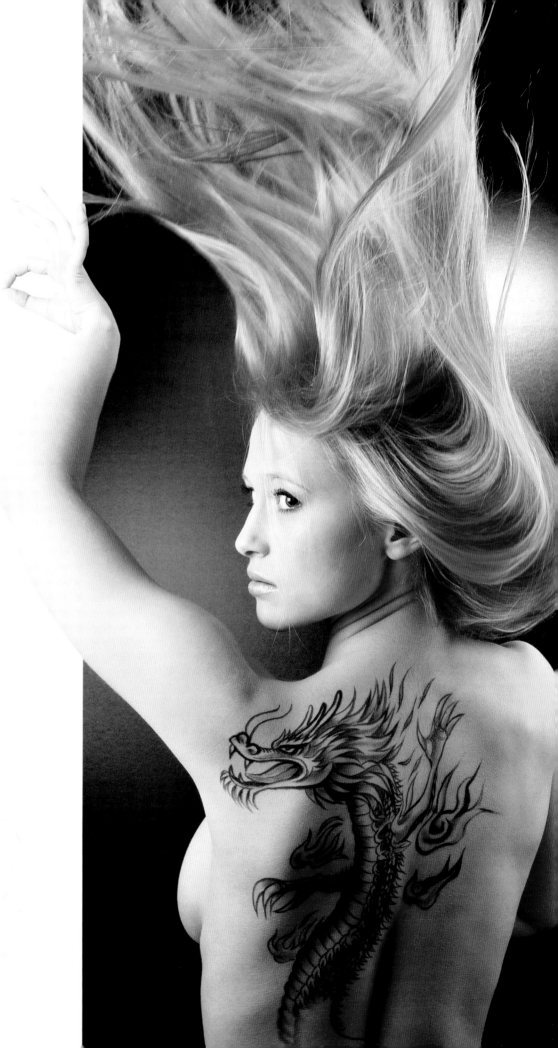

Signing Up

Religious figures and emblems can be versatile images, but more versatile still are some of the non-denominational symbols that appear throughout mathematics and mythology, and indeed throughout the history of tattooing. For those who want an adaptable tattoo that can encompass many meanings and still remain slightly ambiguous, an esoteric symbol might be just the way to go; we still don't know the precise meaning of the tattoos on ancient ice mummies, which only adds to their mystique.

Symbols can also include hieroglyphics, which should always be approached with a little caution, partly because they are easy prey for the fickle whimsy of fashion, but also because even native speakers don't know every symbol. It's easy for Westerners to end up with something nonsensical on their skin without careful research. Tattoo artists, however gifted, may also struggle to render the symbols accurately enough to convey their meaning and as a tattoo changes over time, it might end up saying something completely different. Clearly, the idea of kanji tattoos – which are just as beautiful as any other – should not be dismissed, but the sensible collector will take time in the preparation of the design, just as they might double-check the spelling of any textual tattoo.

Written in the Stars

Sometimes the simplest thing is just to look up. Stars appear regularly in tattoos as flexible design elements to help fill out a piece, or to link separate pieces together, but they can also feature in their own right. As the earliest navigational aids known to man, star tattoos can offer guidance (and reassurance) to those in darkness; more explicitly, the traditional nautical star might help the collector follow the right course in life. And as Oscar Wilde put it, 'We are all in the gutter, but some of us are looking at the stars', thus making them inspirational symbols which encourage us to keep heading towards our goals.

The Never-ending Story

Stars offer light in the darkness. Taking that one step further, some symbols – such as the black and white *taijitu* symbol central to Taoist philosophy – represent the inseparable nature of light and dark, yin and yang, good and evil. You can't have one without incorporating some of the other.

Sticking with the theme of interconnectedness, the Om symbol also packs a lot into a little image. Said to be the sound of the deep breath in the void before the universe began, it's a sacred syllable that repeats throughout Hinduism and Buddhism and will echo for ever, making it something of an all-encompassing spiritual tattoo. But it also possesses a wider philosophical relevance which will appeal to even the most committed atheist, as it encapsulates everything before us and everything that will come after us – whatever that may be. What did the big bang sound like? Om ...

The circle incorporates a similar significance into an even simpler image, albeit one that is extremely hard to get exactly right on the skin: nothing sums up the unending cycle of existence from creation to destruction and back again, more succinctly than the closed loop of the circle (or even the double loop of the infinity symbol). A slightly more arresting design that carries the same meaning is Ouroboros: an ancient symbol of a snake devouring its own tail that represents the eternal process of death and rebirth.

But tattoos really don't have to mean anything at all – which brings us right back to where we started. Full circle, you might say.

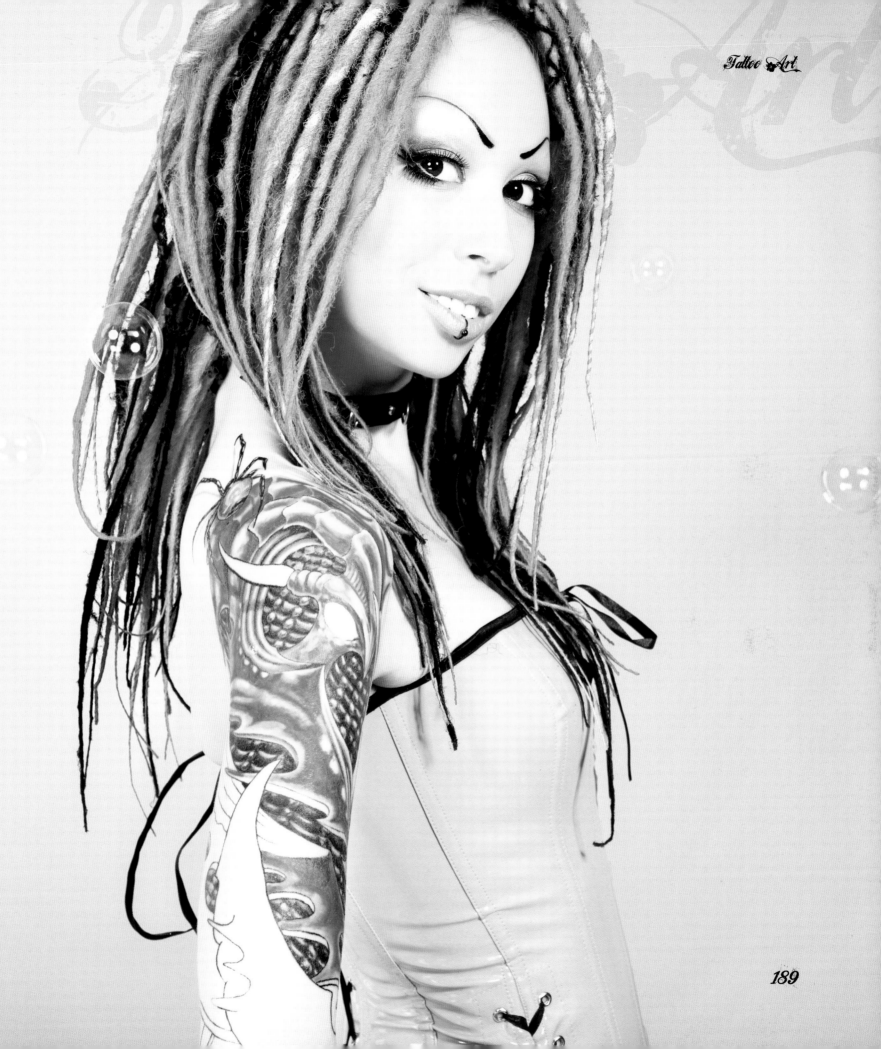

Index